Symbolism

Text: Nathalia Brodskaïa
(except the poems and *The Manifesto of Symbolism* by Jean Moréas)

Maurice Maeterlinck, *Serres chaudes*, © Succession Maeterlinck
Saint-Pol-Roux, *Tablettes*, © Rougerie
Paul Valéry, *Poésies*, © Gallimard

Translation: Tatyana Shlyak and Rebecca Brimacombe (Text)
Eamon Graham (Poems except *Correspondances* and *Spleen* of Charles Baudelaire by Lewis Piaget Shanks)

Layout:
Baseline Co. Ltd.
127-129A Nguyen Hue Blvd
Fiditourist, 3rd Floor
District 1, Ho Chi Minh City, Vietnam

Published in 2007 by Grange Books
an imprint of Grange Books Plc
The Grange Kingsnorth Industrial Estate
Hoo, nr Rochester, Kent ME3 9ND
www.grangebooks.co.uk

ISBN: 978-1-84013-841-2

Printed in China

Symbolism

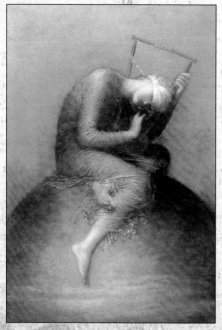
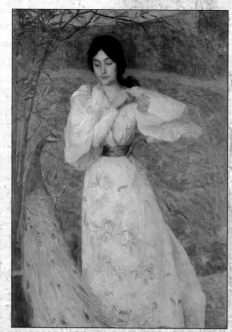
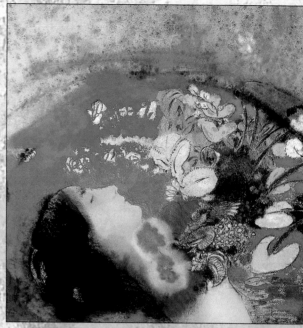
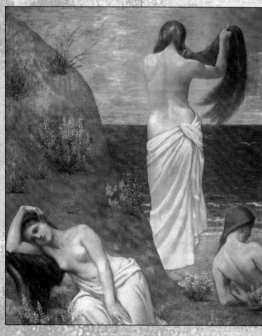
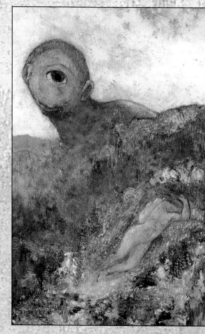
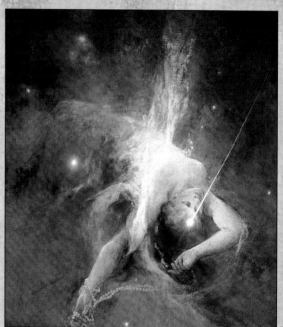
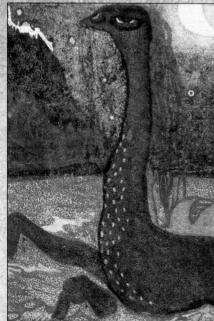
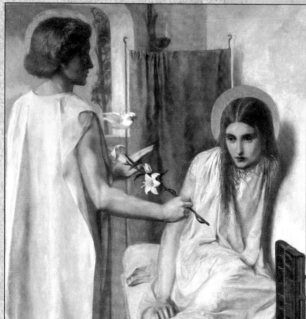

- Contents -

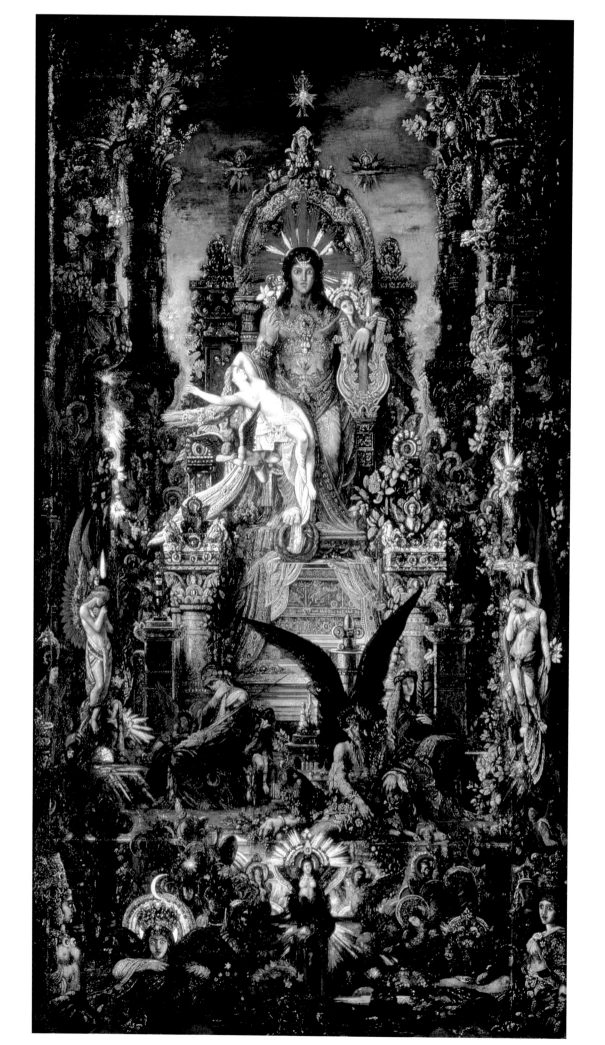

Introduction: The Manifesto of Symbolism by Jean Moréas

"For two years, the Parisian press has been much occupied by a school of poets and prosateurs known as the "Decadents". The storyteller (in collaboration with Mr Paul Adam, the author of Self) of *Le Thé chez Miranda*, the poet of the *Syrtes* and the *Cantilènes*, Mr Jean Moréas, one of the most visible among these revolutionaries of letters, has formulated at our request, for the readers of the Supplement, the fundamental principles of the new manifestation of art."

(*Le Figaro*, literary supplement, September 18, 1886)

SYMBOLISM

*L*ike all arts, literature evolves: a cyclical evolution with strictly determined turns which become complicated by various modifications brought about by the march of time and the upheavals of surroundings. It would be superfluous to point out that each new evolutionary phase of art corresponds exactly to senile decrepitude, to the inevitable end of the immediately previous school. Two examples will suffice: Ronsard triumphed over the impotence of the last imitators of Marot, Romanticism spread its banners over the Classical debris that was poorly guarded by Casimir Delavigne and Étienne de Jouy. It is that every manifestation of art fatally manages to impoverish itself, to exhaust itself; then, from copy to copy, from imitation to imitation, what was once full of sap and freshness dries out and shrivels up; what was the new and spontaneous becomes the conventional and the cliché.

And so Romanticism, after having sounded every tumultuous alarm of revolt, after having had its days of glory and battle, lost its strength and its grace, abdicated its heroic audacities, made itself orderly, sceptical and full of good sense: in the honourable and paltry attempt of the Parnassians it hoped for deceptive revivals, then finally, like a monarch fallen in childhood, it let itself be deposed by Naturalism, to which one can only seriously grant a value of protest, legitimate but ill advised, against the dullness of some then fashionable novelists.

A new manifestation of art, therefore, was expected, necessary, inevitable. This demonstration, incubated for a long time, has just hatched. And all insignificant anodynes of the joyful in the press, all the concerns of serious critics, all the bad temper of the public, surprised in its sheeplike nonchalance, only further affirm every day the vitality of the present evolution in French letters, this evolution noted in a hurry by judges, by an incredible discrepancy, of decadence. Notice, however, that the Decadent literature proves essentially to be tough, long-winded, timorous and servile: all the tragedies of Voltaire, for example, are marked by these specks of Decadence. And with what can one reproach, when one reproaches the new school? The abuse of pomp, the queerness of metaphor, a new vocabulary or harmonies combining themselves with colours and lines: characteristics of any renaissance.

Gustave Moreau,
Jupiter and Semele, 1895.
Oil on canvas, 213 x 118 cm.
Musée national Gustave-Moreau, Paris.

We have already proposed the name of *Symbolism* as the only one capable of reasonably designating the present tendency of the creative spirit in art.

It was mentioned at the beginning of this article that the evolution of art offers an extremely complicated cyclic character of divergences: thus, to follow the exact filiations of the new school, it would be necessary to go back to certain poems of Alfred de Vigny, back to Shakespeare, back to the mystics, further still. These questions would demand a whole volume of commentaries; therefore, let us say that Charles Baudelaire must be considered as the true precursor of the current movement; Stéphane Mallarmé allots to it the sense of mystery and the ineffable; Paul Verlaine broke in his honour the cruel hindrances of verse that the prestigious fingers of Théodore de Banville had previously softened. However, the supreme enchantment is not yet consumed: a stubborn and jealous labour requires newcomers.

As the enemy of plain meanings, declamation, false sentimentality and objective description, Symbolic poetry seeks to clothe the Idea in a sensual form which, nevertheless, would not be its goal in itself, but which, while serving to express the Idea, would remain exposed. The Idea, in its turn, must not be deprived of external analogies; because the essential character of Symbolic art consists of continuing until the concentration of the Idea in itself. Thus, in this art, scenes from nature, the actions of humans, and all concrete phenomena cannot manifest themselves for their own sake; here they are the sensual appearances intended to represent their esoteric affinities with primordial ideas.

The accusation of obscurity thrown in fits and starts by readers against such an aesthetic has nothing which can surprise. But what to do? The *Pythian Odes* of Pindar, Shakespeare's *Hamlet*, Dante's *Vita Nuova*, Goethe's *Faust Part II*, Flaubert's *The Temptation of Saint Anthony* - were they not also taxed by ambiguity?

For the exact translation of its synthesis, Symbolism needs: a complex and archetypical style; unpolluted terms, the period that braces itself alternating with the period with undulating lapses, meaningful pleonasms, mysterious ellipses, the anacoluthon in suspense, all too audacious and multiform; and, finally, good language - instituted and modernised - the good and lush and spirited French language from before Vaugelas and Boileau-Despréaux, the language of François Rabelais and Philippe de Commines, Villon, Ruteboeuf and so many other free writers, darting the term of the language like so many Thracian Toxoteses with their sinuous arrows.

Rhythm: the ancient metrics revived; a learnedly ordered disorder; rhyme hammered like a shield of gold and bronze, near rhyme with abstruse fluidities; the Alexandrine with multiple and mobile stops; the use of certain prime numbers - seven, nine, eleven, thirteen - solved in various rhythmic combinations of which they are the sums.

Here I beg permission to make you attend my small INTERLUDE drawn from an invaluable book: *The Treatise on French Poetry*, where M. Théodore de Banville mercilessly thrusts, like the god of Claros, monstrous donkey's ears on the head of Midas.

Attention!

The characters who speak in this piece are:

A DETRACTOR OF THE SYMBOLIC SCHOOL
MR THEODORE DE BANVILLE
ERATO

Louis Welden Hawkins,
The Halos, 1894.
Oil on canvas, 61 x 50 cm.
Private collection, Paris.

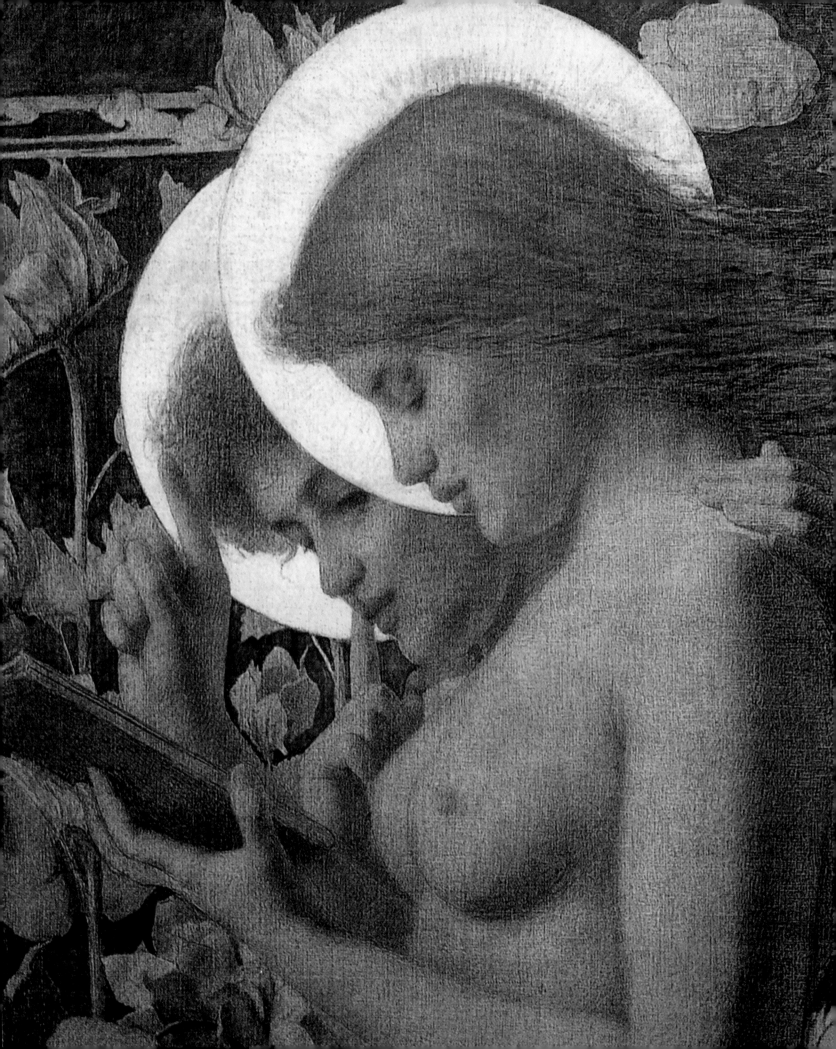

FIRST SCENE

THE DETRACTOR. - Oh! These Decadents! What pomposity! What gibberish! As our great Molière was correct when he said:

This figurative Style of which people are so vain,
Is beside all good taste and truth

THEODORE DE BANVILLE. - Our great Molière committed here two evils towards those who themselves partake as much as possible of good taste. What good character? What truth? The obvious mess, vivid craziness, passionate pomposity is the very truth of lyric poetry. To fall into excess of imagery and colour is not a great evil, and it is not by this that our literature will perish. In the worst of times, when it dies decisively (as, for example, under the First Empire), it is not pomposity and the abuse of ornamentation that kill it, it is dullness. Taste and naturalness are beautiful things undoubtedly less useful than one thinks poetry to be. Shakespeare's *Romeo and Juliet* was written from beginning to end in a style as affected as that of the *Marquis de Mascarille*; that of Ducis shines by the happiest and most natural simplicity.

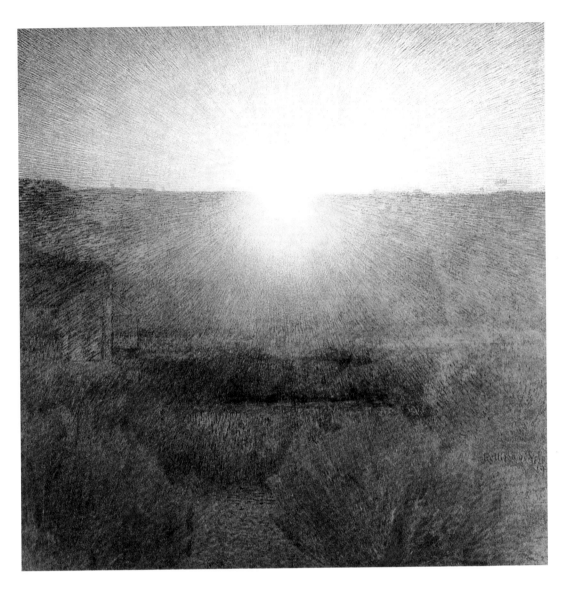

THE DETRACTOR. - But the caesura, the caesura! They're desecrating the caesura!!

THEODORE DE BANVILLE. - In his remarkable prosody published in 1844, Mr Wilhem Tenint establishes that the Alexandrine verse admits twelve different combinations on the basis of the verse which has its caesura after the eleventh syllable. He returns to say that, actually, the caesura can be placed after any syllable of the Alexandrine verse. In the same way, he establishes that verses of six, seven, eight, nine, ten syllables admit variable and variously placed caesuras. Let's do more: let's dare to proclaim complete freedom and say that in these complex questions the ear alone decides. One always perishes not from having been too bold but from not being bold enough.

THE DETRACTOR. - Horror! Not to respect the alternation of rhymes! You know yourself, Sir, that the Decadents dare to even allow hiatus! Hiatus even!!

THEODORE DE BANVILLE. - Hiatus, the diphthong making a syllable in verse, all other things that were forbidden and especially the optional use of masculine and feminine rhymes have provided to the poet of genius one thousand means of delicate effects, always varied, unexpected, inexhaustible. But to use this scholarly verse, genius and a musical ear were necessary, while with stationary rules the most mediocre writers can - while obeying

Giuseppe Pellizza da Volpedo,
The Rising Sun or *The Sun*,
1903-1904.
Oil on canvas, 150 x 150 cm.
Galleria Nazional d'Arte Moderna, Rome.

Giovanni Segantini,
The Bad Mothers, 1894.
Oil on canvas, 105 x 200 cm.
Österreichische Galerie Belvedere, Vienna.

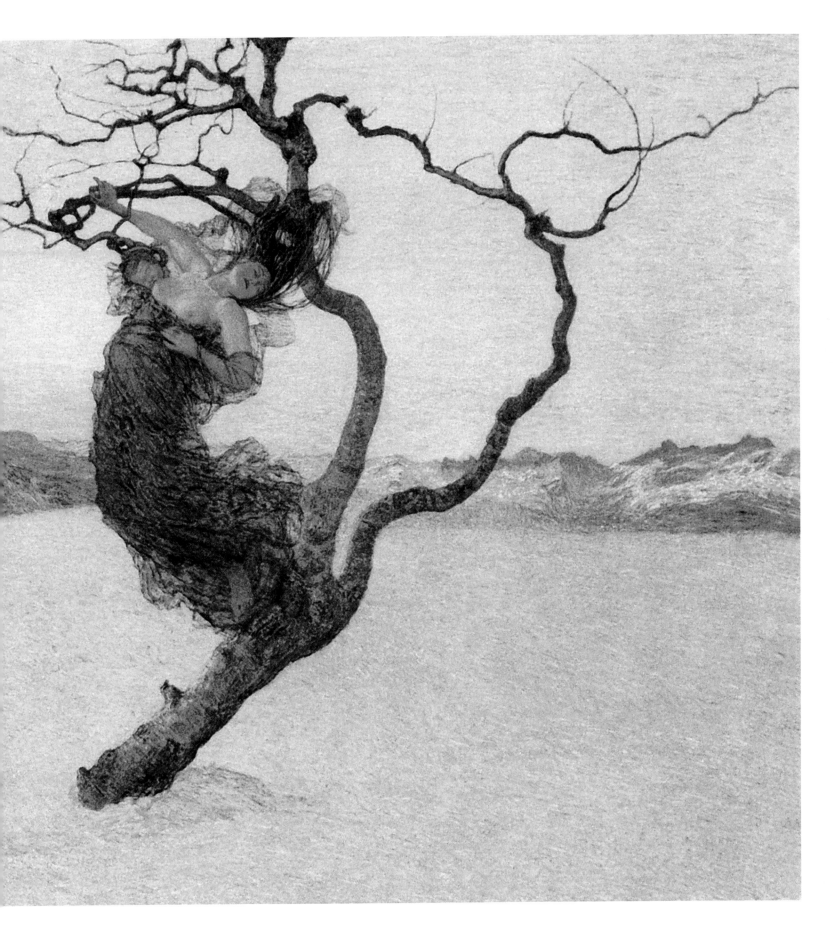

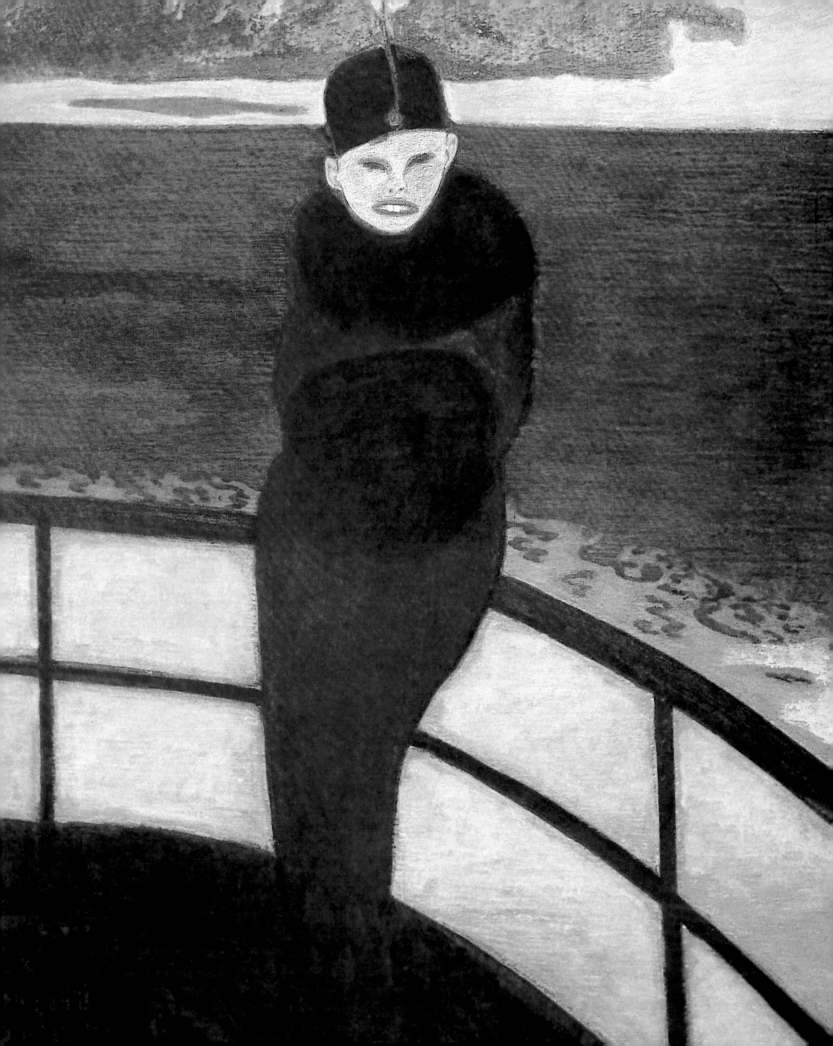

them faithfully - make, alas! tolerable verses! Who therefore gained anything from the regulation of poetry? Poor poets. Only them!

THE DETRACTOR. - It seems to me, however, that the Romantic revolution...

THEODORE DE BANVILLE. - Romanticism was an incomplete revolution. What a pity that Victor Hugo, this victorious, bloody-handed Hercules, was not completely a revolutionary and that he let live a group of monsters which he was put in charge of exterminating with his flaming arrows!

THE DETRACTOR. - All innovation is madness! The imitation of Victor Hugo is the salvation of French poetry!

THEODORE DE BANVILLE. - When Hugo had liberated verse, one was to believe that, educated by his example, the poets coming after him would want to be free and only to raise themselves up. But inside us is such a love of constraint that the new poets, as if in competition, copied and imitated the most typical of Hugo's forms, combinations and cuts, instead of endeavouring to discover new ones. This is how, fashioned by the yoke, we fall again from one slavery to another, and that after the Classical conventions, there were the Romantic conventions, conventions of cuts, conventions of sentences, conventions of rhymes; and convention (that is to say, the cliché become chronic) in poetry, as in anything else, is Death. On the contrary, let's dare to live! and to live is to breathe the air of the sky and not the breath of our neighbour, though this neighbour be a god!

SCENE II

ERATO (invisible). - Your *Small Treatise on French Poetry* is a delicious work, master Banville. But the young poets have blood up to the eyes fighting against the monsters fed by Nicolas Boileau; you are asked for on the field of honour, and you keep silent, master Banville!

THEODORE DE BANVILLE (dreamer). - Curse! I would have failed in my duty as elder and lyric poet!

(The author of *The Exiles* breathes a lamentable sigh and the Interlude finishes.)

Prose - novels, short stories, tales, fantasies - evolves in a sense similar to that of poetry. Elements, seemingly heterogeneous, converge there: Stendhal brings his translucent psychology, Balzac his exorbitant vision, Flaubert his cadences of sentences to the full arches. Mr Edmond de Goncourt brings his modernly suggestive Impressionism.

The conception of the Symbolic novel is polymorphic: sometimes a single character moves in surroundings distorted by his own hallucinations, his temperament; in this distortion lies the only reality. Beings with mechanical gestures, with shadowed silhouettes, are agitated around the single character: to him these are no more than pretexts to sensations and conjectures. He himself is a tragic or comical mask, of humanity however perfect although rational. Soon the crowds, superficially affected by the set of ambient representations, carry themselves with alternations of shocks and stagnations toward acts which remain incomplete. At times, some individual wills appear; they attract, agglomerate, generalise each other towards a goal which, either reached or missed, disperses them in their primitive

Léon Spilliaert,
The Crossing, 1913.
Pastel and coloured pencils,
90 x 70 cm.
Private collection.

Józef Mehoffer,
The Wisla River, near Niepolomice.
Oil on canvas.
Fine Arts Society, Kraków.

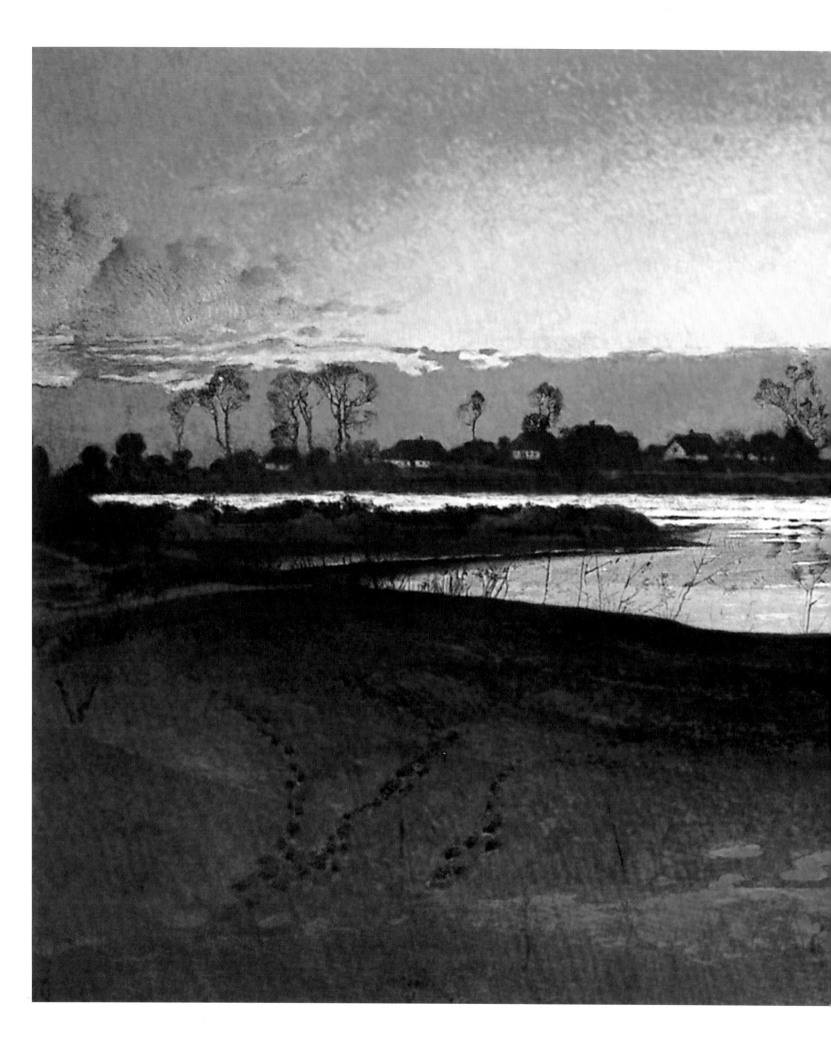

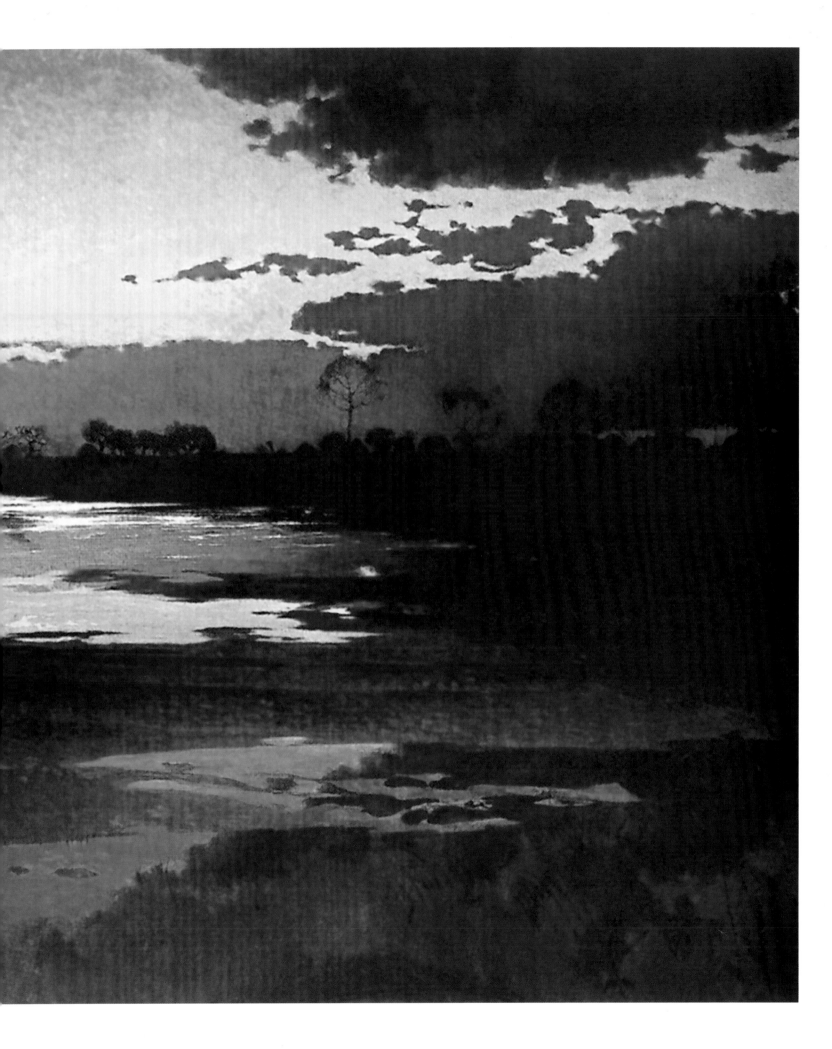

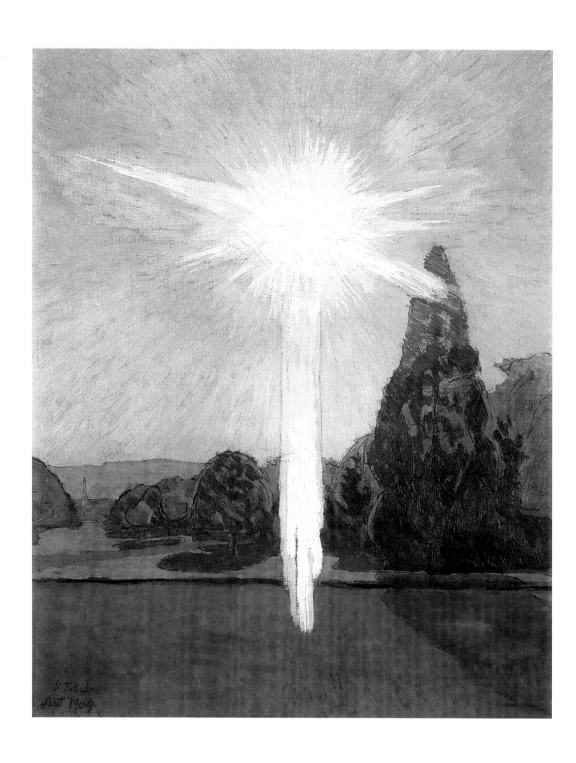

Jens Ferdinand Willumsen,
Sun in the Park, 1904.
Oil and tempera on canvas,
194 x 169 cm.
J. F. Willumsens Museum,
Frederikssund.

Witold Pruszkowski,
Falling Star, 1884.
Oil on canvas.
The National Museum, Warsaw.

elements. Sometimes mythical phantasms are evoked, from the ancient Demogorgon to Belial, from Kabirs to Nigromans, and appear ostentatiously dressed on the rock of Caliban or by the forest of Titania to the mixolydian modes of Barbitons and Octochords.

So scornful of the puerile method of Naturalism - Zola, himself, was saved by a marvellous writer's instinct - the Impressionist-Symbolic novel will build strong its work of *subjective distortion* from this axiom: that art should seek in the *objective* only one simple, extremely brief starting part.

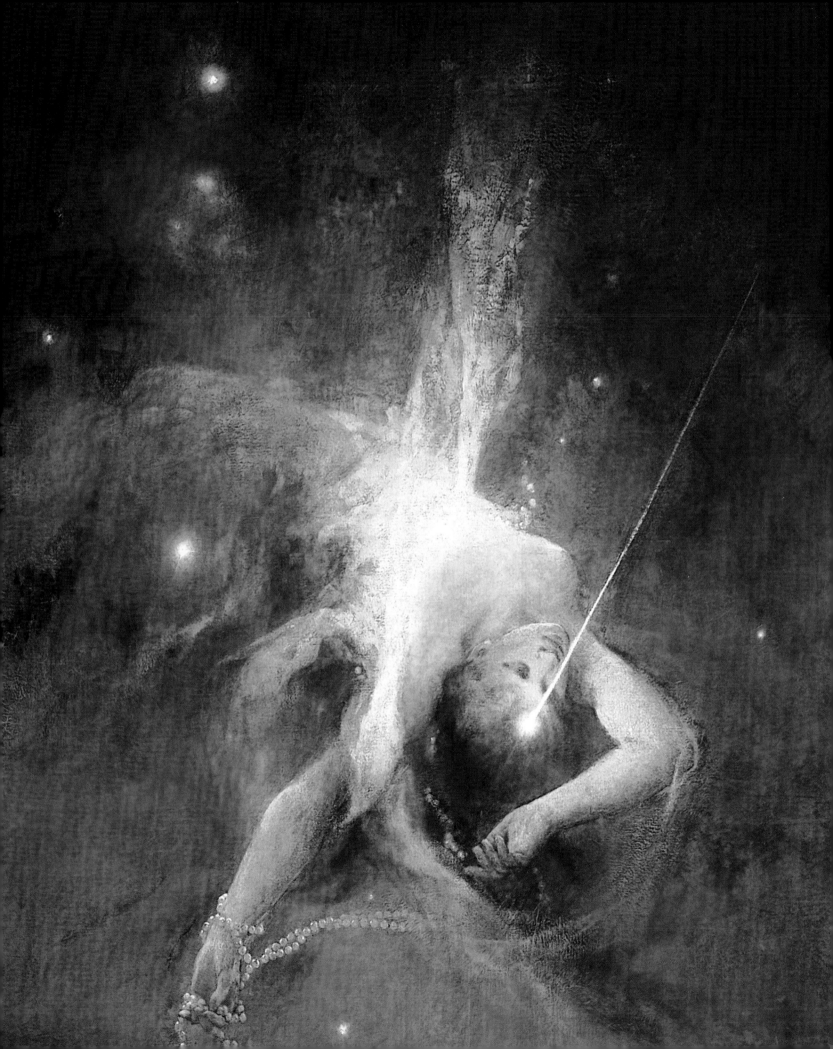

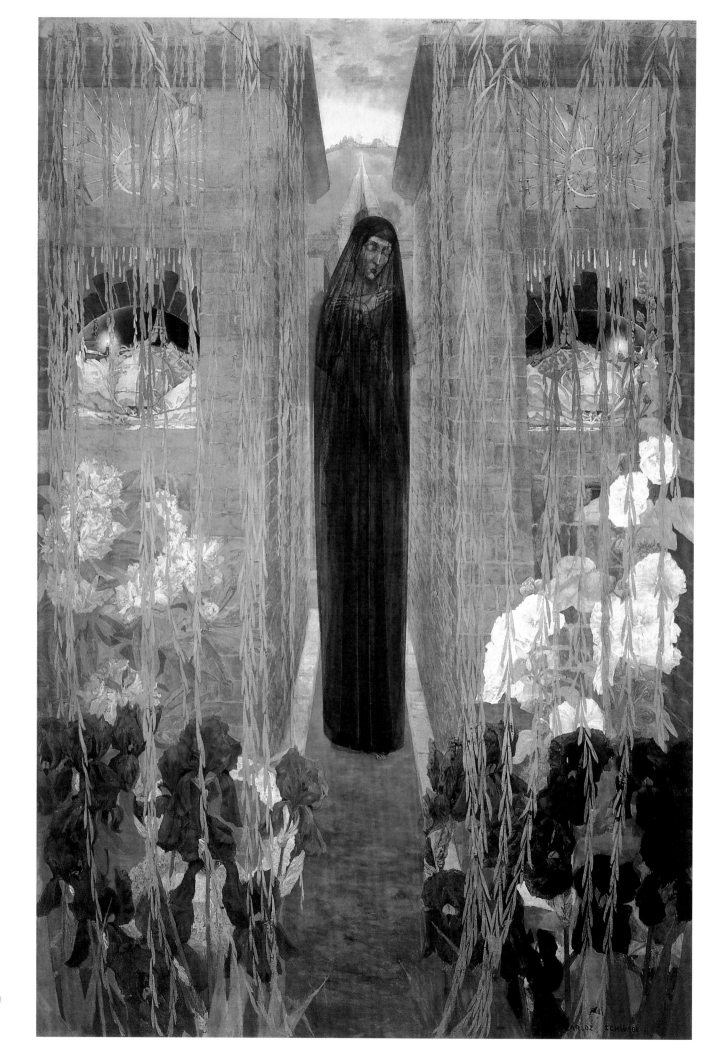

I. Symbolism in Literature

rucial transformations in the concept of man and of the world caused the emergence of new tendencies in literature, the field that always reacts the quickest to the changes in social surroundings. Precisely, literature has always possessed the prerogative of ideology formation in a society. Painting has always been connected with literature the most closely since the Renaissance. Literature has created the background for the appearance of new trends in fine arts.

At the close of a century, the interest in literature increases extraordinarily. Its scope widens, the writers of many countries are drawn to it. By 1886 France had learned of the latest achievements of Russian literature - Dostoyevsky's *Crime and Punishment* and Tolstoy's *Anna Karenina*. Scandinavian countries had opened a new world for the French in the works by Ibsen, Hauptmann, Strindberg. In the eighties, in Paris, the fascinating adventure novels of the Englishman Stevenson, *Treasure Island* and *The Master of Ballantrae*, were printed; after them, readers acquainted themselves with his *The Strange Case of Dr Jekyll and Mr Hyde*, which allowed them to peer into the sphere of man's unbelievable possibilities, and into the mysteries of his subconscious. One after another, Nietzsche and Schopenhauer's works were published, and Bergson's philosophy astounded contemporaries. At the threshhold of the new century works by Freud and Jung appeared. *Belles-lettres* embraced the unusually wide world in the geographical aspect as well, novels by Loti, Kipling, Conrad beckoning the reader to far away, unexplored lands, and now it did not seem impossible. At the close of the century *The Time Machine*, *The Island of Dr. Moreau*, *The Invisible Man*, and, lastly, *The War of the Worlds* by the Englishman H.G. Wells were published in France; Wells thought that man's fantasy was unable to invent that which could not be accomplished in life. His works seemed to sum up the century, foretelling inconceivable cataclysms.

It can be said of *fin de siècle* French literature that it was at the forefront of realism. The "natural school", the most consonant with the paintings of Impressionism, had not yet yielded its position by the end of the century. The fame of Flaubert, who died in 1880, was growing; the novels of Maupassant, the Goncourts, Daudet, and, of course, Emile Zola, who remained one of the important figures in the public life of France, continued to be published. Zola gathered writers in his house in Medan, and published an anthology of their works. His noble speech in Dreyfus's defence drew loyalist society's hate upon himself. However, literary realism had already passed its apogee and was gradually becoming the property of the classics. The society's indignation was now addressed to a new generation in literature. In the seventies, simultaneously with "naturalists", such names as Rimbaud, Verlaine, Leconte de Lisle and Huysmans were appearing more and more often in the press. In 1876 *L'Après-Midi d'un faune* by Stéphane Mallarmé was published, having become the cause for the creation of one of the most remarkable compositions by Debussy – *Prélude à l'Après-Midi d'un faune* – in 1894. Music, together with literature, affirmed the new in art – that which scared a society hardly used to naturalism. In 1884 Huysmans' novel *Vice Versa* was published. The author broke up with his friends from Medan, extolled Mallarmé and the artists close to Symbolism – Gustave Moreau and Odilon Redon.

Carlos Schwabe,
Sadness, 1893.
Oil on canvas, 155 x 104 cm.
Musée d'Art et d'histoire, Geneva.

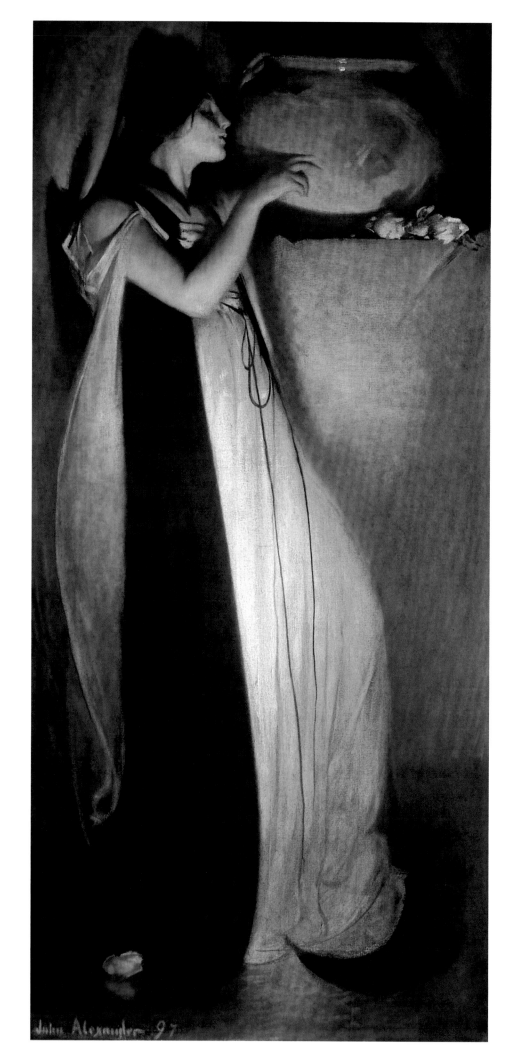

John White Alexander,
Isabel and the Pot of Basil, 1897.
Oil on canvas, 192.1 x 91.8 cm.
Museum of Fine Arts, Boston.

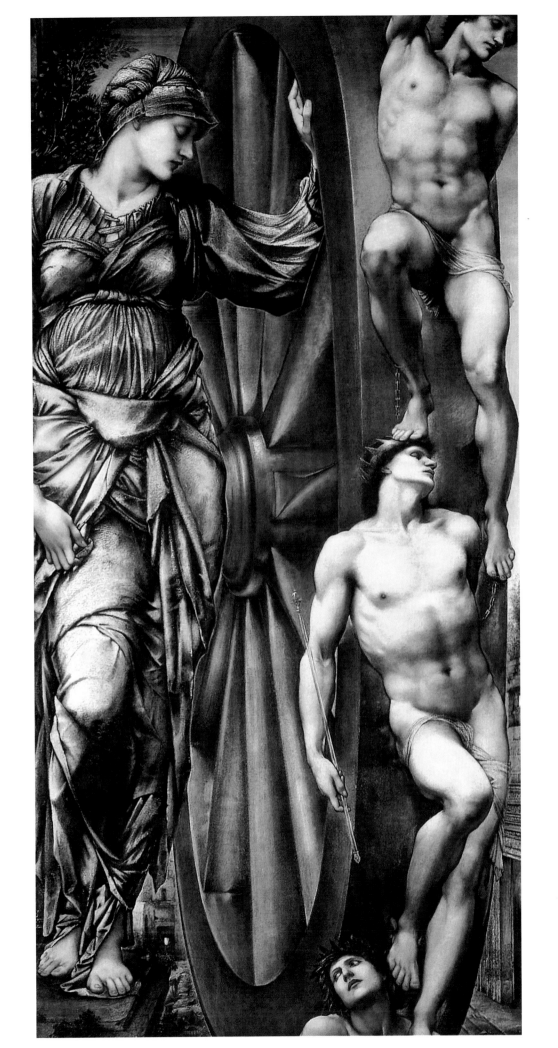

Edward Burne-Jones,
The Wheel of Fortune, 1883.
Oil on canvas, 200 x 100 cm.
Musée d'Orsay, Paris.

23

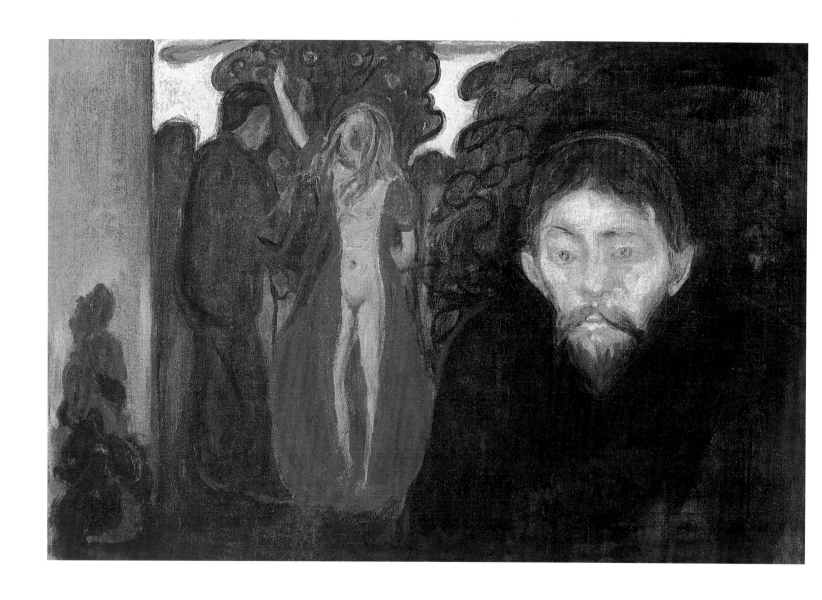

Edvard Munch,
Jealousy, 1895.
Oil on canvas, 67 x 100.5 cm.
Rasmus Meyer collections, Bergen.

On 18 September 1886, the significant year of the Impressionists' last exhibition, in the appendix to the newspaper *Figaro*, "The Manifesto of Symbolism" appeared, written by the poet Jean Moréas: immediately after that the term "Symbolism" came into usage. Moréas consolidated the new conception of literature, formed by that time. In 1855, when there was yet no Symbolism in literature, in the anthology *The Flowers of Evil*, Charles Baudelaire published the poem "Correspondances" that sounded as the rallying-cry of the new literary school. "Baudelaire was its precursor," Moréas wrote, "Stéphane Mallarmé infused it with the taste for the mystery of the unsaid, Paul Verlaine broke the cruel fetters of versification." (*The Poetry of French Symbolism*, Moscow: Moscow University Press, 1993, p.430). From 1884, the acknowledged head of the new trend, Stéphane Mallarmé, gathered its adherents, inviting artists, critics, musicians and theatrical figures to his "Tuesdays". The theatre *Creation* and *Free Theatre* of the producer Antoine acquainted Paris with Ibsen's drama, staging plays by Symbolists and closely-related authors. In unison with Symbolism, there sounded the music of Richard Wagner, the German composer and philosopher, the new wave of interest in whom rose after his death in 1883. Paris experienced its first infatuation for Wagner in the beginning of the 1860s, when Charles Baudelaire, among others, appealed in support of the composer's. Attention was riveted on Wagner again after the attempt to

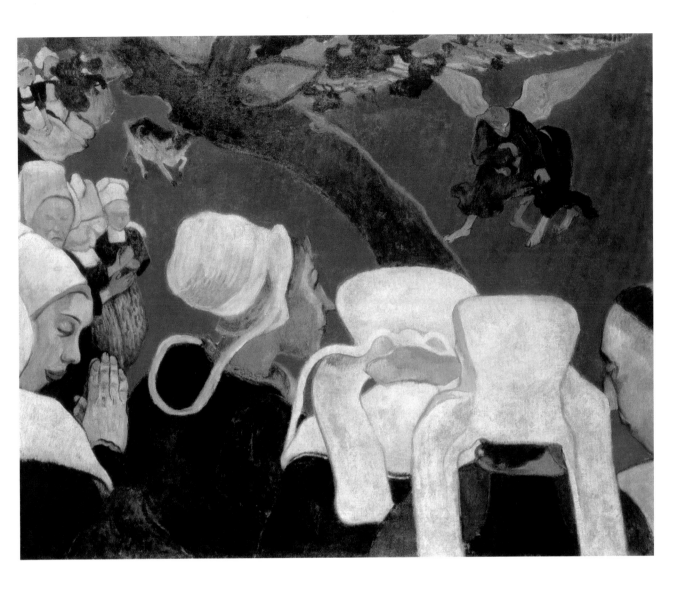

stage his opera *Lohengrin* in 1887, in *L'Eden-Theatre*, had provoked violent protests. His music astounded with exaltation, now with flashes of ecstasy, now with gloomy, mourning intonations. Wagner's strength consisted also in myth-creation that corresponded with the Symbolists' doctrine. In the middle of the eighties, in collaboration with Mallarmé, there appeared *Revue Wagnerienne*, around which the poets, artists and musicians of the Symbolism circle united. In 1891, the artist from the Nabis group, Félix Vallotton, made a remarkable portrait of Wagner using the technique of xylography. In 1889, two years earlier, there had been published the first issue of the journal *La Revue blanche*, to which its publishers, the Natanson brothers, attracted the writers of Symbolism and quite a number of artists close to the movement.

It was not just the populace in general but also adherents of former schools of art, now become classical, who reacted painfully to Symbolism. In the originality of its creators, they saw unnaturalness, a whim, the aspiration to put the self outside of society. Symbolism frightened them especially because it was not current in literature or art, but a philosophical concept, another attitude to reality, a new outlook. It was generated as a result of that grandiose revolution in science which so shook and frightened its contemporaries. It seemed that everything in life found a rational explanation and no mysteries remained in nature.

Paul Gauguin,
The Vision After the Sermon or *Jacob Wrestling with the Angel*, 1888.
Oil on canvas, 72.2 x 91 cm.
National Gallery of Scotland,
Edinburgh.

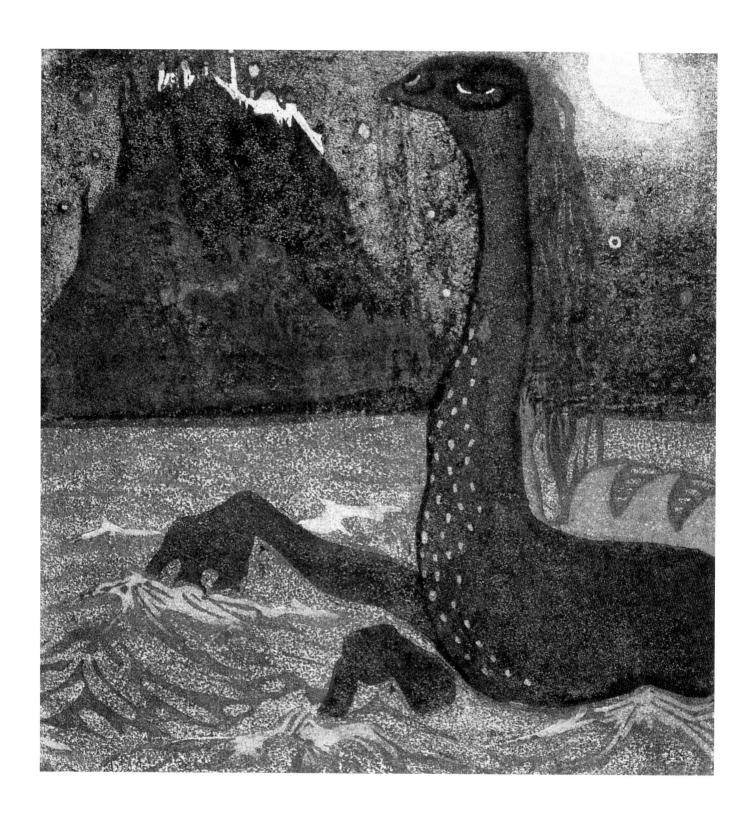

Wassily Kandinsky,
Moonlit Night, 1907.
Watercolour woodblock print,
20.8 x 18.6 cm.
The State Tretyakov Gallery, Moscow.

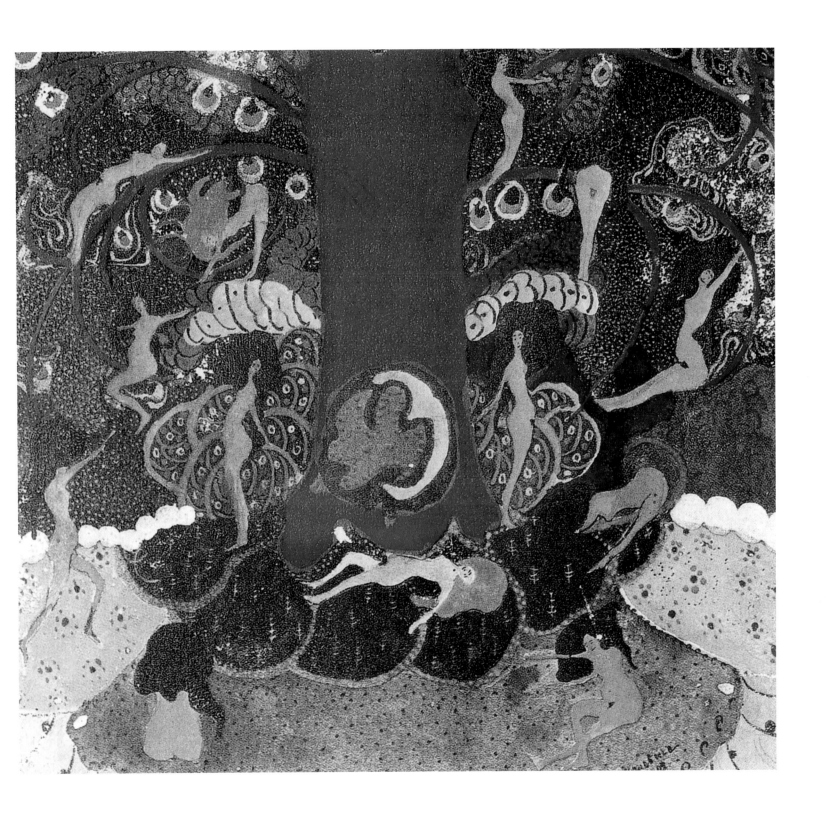

Kazimir Malevich,
Oaks and Dryads, c. 1908.
Watercolour and gouache on paper,
21 x 28 cm.
Private collection.

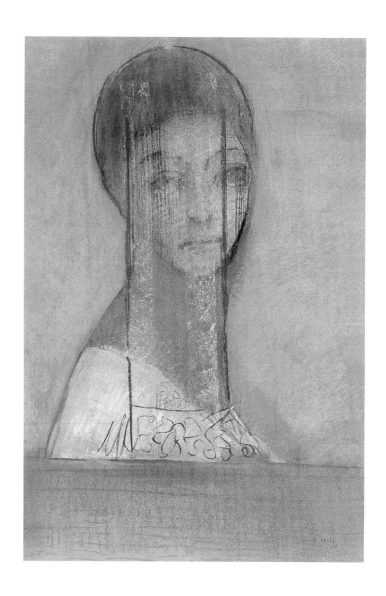

Odilon Redon,
Veiled Woman, c. 1895-1899.
Pastel, 47.5 x 32 cm.
Kröller-Müller Museum, Otterlo.

Symbolism opposed society's ideas of science, aspiring to return to art the priority of the spiritual over the material. Its adherents addressed not scientific logic, but intuition, the subconscious, imagination – the forces inspiring the struggle against the absolute power of matter and laws established by Physics.

As to literature, the main enemy and opponent of Symbolism in it remained realism. In the humdrum of life Symbolism opposed mysticism, the mystery of the "other worldly", the search for the latent sense in any phenomenon or image. It drew attention to the huge, incomprehensible world surrounding us, asking us to discover the mysterious meaning of being, which is accessible only to a true creator. Instead of mere observation of life, it put forward an unusual imagination, inaccessible to the ordinary artist. Searching for the secrets of this imagination, twentieth-century surrealists turned precisely to Symbolism. In *The Manifesto of Surrealism* André Breton said that the poet-Symbolist Saint-Pol-Roux, going to bed, hung up on his door a note with the request to not disturb him, because "the poet is at work". However, Symbolists did not mean literally the images coming to the artist in a dream. Sung by them, both in literature and in painting, the dream was a

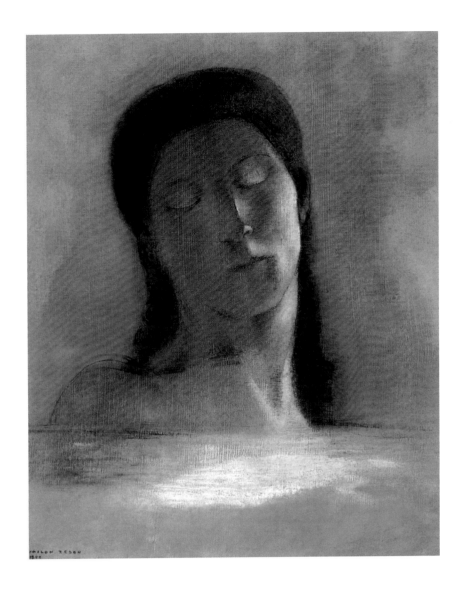

demonstration and even a symbol of their exceptional imagination, capable of transcending reality.

It seemed that with the death of Hugo in 1883, Romanticism, in the atmosphere of which the artists of the middle of the century created, finally left. Analysing Symbolism, Saint-Pol-Roux said: "Romanticism sang only sparkles, and shells, and small insects that come across in sandy thickness. Naturalism has counted every single grain of sand, whereas the future generation of writers, having played long enough with this sand, will blow it away in order to reveal a symbol hidden under it…"[1]. Although the contemporaries of post-Impressionism considered Romanticism obsolete, in reality it was not able to regenerate itself for some time, yielding under the pressure of realism in all its aspects. But Symbolism had become its closest heir. The researchers of Symbolism even sometimes called it "post-Romanticism". Like the Romanticism of the first half of the nineteenth century, Symbolism appeared the brightest and the fullest style in the realm of literature. Nevertheless, it had penetrated the arts.

Symbolism in literature, which Jean Moréas introduced and defined in his manifesto in 1886, was to become a fully-fledged genre. Moréas established that every renewal of a

Odilon Redon,
Closed Eyes, 1890.
Oil on canvas remounted on board,
44 x 36 cm.
Musée d'Orsay, Paris.

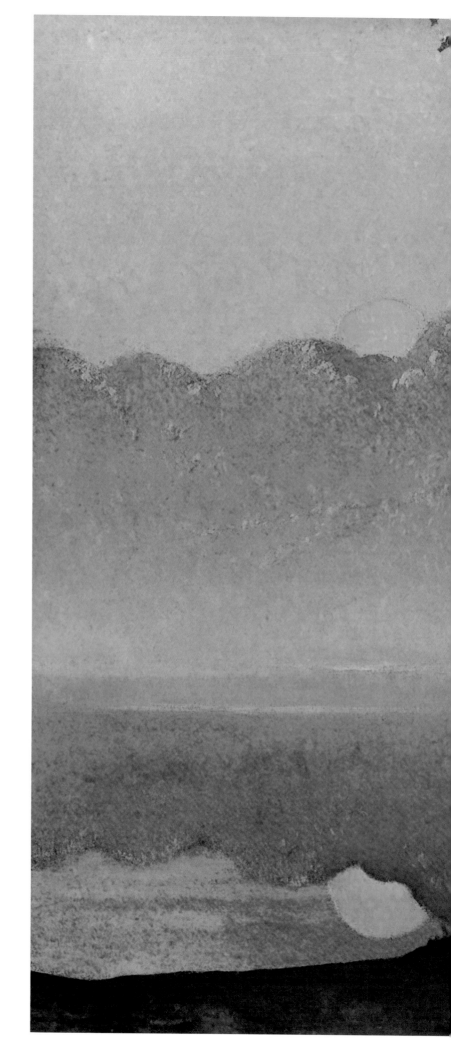

Alphonse Osbert,
Muse at Sunrise, 1918.
Oil on wood panel, 38 x 46 cm.
Private collection.

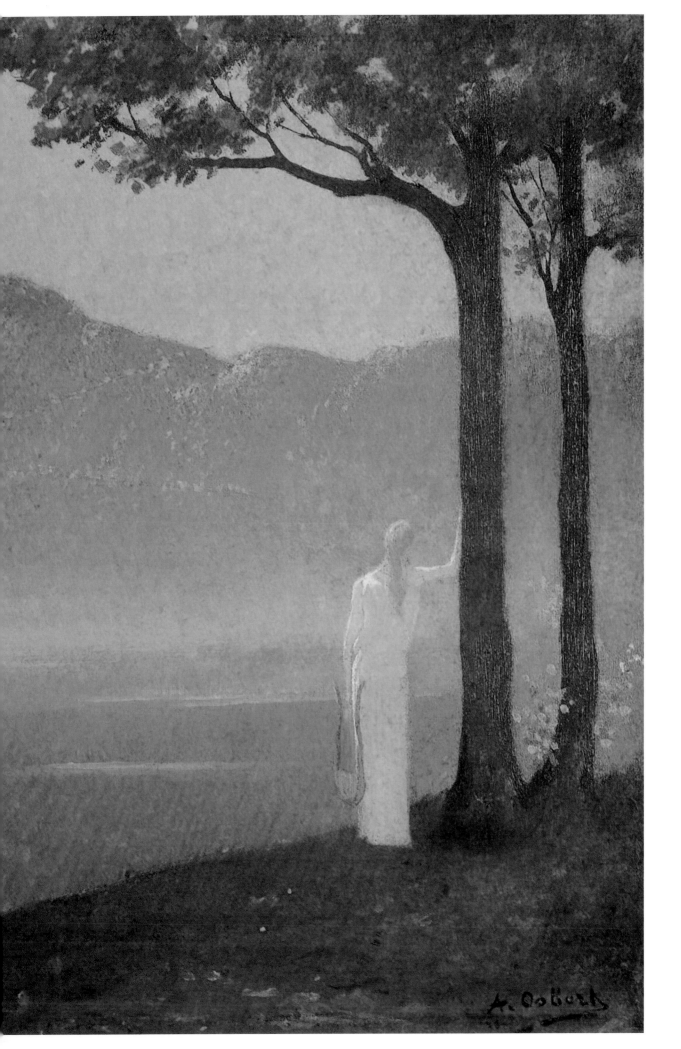

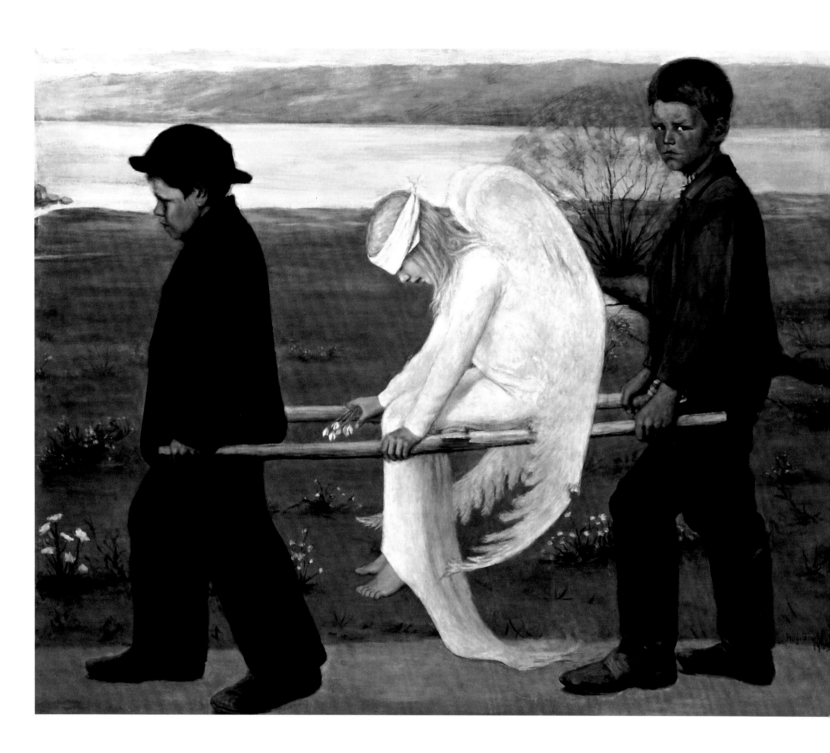

genre met the corresponding decrepitude and atrophy of a previous school. "Romanticism, ringing loudly the alarm bell of riot and surviving the days of battle and glorious victories, lost its strength and attraction…, it surrendered to naturalism…," he wrote. Consequently, naturalism was subjected to the severest criticism and accusations by the ideologists of Symbolism. Emile Zola remained for them the embodiment of naturalism in literature. Despite his admiration for Zola's talent, Mallarmé considered his works to be on the lowest level of literature. Moreover, Remy de Gourmont, in the heat of the struggle, called Zola's writings "culinary art" that merely borrows the ready "pieces of life"[2], ignoring ideas and symbols. Replying to the question about naturalism, Stéphane Mallarmé found a literary image from the treasury of Symbolists for its definition. "So far, literature imagined quite childlike," he said, "as if, having gathered precious stones, and then, having written down – albeit even very beautifully – their names on paper, it thus makes precious stones. Nothing of the kind! … Things exist apart from us, and it is not our task to create them; we are required just to capture connections between them…"[3].

Charles Baudelaire splendidly stated the priority of these connections in the new world perspective in his *Correspondances*:

> *Nature's a temple where down each corridor*
> *of living pillars, darkling whispers roll,*
> *— a symbol-forest every pilgrim soul*
> *must pierce, 'neath gazing eyes it knew before.*

Nature tries to talk to man in its own language, but man is unable to understand it; this language is full of obscure symbols, and it would be vain to look for their solutions. The magnetic force of Symbolism, in contrast with the simplicity and clarity of naturalism, consists precisely in its enigmatic quality, in the deeply-hidden mystery, the revelation of which actually does not exist. The difference between Symbolism and naturalism was best explained by Emile Verhaeren. "Here, before the poet, is the night Paris - the myriads of luminescent specks in the boundless sea of darkness," writes Verhaeren. "He (the writer) can reproduce this image directly, as Zola would have done: to describe streets, squares, monuments, gas-burners, ink-like darkness, feverish animation under the gaze of immobile stars - undoubtedly, he will achieve an artistic effect, but there will be no trace of Symbolism. However, he can gradually infuse the same image into the reader's imagination, having said, for example: 'This is a gigantic cryptogram, the key to which is lost,' - and then, without any descriptions and enumeration, he will find room in one phrase for the entire Paris - its light, darkness, and magnificence"[4].

Only the chosen one, only a lone artist is capable to create the abstracted from actual reality, generalised, symbolic image. Quoting Mallarmé, "This is the person, intentionally secluding himself in order to sculpt his own gravestone"[5]. Symbolists create something like the cult of the chosen loner. Listing the qualities inherent in Symbolism, Remy de Gourmont first of all names individualism, creative freedom, the renunciation of studied formulae, the aspiration for everything new, unusual, even strange. "Symbolism … is nothing else than the expression of artistic individualism"[6], he wrote in *The Book of Masks*, illustrating his thesis by the brilliant literary portraits of poet-Symbolists. Remy

Hugo Simberg,
The Wounded Angel, 1903.
Oil on canvas, 127 x 154 cm.
Ateneumin taidemuseo, Helsinki.

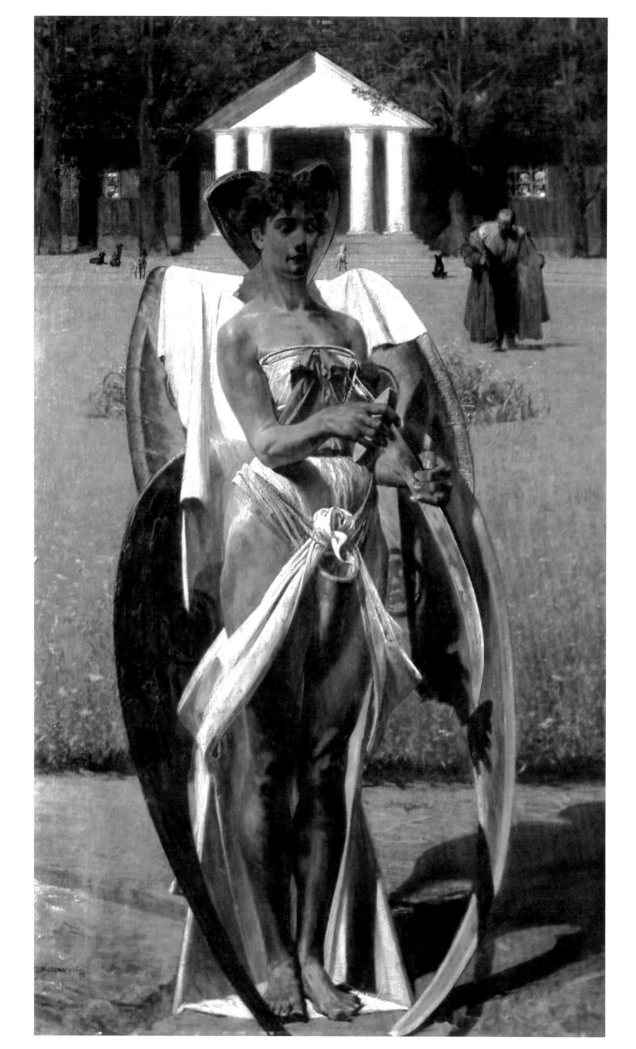

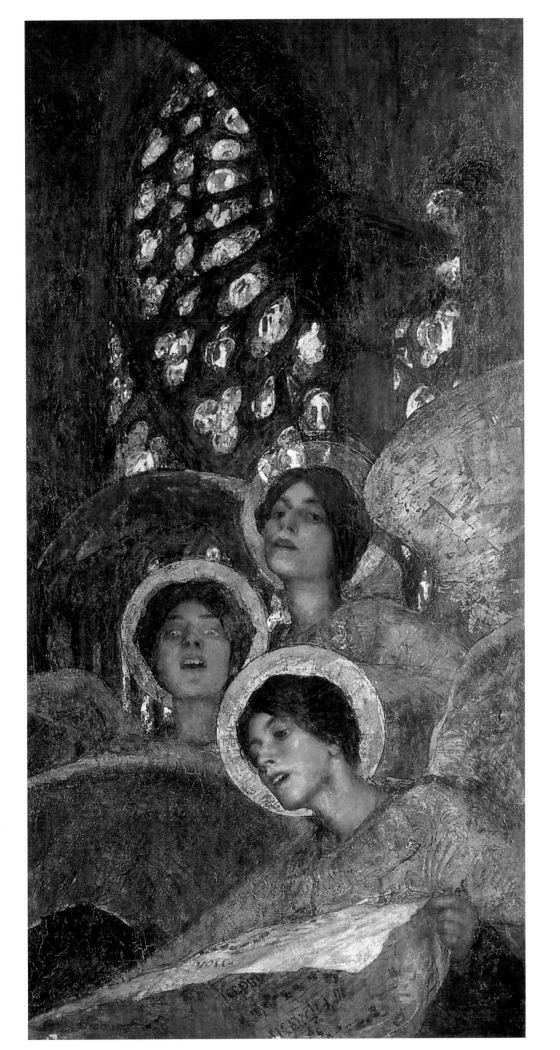

Jacek Malczewski,
Thanatos I, 1898.
Oil on canvas, 134 x 74 cm.
The National Museum, Warsaw.

Edgard Maxence,
The Concert of Angels, 1897.
Oil on canvas, 164 x 85 cm.
Musée départemental de l'Oise,
Beauvais.

35

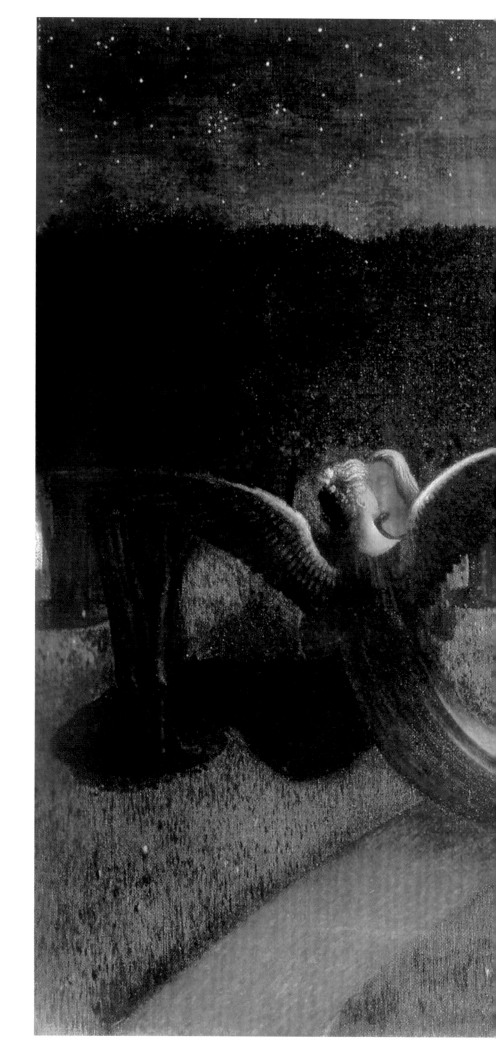

William Degouve de Nuncques,
Angels of the Night, 1894.
Oil on canvas, 48 x 60 cm.
Kröller-Müller Museum, Otterlo.

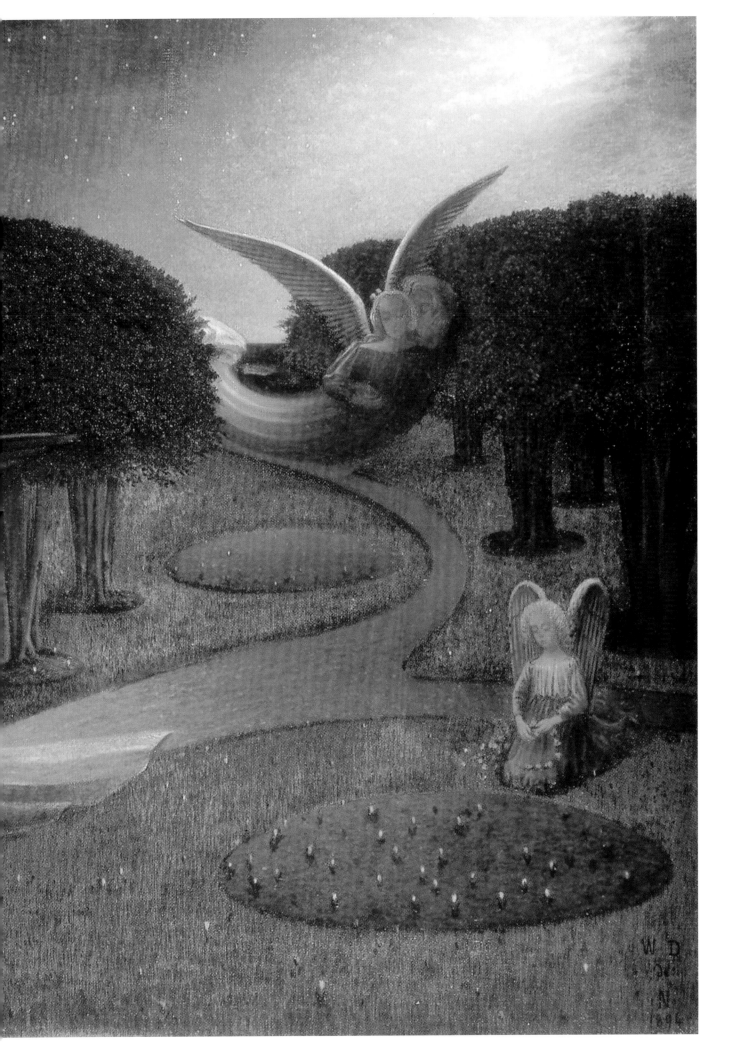

37

de Gourmont calls them "Daffodils in love with their own faces"[7]. His psychological analysis of each of these strange personalities involuntarily leads to their comparison with the similarly unusual, and misunderstood by their contemporaries, artist-loners of the post-Impressionism epoch – Cézanne, Gauguin, Van Gogh, Toulouse-Lautrec, le Douanier and Rousseau. The heightened emotion of their paintings, its subjection not to an original, but only to a master's individuality fully corresponds with a Symbolist poet's creed. Defining a creator's new image, Remy de Gourmont writes about Maeterlinck that he "found a hollow, unexpected shout, some cold, unsteady, mystical moan," intensifying the meaning of mysticism in his creations to the limits[8]. Mysticism, which is included as an integral sign in the concept of Symbolism, draws nearer to the concept of individualism. "Mysticism," Remy de Gourmont says, "can be seen as such a condition, in which, not feeling itself connected to the physical world, dismissing everything accidental and unexpected, the soul gives itself exclusively to spontaneous fusion with the infinite"[9].

Mysticism, a mystery beyond solution first of all, had come from literature into the fine arts in the form of subject matter. Poets as well as painters looked for symbolic topics in religion. "The child of religion," the poet George Vanor wrote, "a symbol is derived from the teachings of Zoroastrian priests, who represented the world in the shape of an egg harbouring good and evil powers[10]... The manifesto author Jean Moréas thought that topics worthy of Symbolism were always in literature. "Don't Pindar's *Pythian Odes*, Shakespeare's *Hamlet*, Dante's *Vita Nuova*, the second part of Goethe's *Faust*, Flaubert's *The Temptation of Saint Anthony* preserve the stamp of the same mysteriousness?" he writes in the manifesto. The art of painting had also used them many times in the process of its existence; however, now it tried to find a symbol in them and to reveal an idea through that symbol. German Romantics were wonderfully capable of finding subject matter for literature and painting. They drew topics from nature, studied the folk-tales and myths of different countries, discovering the most capacious symbols in them. Maeterlinck considered that there was an unconscious Symbolism that manifested itself quite apart from its creator's will. "It is inherent in every brilliant creation of the human spirit," he said in one of his interviews, "its first examples – works by Eskhil, Shakespeare…"[11]. The works of Maeterlinck himself, in Remy de Gourmont's opinion, represent a generalised image and, possibly, the model of symbolical subject matter. In *The Book of Masks*, he recreates the image of Maeterlinck's typical plot:

Somewhere in the mists, there is an island. On the island, there is a castle. In the castle, there is a large hall, lighted with a small lamp. In the hall, there are people who wait. Wait - for what? They don't know. They wait for someone to come and knock on their door. They wait for the lamp to go out. They wait for Fear. They wait for Death…. It is already late. Maybe, it will come only tomorrow! And the people, who have gathered in the large hall, lighted with the small lamp, smile. They hope. And now, at last, knocking is heard. This is all. This is the whole life. This is an entire life.[12]

Edmond Aman-Jean,
Young Girl with a Peacock, c. 1895.
Oil on canvas, 148 x 102 cm.
Musée des Arts Décoratifs, Paris.

Henri Le Sidaner,
Sunday, 1896.
Oil on canvas, 112.5 x 192 cm.
Musée de la Chartreuse, Douai.

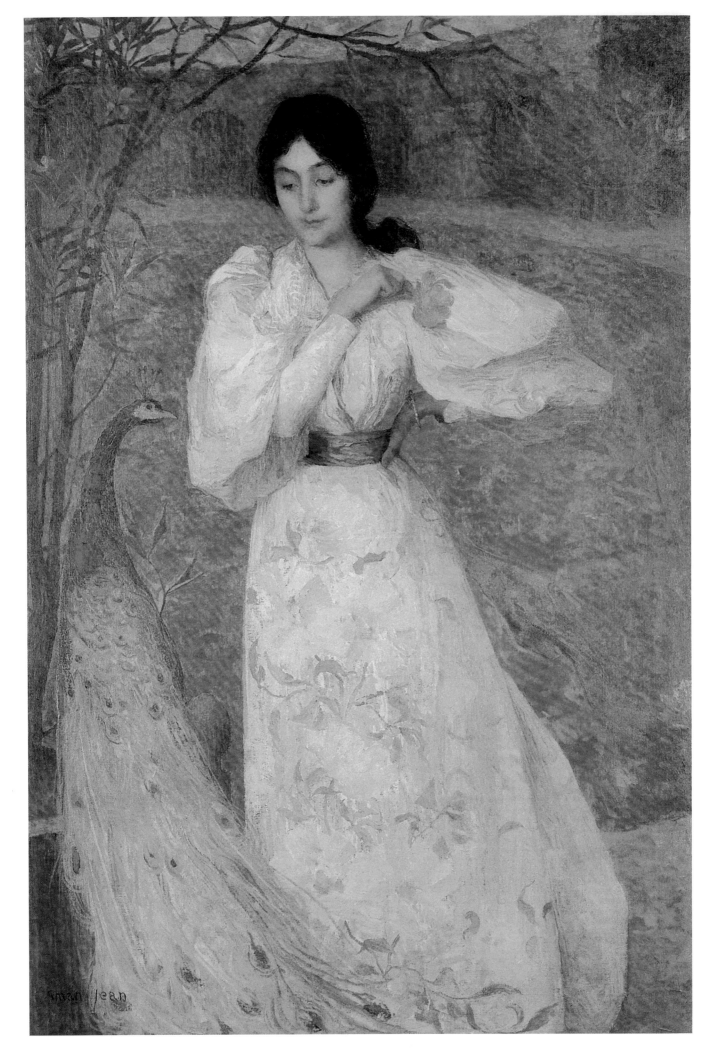

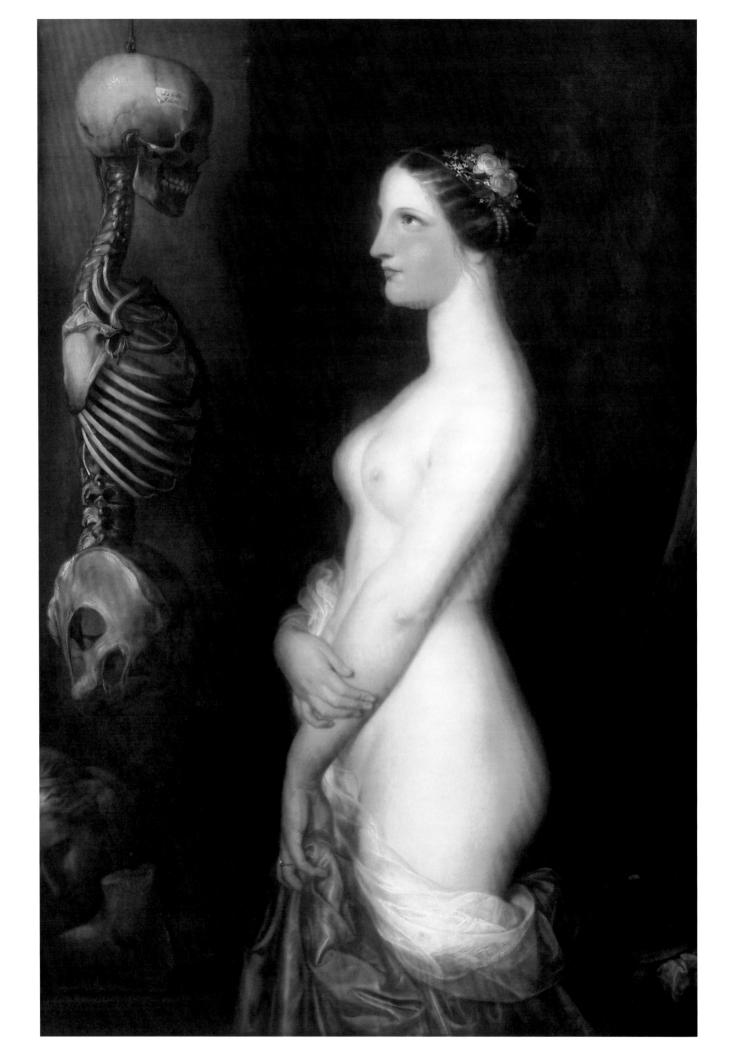

II. Symbolist Poems

Charles Baudelaire, *A Carcass*

Recall the object we saw, my soul,
That beautiful summer morning, so sweet,
A foul carcass along the turn in the path
On a bed sown with pebbles.

Legs in the air, like a lewd woman,
Burning and sweating poisons,
Opened nonchalantly and cynically,
Its belly full of exhalations.

The sun shone on this rottenness,
To cook it to a turn,
And reclaim a hundredfold for great Nature
All that she had joined together;

And the sky watched that superb carcass
Like a flower blossoming out.
The stench was so strong, that on the grass
You thought you would pass out.

Flies buzzed over the belly so putrid,
Whence came forth black battalions
Of larvae which flowed like a thick liquid
Along the length of these living rags.

All together it descended and rose like a wave
Or sprang forth, sparkling,
It was said that, swollen with vague breath,
The body lived in multiplying.

And this world produced a strange music
Like running water and of wind,
Or of grain in a rhythmic winnow
Shaken and tossed in the fan.

Antoine Wiertz,
The Beautiful Rosine, 1847.
Oil on canvas, 140 x 110 cm.
Musées royaux des Beaux-Arts de
Belgique, Brussels.

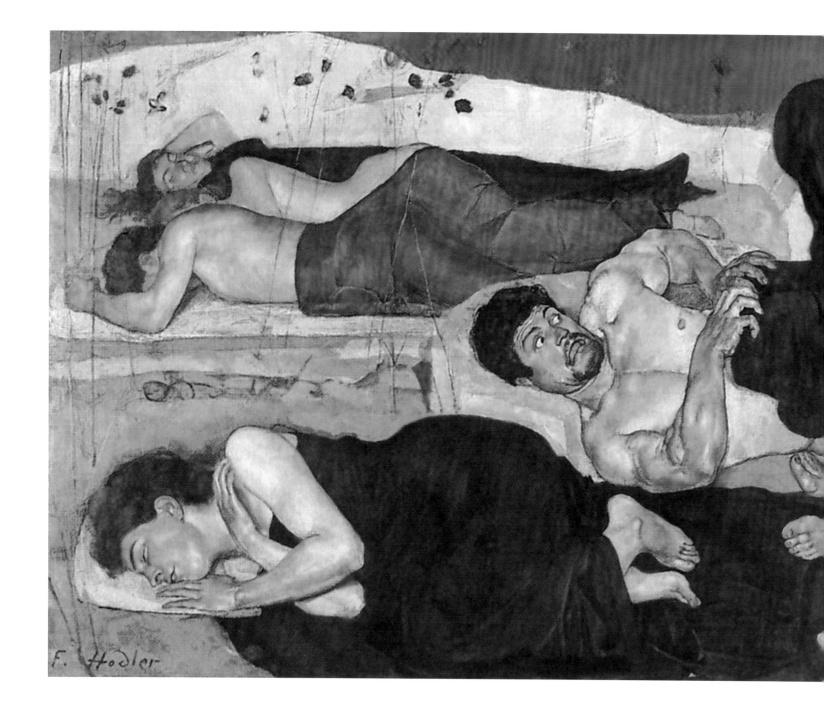

Ferdinand Hodler,
Night, 1890.
Oil on canvas, 116 x 239 cm.
Museum of Fine Arts, Bern.

Forms fade and are nothing more than a dream,
A sketch coming only slowly,
On the forgotten canvas, which the artist completes
Only through memory.

Behind the rocks a restless bitch
With an angered eye watched,
Spying the moment to take from the skeleton
The morsel that she had dropped.

And yet you will be similar to this rubbish,
To this horrible infection,

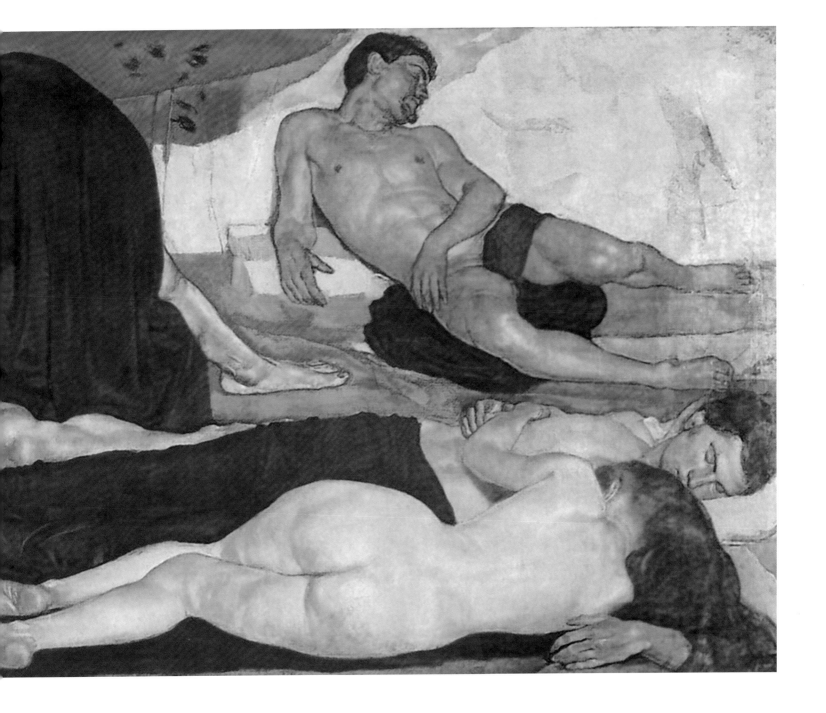

Star of my eyes, sun of my nature,
You, my angel and my passion!

Yes, such you shall be, O queen of the graces,
After the last sacraments,
When you go beneath the grass and oily flowers,
To mould among the bones.

Then, O my beauty! You will say to the vermin,
Which will devour you with kisses,
That I have preserved the form and essence divine
Of my decayed loves!

Charles Baudelaire, *Correspondances*

Nature's a temple where down each corridor
of living pillars, darkling whispers roll,
— a symbol-forest every pilgrim soul
must pierce, 'neath gazing eyes it knew before.

Like echoes long that from afar rebound,
merged till one deep low shadowy note is born,
vast as the night or as the fires of morn,
sound calls to fragrance, colour calls to sound.

Cool as an infant's brow some perfumes are,
softer than oboes, green as rainy leas;
others, corrupt, exultant, rich, unbar

Wide infinities wherein we move at ease:
— musk, ambergris, frankincense, benjamin
chant all our soul or sense can revel in.

Paul Sérusier,
Bretons. Meeting in the Sacred Wood,
c. 1891-1893.
Oil on canvas, 72 x 92 cm.
Private collection.

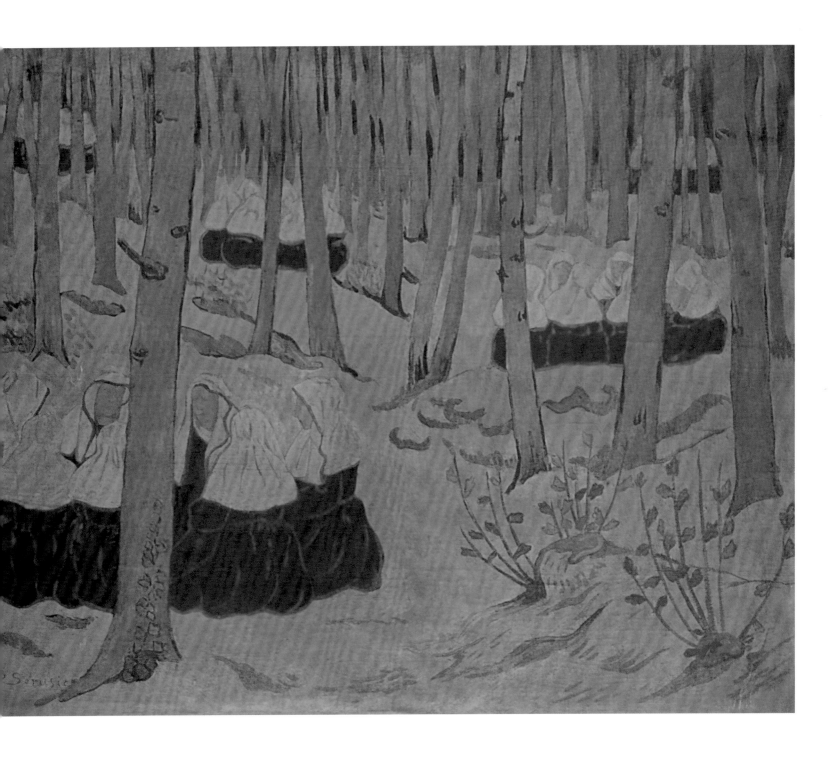

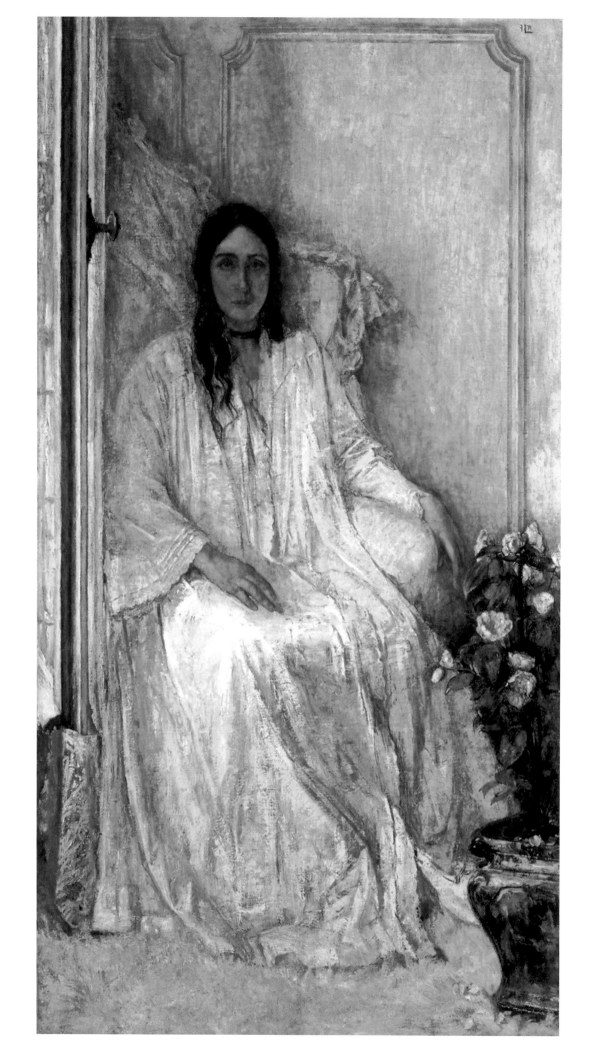

Charles Baudelaire, *Spleen*

When low skies weightier than a coffin-lid
Cast on the moaning soul their weary blight,
And from the whole horizon's murky grid
Its grey light drips more dismal than the night;

When earth's a dungeon damp whose chill appals,
In which — a fluttering bat — my Hope, alone
Buffets with timid wing the mouldering walls
And beats her head against the dome of stone;

When close as prison-bars, from overhead,
The clouds let fall the curtain of the rains,
And voiceless hordes of spiders come, to spread
Their infamous cobwebs through our darkened brains,

Explosively the bells begin to ring,
Hurling their frightful clangour toward the sky,
As homeless spirits lost and wandering
Might raise their indefatigable cry;

And ancient hearses through my soul advance
Muffled and slow; my Hope, now pitiful,
Weeps her defeat, and conquering Anguish plants
His great black banner on my cowering skull.

Frédéric Lottin,
Reminiscence, c. 1904.
Oil on canvas, 184 x 98 cm.
Musée Fabre, Montpellier.

49

René Ghil, *In the Times of the Gods*

Quite modern, and seeing from our modern souls,
Ancient evenings, in spite of himself, without Truth, without Paphos
Nor goddesses, he is exiled! and, in the markets
Azures and golds, and the nude of Paros,
Lies and gods he cries, and You, O pale Ames!
Wandering Virgins, with the long folds of the long *peplos*! ...

... Then, millennial old man, high azure under the azure,
Old, stripped branches! you lived grand and glaucous,
Temples! solemn and broad in the pure air,
Beloved of the Virgin, angst of the aged man,
Then, you lived alone, alone with the non-raspy zephyrs!

When the virgin with April eyes went towards you,
Under the virgin flax afraid of its tanless skin:
You sighed, branches, a virile aroma,
Tepid: and the Unpolluted One with the puerile sex
Had long anxieties under the pale length *peplos*...

Then, you slipped, goddesses, to the large nudes!
Glaucous and pale under the glaucour of leafed branches:
In our time, of Us, we the newcomers,
You are afraid, alas! and, your naïve breasts,
No one will see them any longer, O pale corpses!

Then, goddesses, if like a grand dream
We saw with golden Eyes in sudden ardours
Hurling into the glaucours, taking a long animal swing
That closely trailed: and the savage groan
Panted, from black knotty-veined Aegipans! ...

Therefore, ally yourself, virgin with the undulating *peplos*!
When you passed near the rigid greenery,
Full of sudden agitation: when, magic and nervous,
An aroma not put at the feet of great Forebears
Mirroring your divine pleats of soft and livid waters...

Thus it happened in the Times of the gods and the Lie,
Climbing to the Temples where the heights turn one blue, craving
Horizons, the greenery! and You, for stretching out
One's long reverie, sound out in a steady dream,
Oh pennywhistles! a soft sparse laugh in the Lie
From half-surprised lip and half-delighted breast!

Emile Bernard,
After the Bath (*The Nymphs*), 1908.
Oil on canvas, 121 x 151 cm.
Musée d'Orsay, Paris.

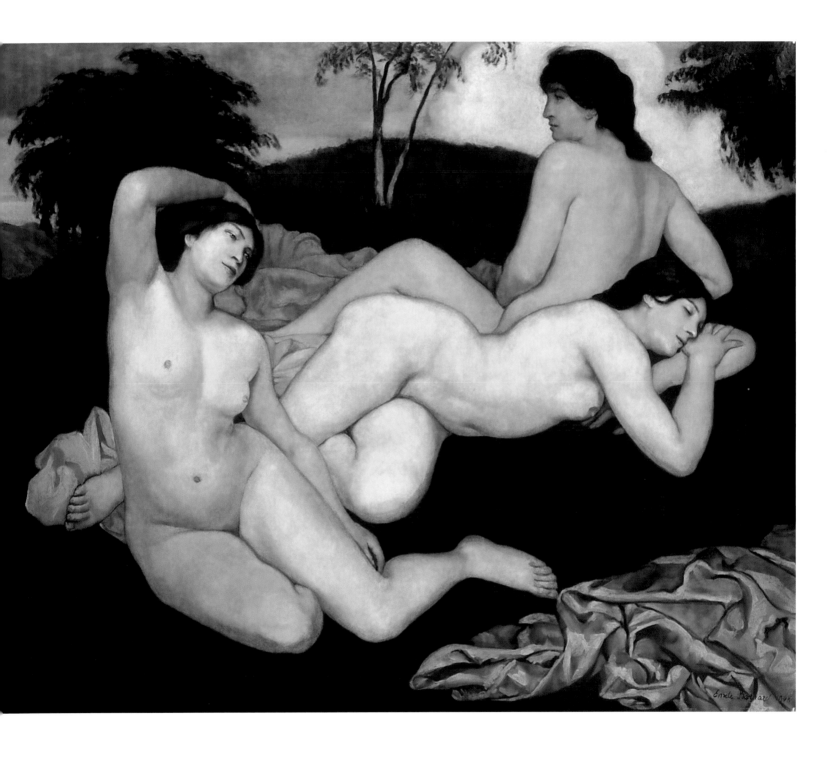

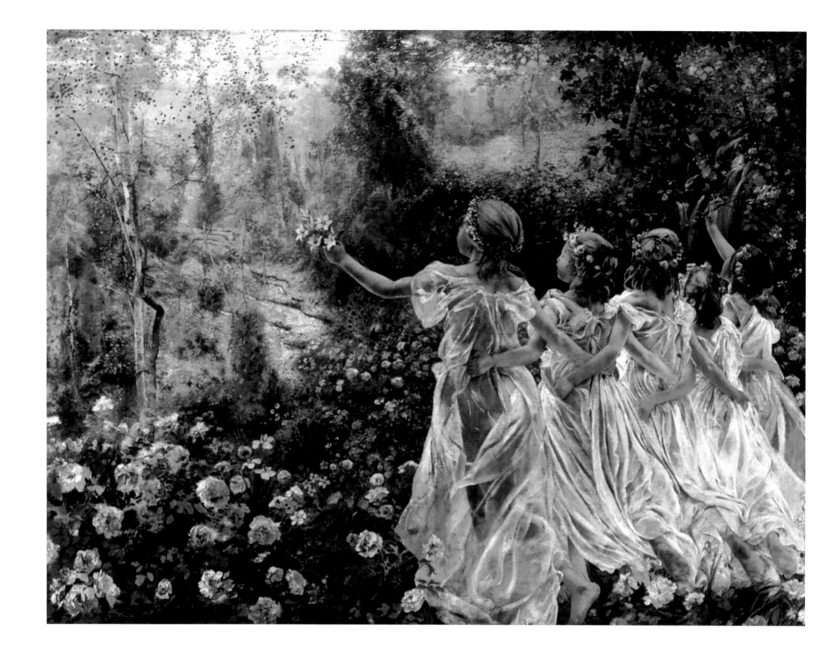

Remy de Gourmont, *Hieroglyphs*

O, my brother's purslanes, golden purslanes, flower of Anhur,
My body shivers in joy when you make love to me,
Then I fall asleep, peaceful at the feet of sunflowers
I want to sparkle like the arrows of Hor:
Come, the *kupi* embalms the secrecies of my body,
The *hesteb* tints my nails, my eyes are made up with kohl.
O master of my heart, how beautiful she is, my hour!
It is eternity when your kiss grazes me,
My heart, my heart rises, ah! so high that it flies away.

Mugworts of my brother, O bloody blossoms,
Come, I am Amm where grows every odorous plant,
The sight of your love renders me thrice more beautiful
I am the royal field where your favour harvests,

Léon Frédéric,
One Day the People Will See the
Sunrise (Left side panel of the triptych),
1890-1891.
Oil on canvas, 106 x 138.5 cm.
Collection of the Belgium Government,
Brussels.

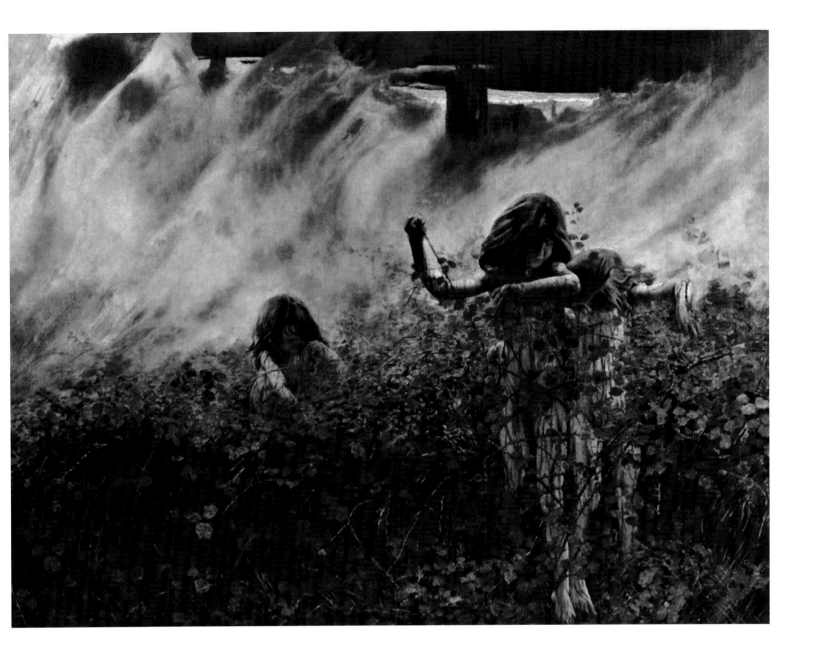

Come towards the acacias, towards the palm trees of Ammonn;
I want to love you in the blue shade of their fans.
I want to love you again under the russet eyes of Phra
And to drink the delights of the pure wine of your voice,
Because your voice refreshes and intoxicates like Ellel.

O marjorams of my brother, O marjorams,
When your hand walks like a sacred bird
In my adorned garden of lily and *sesnis*,
When you eat the gilded honey of my breasts,
When your mouth buzzes like a flight of bees
And is posed and concealed on my flowered belly,
Ah! I die, I go away, I spread myself in your arms,
Like a flowing spring full of water-lilies,
Mugworts, marjorams, purslanes, flowers of my life!

Léon Frédéric,
*One Day the People Will See the
Sunrise* (Right side panel of the
triptych), 1890-1891.
Oil on canvas, 106 x 138.5 cm.
Collection of the Belgium Government,
Brussels.

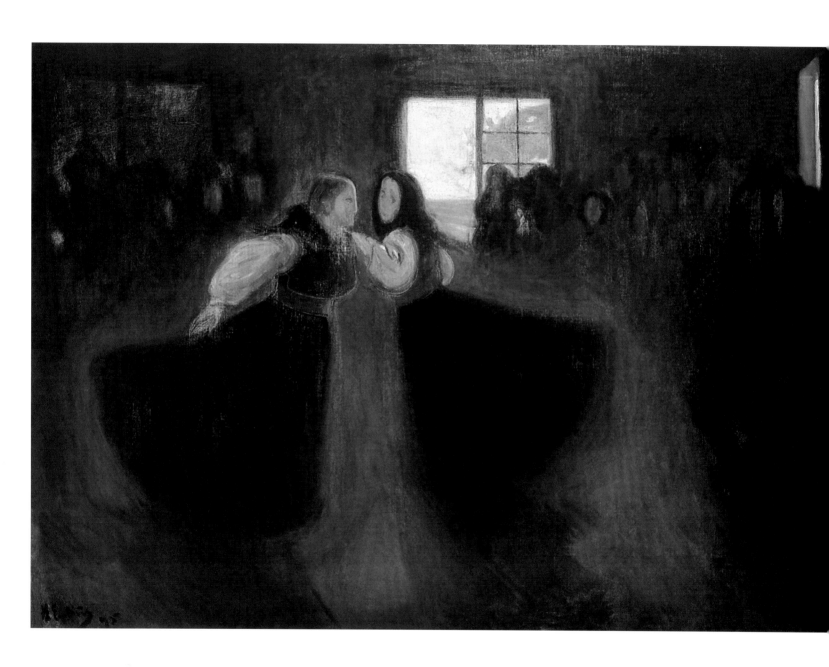

Joris-Karl Huysmans, *Preliminary Sonnet*

Sketches of concerts and of bals de barrière;
Queen Marguerite, also cameos of crimson;
Some sewer naiads with a sad and tearful grin,
Drowning their long ennui in pint glasses of beer;

Embroidered cabarets of vine branch and ivy;
The poet Villon, prostrate in dungeon lying;
My so very gentle torment, a bronze herring,
The love of a peasant and market gardener:

Such are the principal subjects with which I dealt:
Choice bric-à-brac, also old sculpted medallions,
Enamels, faded pastels, rusty prints, etchings,

Big-eyed idols, with their so deceptive charm,
Peasants by Brauwer are there, drinking, carousing,
Will you take them? At a low price I'm selling them.

Alfdan Egedius,
The Dance in the Barn, 1895.
Oil on canvas, 69.5 x 99.5 cm.
Nasjonalgalleriet, Oslo.

Alfred Jarry, *Bards and Cords*

The dead king, the twenty-one shots of the bombard
Thunder, signal of mourning, Place de la Concorde

Silence, merry lute, and viola and guimbarde:
Let us tighten on the coffin the most macabre cord

To accompany the anthem belched by the bard:
The sky begs the funeral oration for exorde.

Incense overcomes the aroma of the ortolans which bard
The shrew, child no less repulsive than a boor.

At the barriers of the Louvre he slept, the guard:
The palates are large gates where night approaches;

Corsican, Kamulk, Kurd, Iroquois and Lombard
The bier is encircled by the gullible horde.

Its vigil had not at all squashed the camarde:
A grin must contort and a mouth must bite

The blade or the tooth slices as much as lead burns:
Wasting powder and shot, cannons, Place de la Concorde.

Pale weapon, the whetstone does not fear the *espingarde*:
Thunder, signal of mourning; vibrate, macabre cord.

The pavement Swiss dash into the halberd:
Lord, take the deceased in your mercy.

Ferdinand Keller,
Böcklin's Tomb, 1901-1902.
Oil on canvas, 117 x 99 cm.
Staatliche Kunsthalle, Karlsruhe.

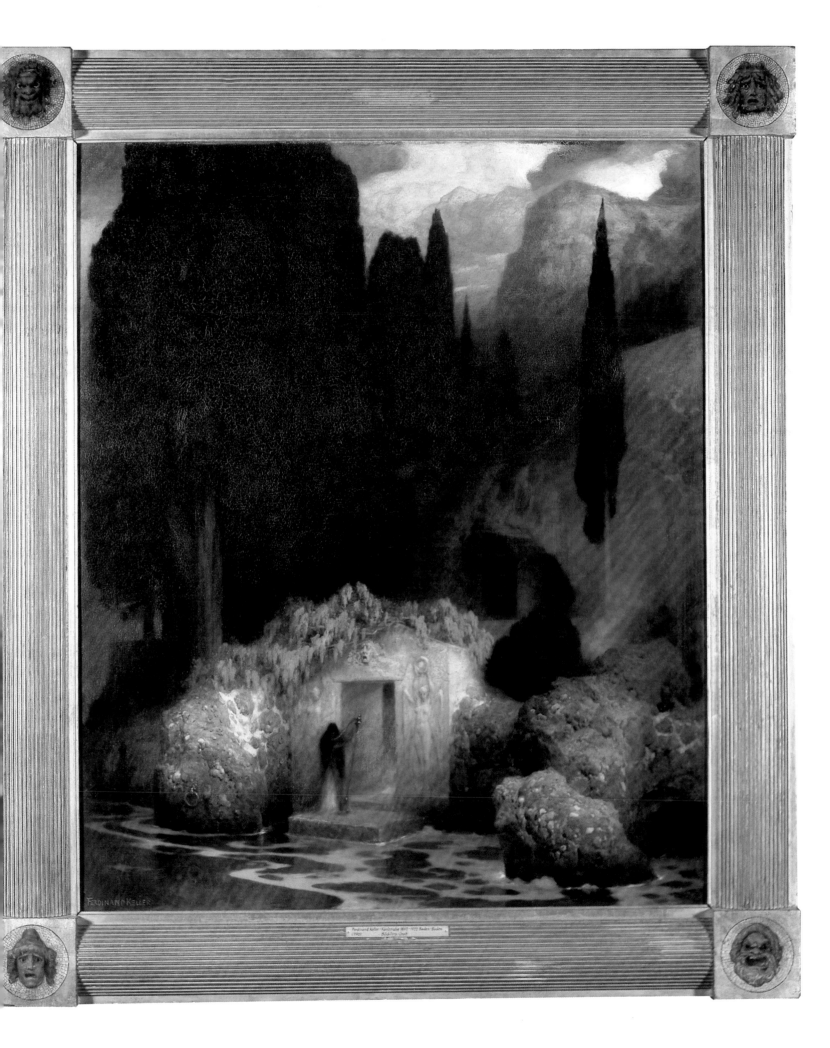

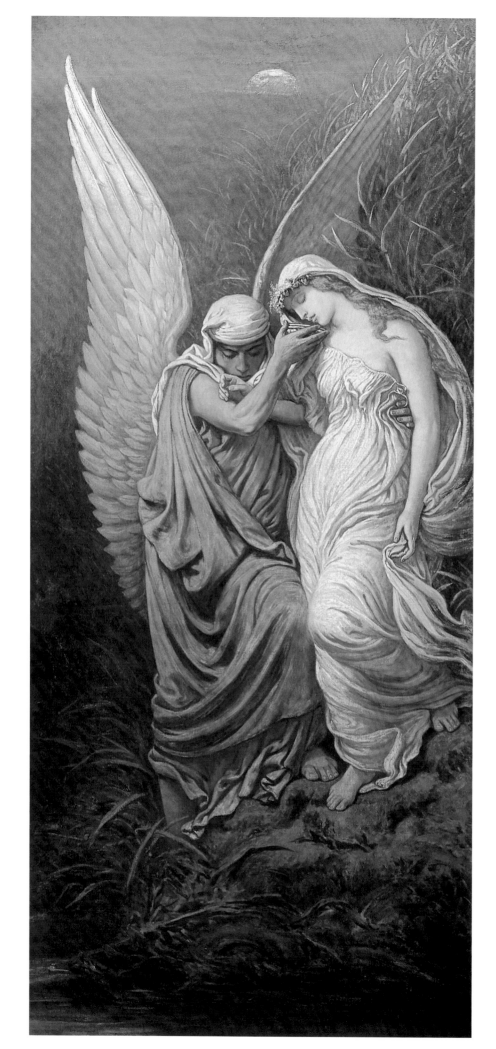

Gustave Kahn, *The Cup*

In this cup of onyx
clawed of its ebony by a chimaera
the ephemeral wave of the Styx
passes and runs out towards the sea;

The sea sinks where the green veils
of hopes are broken down
in the bonnasse with the fingers inane;
the sky yawns like open wound

Red droplets in the cup of onyx
fall and are washed out
and the black dream only shows its face
at the bottom of the cup, and its glance fixed.

Elihu Vedder,
The Cup of Death, 1885 and 1911.
Oil on canvas, 113.9 x 57 cm.
Smithsonian American Art Museum,
Washington, D.C.

Jean Delville,
Parsifal, 1890.
Charcoal drawing, 70 x 56 cm.
Private collection.

Edvard Munch,
Madonna, 1895-1902.
Lithograph, 60.5 x 44.5 cm.
The Museum of Modern Art, New York.

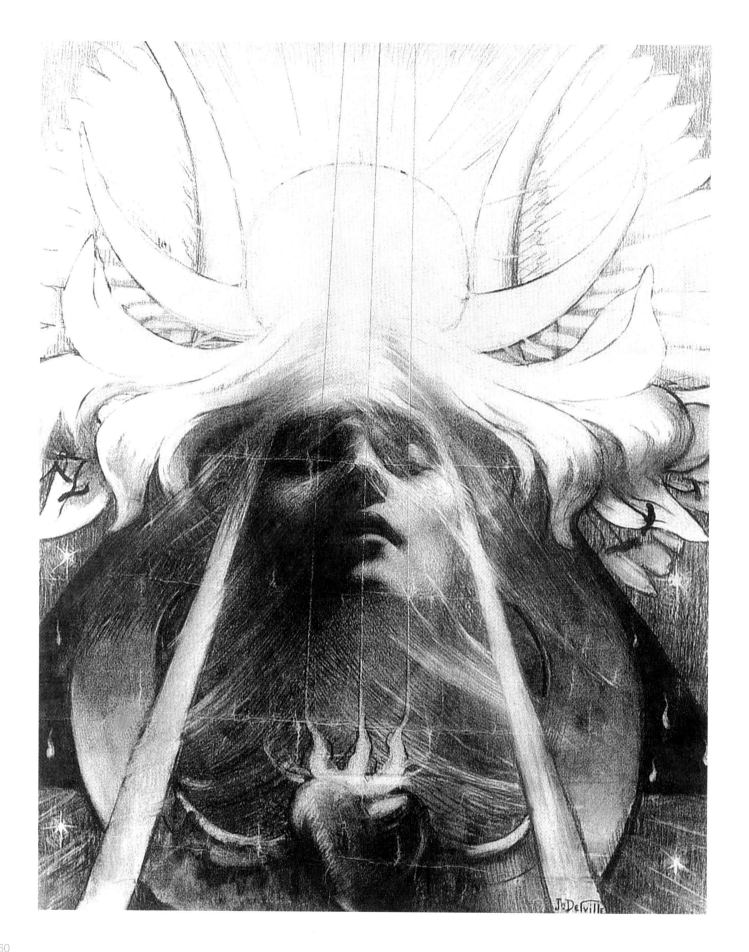

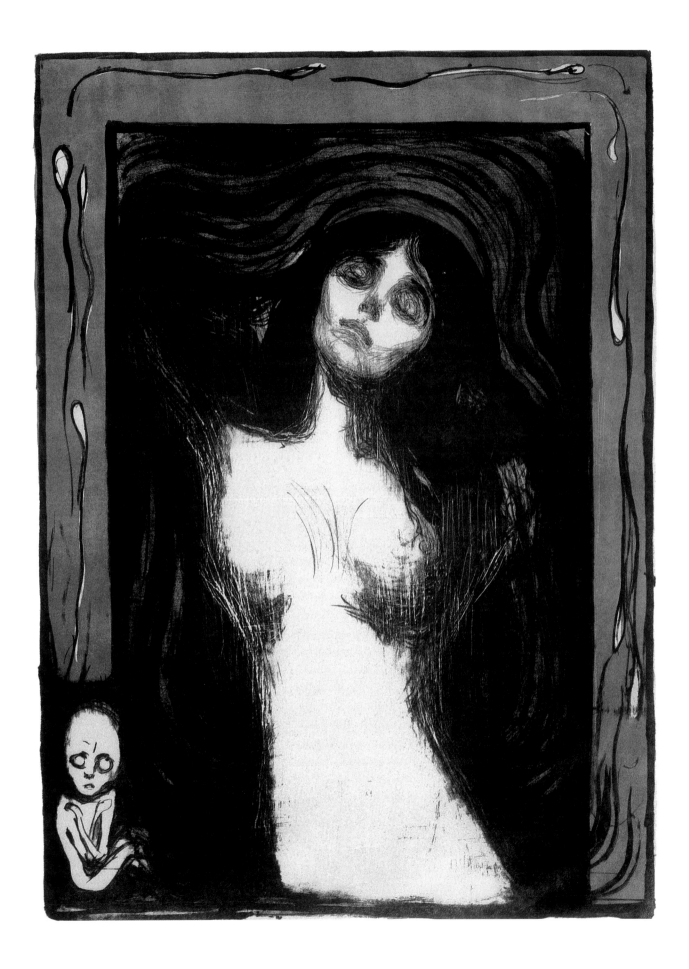

61

Jules Laforgue, *Complaint of the Pianos One Hears in Better Neighbourhoods*

Lead the well-fed literary soul,
Pianos, pianos, through posh neighbourhoods!
Early evenings, no overcoat, chaste stroll,
To the laments of nerves broken or misunderstood.

These children: of what do they dream
In the worried refrains of the theme?

"Evening playgrounds,
Dorm room Christs!

"You are going away and leaving us,
Leaving us and going away,
Undoing and redoing our tresses,
Weaving eternal tapestries."

Pretty or plain? Sad or wise? Still pure?
O days, what do I care? World, what do I want?

And so virginal, at least of that good wound,
Knowing what red sunsets make the whitest vows?

My God, of what do they dream?
Of Rolands, of lace?

"Hearts in prisons,
Lazy seasons!

"You are going away and leaving us,
Leaving us and going away,
Grey convent, choirs of Shulamites,
Over null chests we cross our arms."

Being's fatal keys appeared one lovely day;
Pssst! to punctually fermenting inheritances,
In the incessant balls of our strange streets;
Ah! Boarding schools, theatres, magazines, novels!

William Degouve de Nuncques,
The Blind House (The Pink House),
1892.
Oil on canvas, 63 x 43 cm.
Kröller-Müller Museum, Otterlo.

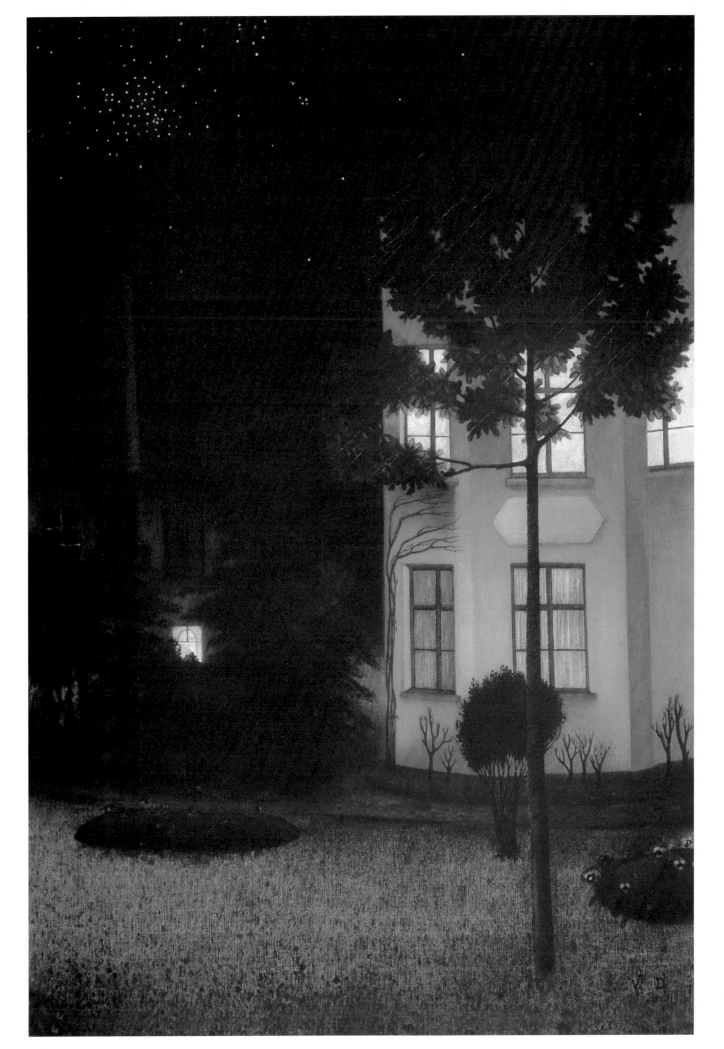

Go, sterile refrains,
Life is true and criminal.

"Curtains pulled back,
May I enter?

"You are going away and leaving us,
Leaving us and going away,
The source of fresh roses is drying up,
Really! And he who does not come..."

He will come! You will be poor hearts at fault,
Engaged to remorse as to bottomless trials,
And satisfied posh hearts, having no other host
Than a gloating humdrum of respect and rags.

Dying? Perhaps they embroider braces
For a well-off uncle?

"Never! Never!
If only you knew!

"You are going away and leaving us,
Leaving us and going away,
But won't you return quickly enough,
To cure my lovely illness?"

And it's true! The Ideal leaves them all delirious,
Bohemian vine, even in these posh districts.
Life is there: the pure bottle of exquisite drops
Will be, as it should, baptised in clean water.

Soon, too, more exact
Refrains will be played.

"Lonely pillow!
Familiar wall!

"You are going away and leaving us,
Leaving us and going away,
I could have died at mass!
O months, O linens, O dinners!"

Maurice Maeterlinck, *Foliage of the Heart*

Under the blue crystal bell
Of my weary melancholies,
My vague, voided pains
Still themselves little by little

Vegetation of symbols,
Mournful water-lilies of pleasures
Sluggish palms of my desires,
Cold mosses, soft lianas.

Alone, a lily rises from among them,
Pale and rigidly weak,
Its motionless rise
Over the sorrowful foliage,

And in the glimmering which it vents
Little by little, like a moon,
Raises towards the blue crystal
Its mystic white prayer.

Giovanni Segantini,
Love at the Fountain of Life, 1896.
Oil on canvas, 70 x 98 cm.
Galleria Nazionale d'Arte Moderna,
Rome.

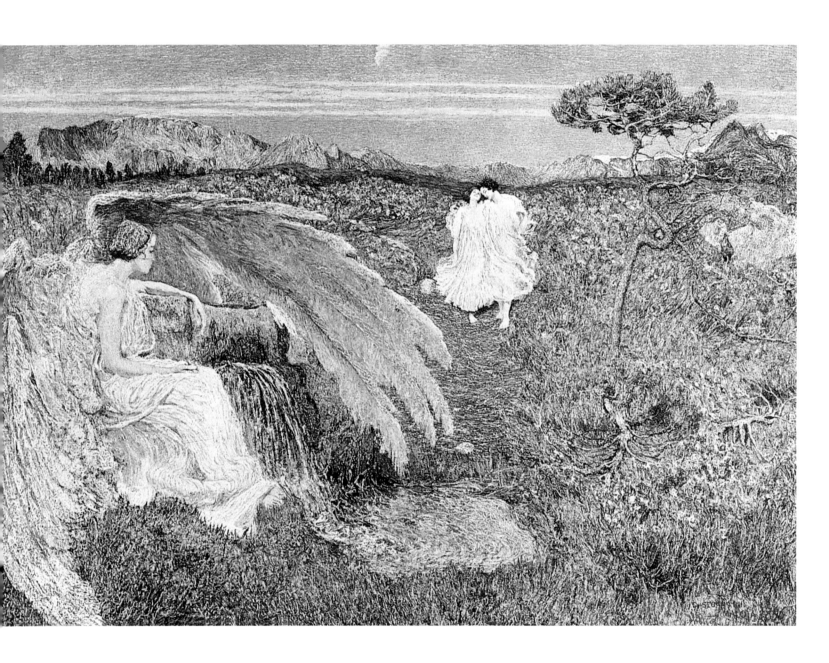

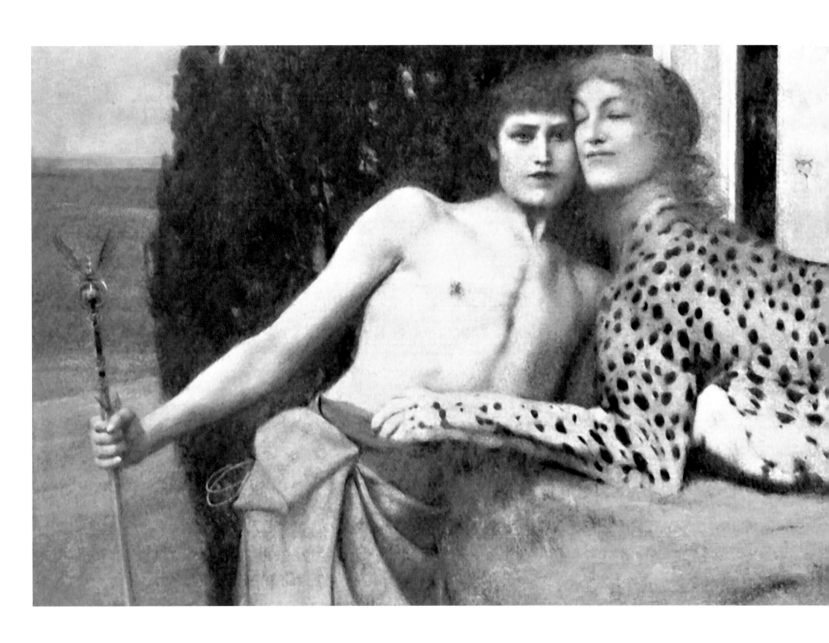

Fernand Khnopff,
The Caress or *The Art*, 1896.
Oil on canvas, 50.5 x 151 cm.
Musées royaux des Beaux-Arts de
Belgique, Brussels.

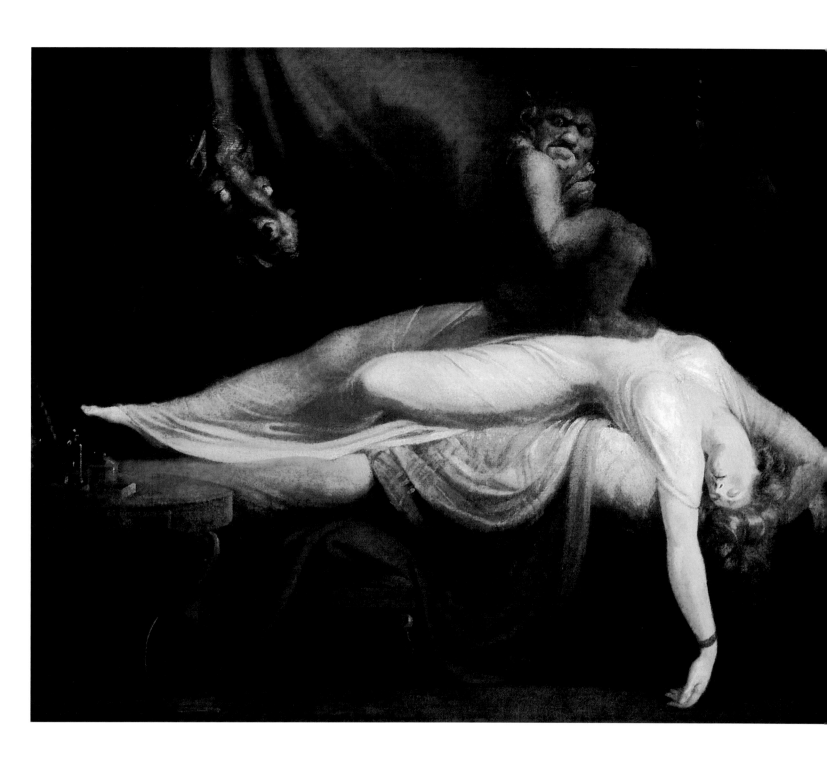

Stéphane Mallarmé, *Afternoon of A Faun*
(extract)

The Faun:
These nymphs that I would perpetuate: so clear
And light, their carnation, that it floats in the air
Heavy with leafy slumbers.
 Did I love a dream?
My doubt, night's ancient hoard, pursues its theme
In branching labyrinths, which being still
The veritable woods themselves, alas, reveal
My triumph as the ideal fault of roses.

Consider...
 if the women of your glosses
Are phantoms of your fabulous desires!
Faun, the illusion flees from the cold, blue eyes
Of the chaster nymph like a fountain gushing tears:
But the other, all in sighs, you say, compares
To a hot wind through the fleece that blows at noon?
No! through the motionless and weary swoon
Of stifling heat that suffocates the morning,
Save from my flute, no waters murmuring
In harmony flow out into the groves;
And the only wind on the horizon no ripple moves,
Exhaled from my twin pipes and swift to drain
The melody in arid drifts of rain,
Is the visible, serene and fictive air
Of inspiration rising as if in prayer.

Relate, Sicilian shores, whose tranquil fens
My vanity disturbs as do the suns,
Silent beneath the brilliant flowers of flame:
"That cutting hollow reeds my art would tame,
I saw far off, against the glaucous gold
Of foliage twined to where the springs run cold,
An animal whiteness languorously swaying;
To the slow prelude that the pipes were playing,
This flight of swans -- no! naiads -- rose in a shower
Of spray..."
 Day burns inert in the tawny hour
And excess of hymen is escaped away --
Without a sign, from one who pined for the primal A:
And so, beneath a flood of antique light,
As innocent as are the lilies white,
To my first ardours I wake alone.

Johan Heinrich Füssli,
The Nightmare, 1781.
Oil on canvas, 101.6 x 126.7 cm.
The Detroit Institute of Art, Detroit.

Robert de Montesquiou, *Hymn to the Night*

The mystery of the night exalts chaste hearts!
There they feel themselves open like an embrace
Which, in the eternity of its vast caresses,
Satisfy all desires, overcoming each torment.

The night's perfume inebriates the tender heart!
The flower we cannot see has stronger balms...
All senses are confounded: olfaction believes it hears!
To useless eyes all contours are dead.

The night's opacity attracts the dull heart!
There it feels itself call to the affinity of mourning;
And the glance rolls through thicknesses without bound
Shadows, better than in the sky where an eye always watches!

The night's silence bandages the wounded soul!
Philters are tilted by touched chalices;
And towards the abandonments of love forsaken
Invisible kisses slowly were driven.

Cry in the fold of this inviting night,
You whom proud prudery avowed to the dry lash,
You whom no friendly arm supports nor tempts
For the confession of secrets... – cry! cry with

With the gold star plated silver by its softness,
But which wants so much, yonder, to leave this dark corner,
So that the eye dried of its sobbing is there enchanted
In the flap of a coat which hides it from the azure!

Artur Grottger,
Large Forest, 1864.
Chalk and pencil on cardboard.
Muzeum Narodowe, Kraków.

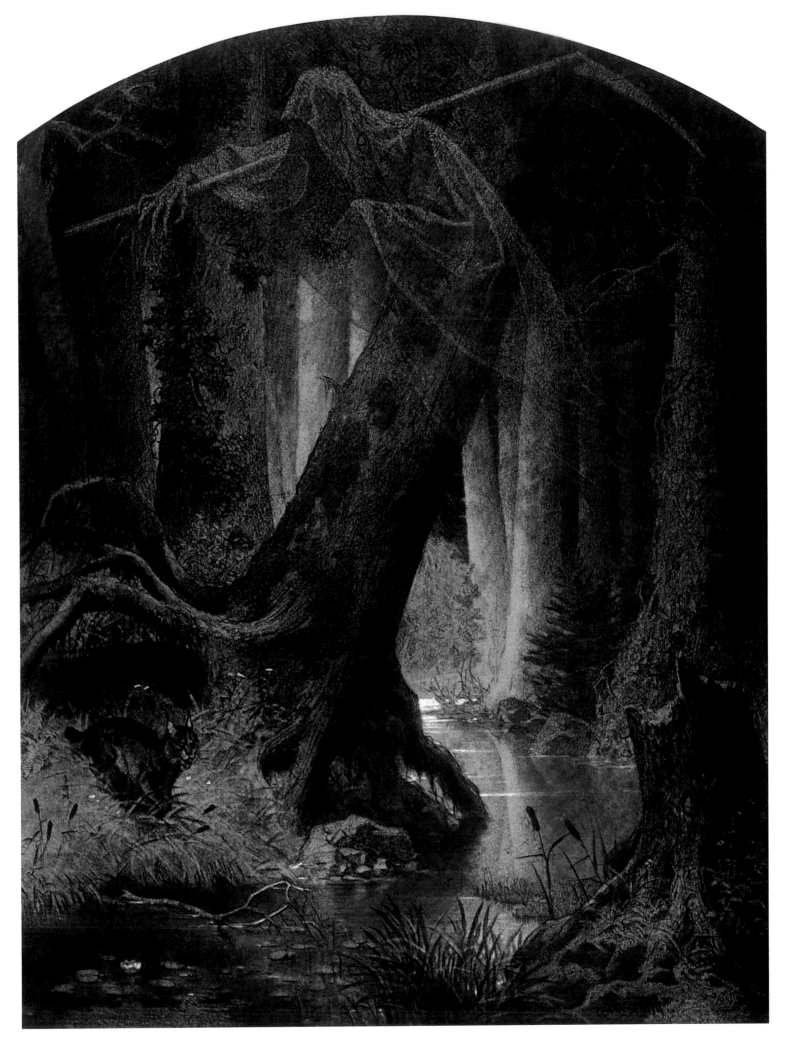

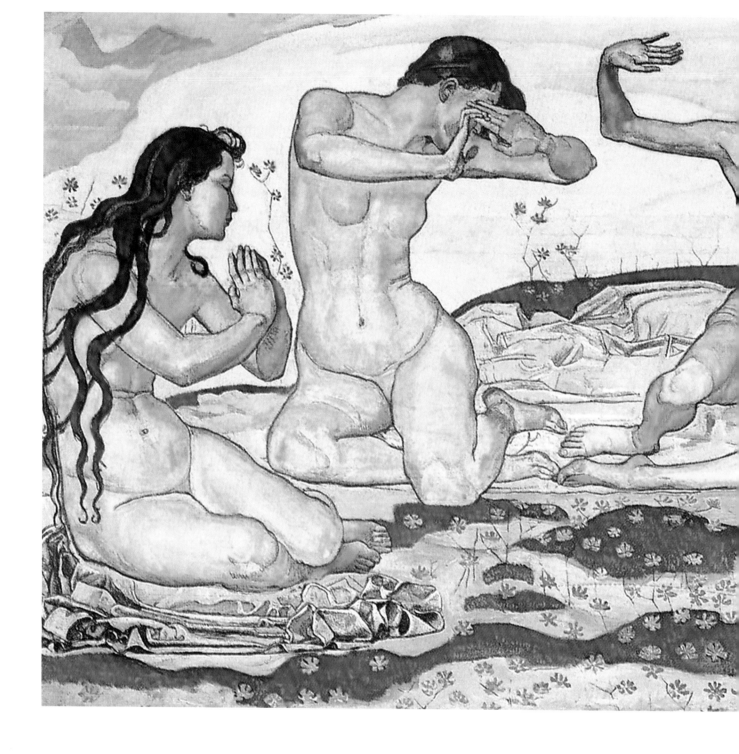

Ferdinand Hodler,
Day I, 1899-1900.
Oil on canvas, 160 x 340 cm.
Museum of Fine Arts, Bern.

Jean Moréas, *Sensuality*

Listen no more to the plaintive bow which laments
Like a dying woodpigeon along the bowling greens;
Risk no more the flight of peregrin dreams
Trailing gold wings in the slanderous clay.

Come here: here are the fairy decorations,
In exquisite Sèvres dishes from which you wean yourself,
Samian cups with which to soak your lips,
And deep couches on which to rest your body.

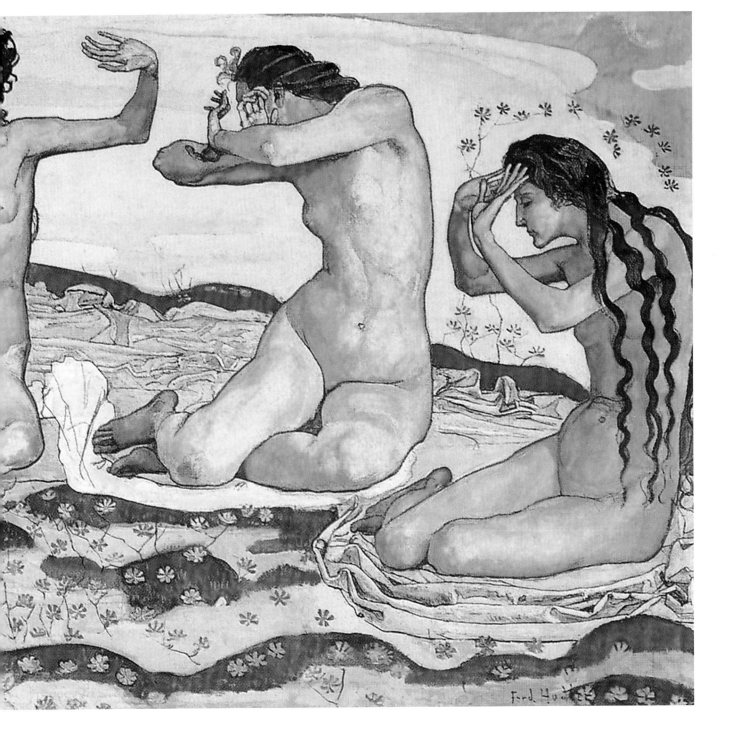

Come here: here is the ardent erubescence
Of russet hair stitched with flowers and beryls,
Ponds of the sea-green eyes, and the pink Aprils
Croups, and lilies of breasts scrubbed with spirits

Come smell the aroma and bite with full teeth
The soft banality of life,
And sleep the sleep of the satisfied animal
Scornful of the splendours of transcendent dreams.

Anna de Noailles, *Death said to the Man…*

Now that you have suffered enough, poor fellow,
Known enough love, desire, disgust,
The harshness of wanting and the torpor of naps,
The pride of being alive and crying astir...

May you wish to know something more delightful
Than the softness of the days you held,
Leave time, leave the house and the table;
You will have neither regret nor fear of having come.

I will fill up your heart, your hands and your mouth
With such deep repose, so hot and so heavy,
That the sun, the rain and the savage storm
Will not wake your heart and your blood.

Poor soul, like the day when you had not been born
You will be full of shadow and a pleasant oblivion,
Then others will come by hard days
Crying to the hollows of the hands, tombs and beds.

Others will fall prey to the painful giddiness
Deep loves and bitter destiny,
And then you will be the sap in the stems,
The pink of the rose and the salt of the sea.

Others will go wounded from desire and from dreams
And their gestures will make pain in the air,
But you will not know that the morning rises
That you must live again, that day is dawning, that it is
becoming bright.

They will take back their staggering souls
And stumbling like a man taken by wine;
- And then you will be in my eternal night,
In my calm house, in my divine garden...

Jacek Malczewski,
Death, 1902.
Oil on panel, 98 x 75 cm.
The National Museum, Warsaw.

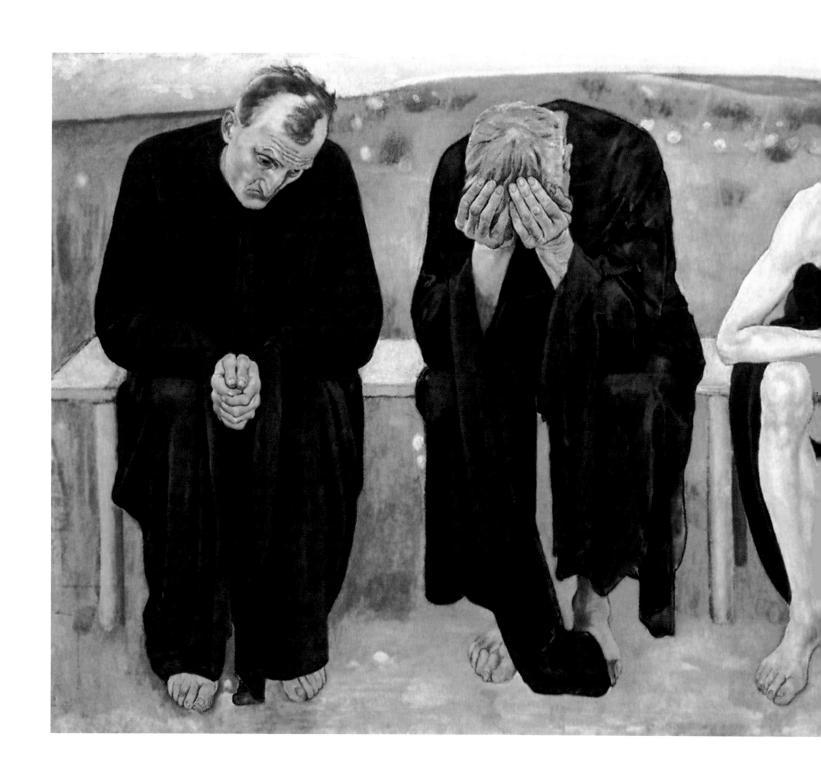

Ferdinand Hodler,
The Lakes of Life, 1892.
Oil on canvas, 149 x 294.5 cm.
Neue Pinakothek, Munich.

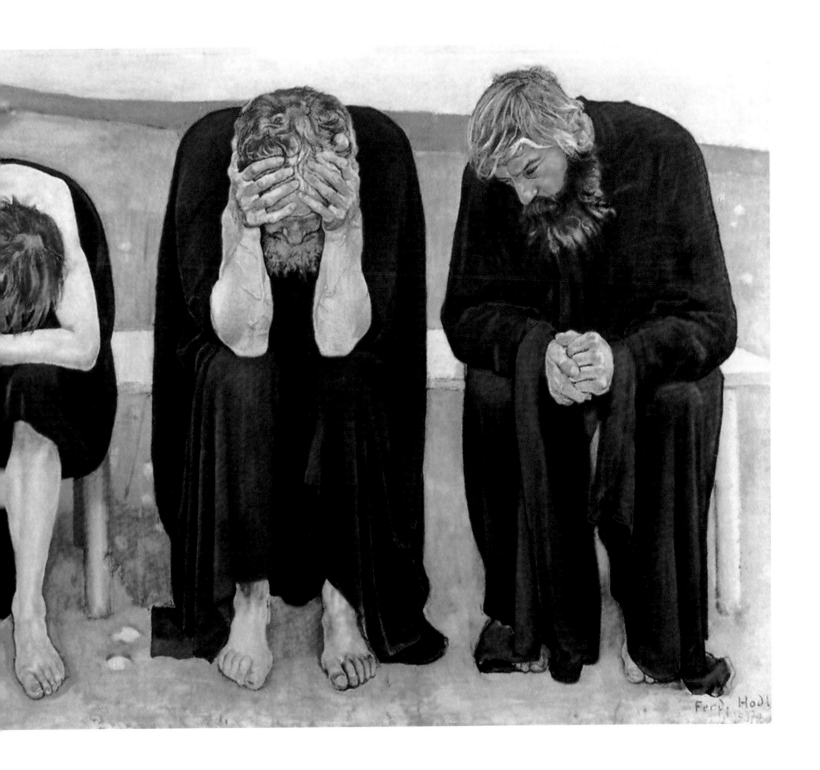

Henri de Régnier, *To Stéphane Mallarmé*

Those weary of the dawn and what life attempts,
Stop forever under the tree which tenders them
Its delicious flower and its bright fruit
And gathers their destiny with the ripened branch.

These, in hard onyx and through what the vein shoots,
After being inclined over the water reflecting them
In stone, in its turn, and who it already awaits
Appear the profile of their own effigy.

Others gathered nothing and laugh in the shade
Uprooting the nettle in the cracks of the debris,
The sad one-eyed owl hoots by their side.

And you alone blinded by an unknown glory,
And you walk in life and the truth
Towards the invisible star which appeared inside you.

Antoine Wiertz,
The Reader of Novels, 1853.
Oil on canvas, 125 x 157 cm.
Musées royaux des Beaux-Arts de
Belgique, Brussels.

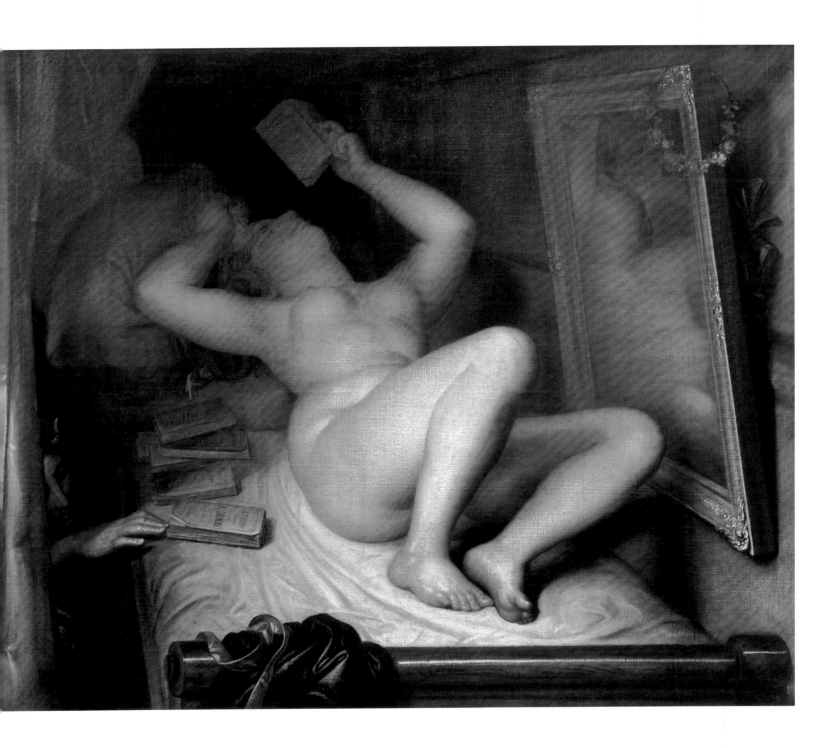

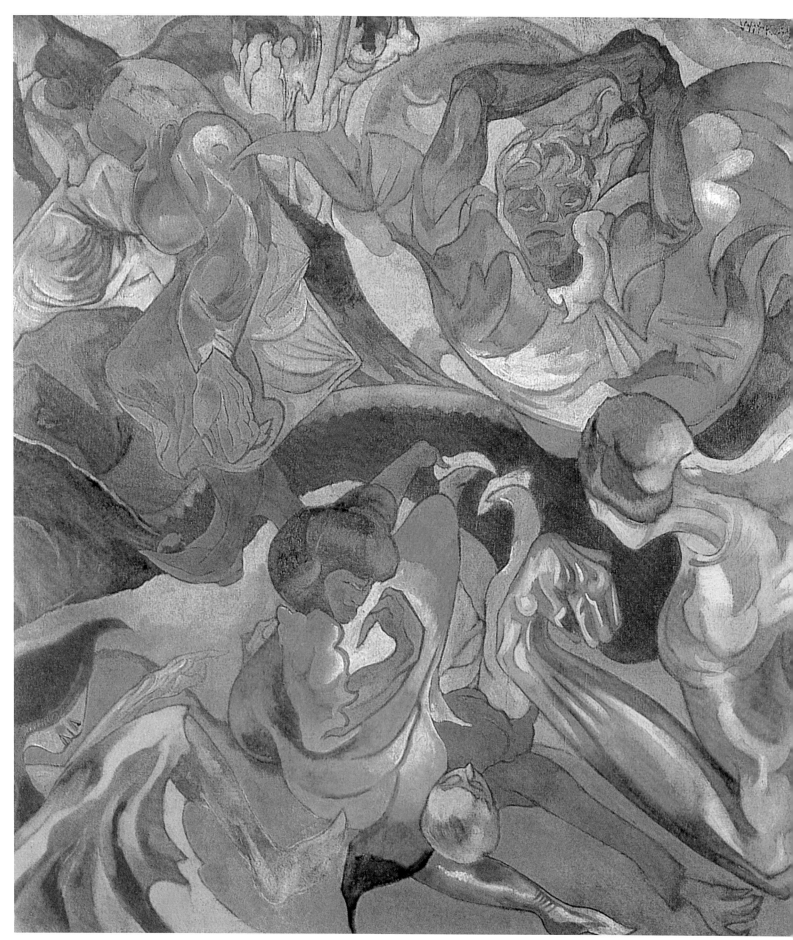

Arthur Rimbaud, *Vowels*

Black A, white E, red I, green U, blue O: vowels,
One day I shall tell of your latent births:

A, black velvety corset of dazzling flies
Buzzing around cruel stenches,

Gulfs of shadow; E, candour of mists and tents,
Lances of proud glaciers, white kings, shiverings of umbels;
I, crimsons, spat blood, laughter from beautiful lips
In anger or penitent inebriations

U, cycles, divine vibrations of viridian seas,
The peace of animal-dotted pastures, the peace of the furrows
Which alchemy imprints upon broad, studious brows;

O, supreme clarion fraught with strange strides,
Silences crossed through Spheres and Angels;
- O, Omega, violet ray of His Eyes!

Stanislas Ignacy Witkiewicz,
General Confusion, 1920.
Oil on canvas, 99 x 90 cm.
Muzeum Narodowe, Kraków.

Saint-Pol-Roux, *The Purifying Rain*

Flying watering-cans are pouring over the gaol
Where the snake tied-up rogue humanity;
Under divine toes, it is like a vast willow
Scattering its long branches of dampness.

Nevertheless, I left the maternal tile
And I offer myself naked to the extravagant sky;
Even I flee the *parvule aegis* of a wing,
Thirsty for the forgiveness which the hurricane rains.

Holy pearls of proud Melancholy
Undertake the rough laundering of the sins
Of this ugly flesh formerly so pretty;

And come, swan, to the old park of my debauched bones,
To carry out the wish of my rainy chasuble
Through the remorse of the fleeing Darkness!

Maurice Denis,
*Portrait of Marthe Denis, the Artist's
Wife* or *Suzanne with Yellow Houses*,
1893.
Oil on canvas, 45 x 54 cm.
The Pushkin Museum of Fine Arts,
Moscow.

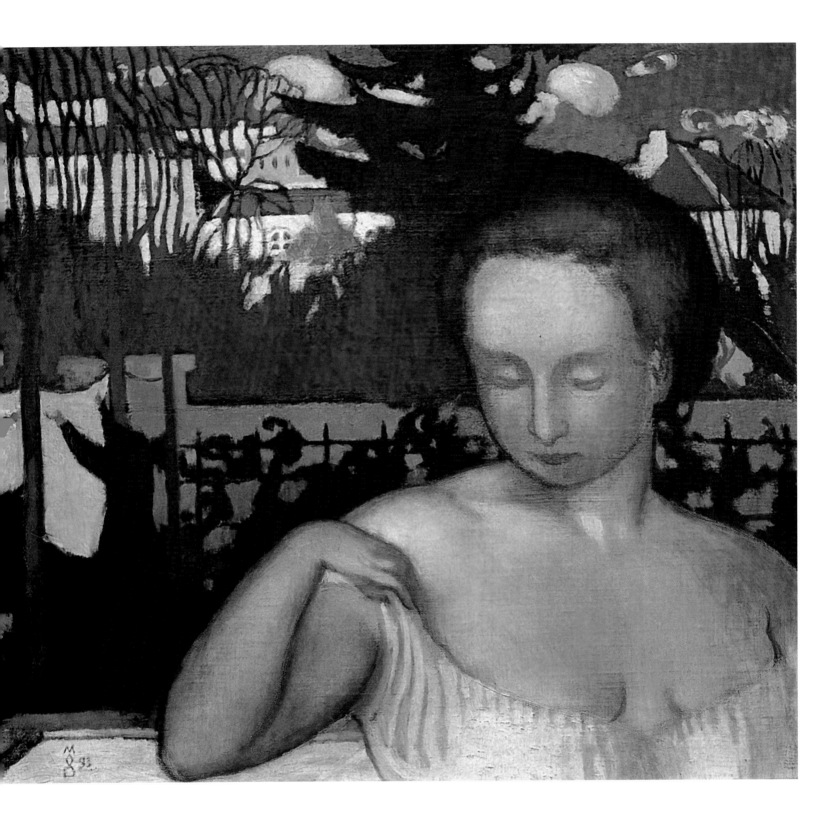

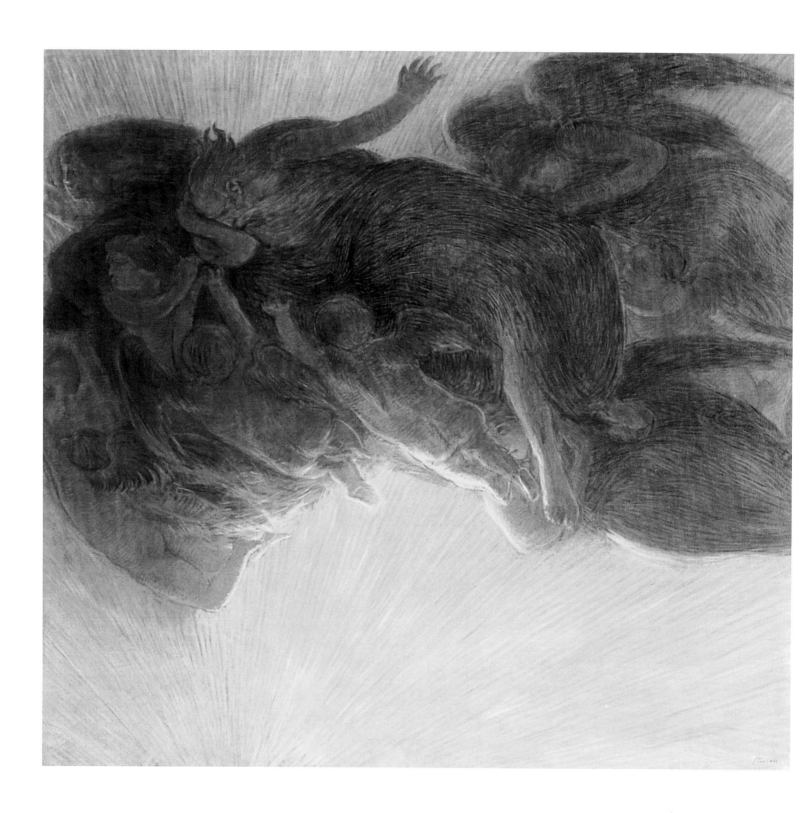

Paul Valéry, *Hélène*

Azure! it's me… I come from death's grottos
To hear the wave break in sonorous degrees,
And again see auroras in the galleys
Resuscitate from the shadow in the current of golden oars

My solitary hands call the monarchs
Whose salty beards amuse my fingers pure;
I cried. They sang of their triumphs obscure
And the gulfs buried at the sterns of their barks,

I hear the deep conchs and military clarions
Give rhythm to the scullers' flight;
The clear song of the rowers enchains the tumult,

And on the heroic prow the Gods exalted
In their ancient smile the waves insult
Extending me their arms, indulgent and sculpted.

Gaetano Previati,
The Creation of Light, 1913.
Oil on canvas, 199 x 215 cm.
Galleria Nazionale d'Arte Moderna,
Rome.

Emilio Longoni,
Alone, 1900.
Pastel on paper.
Casa di Livorno, Milan.

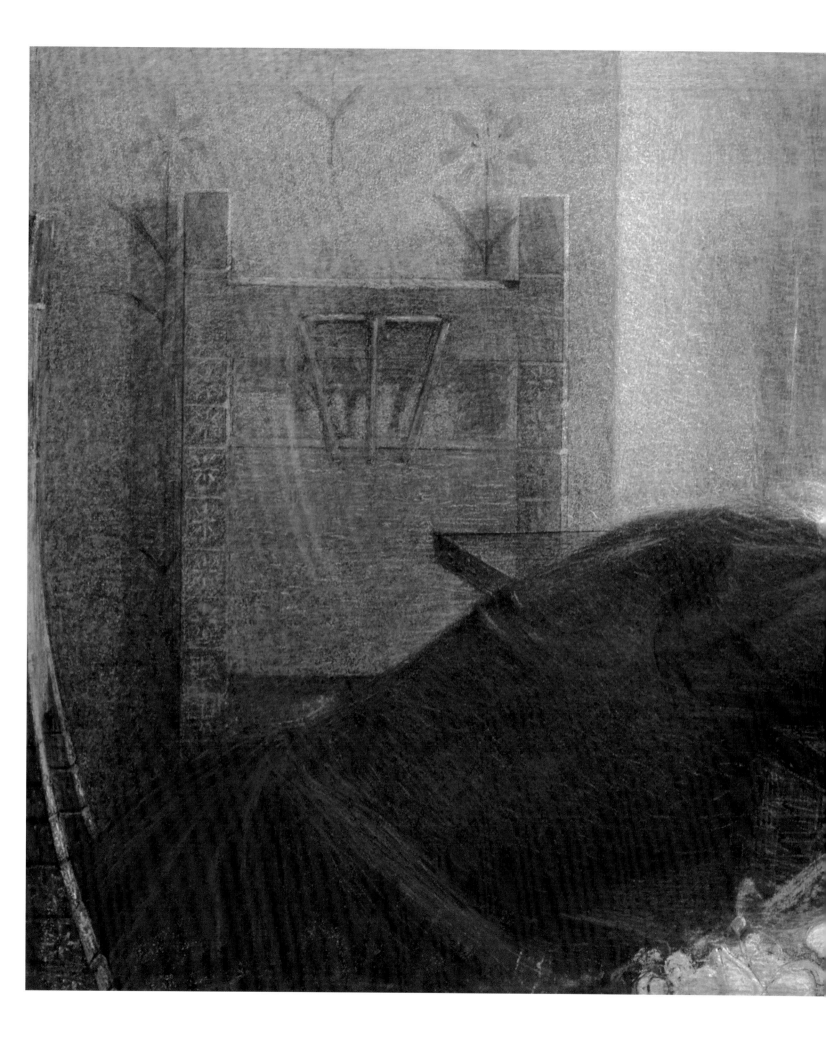

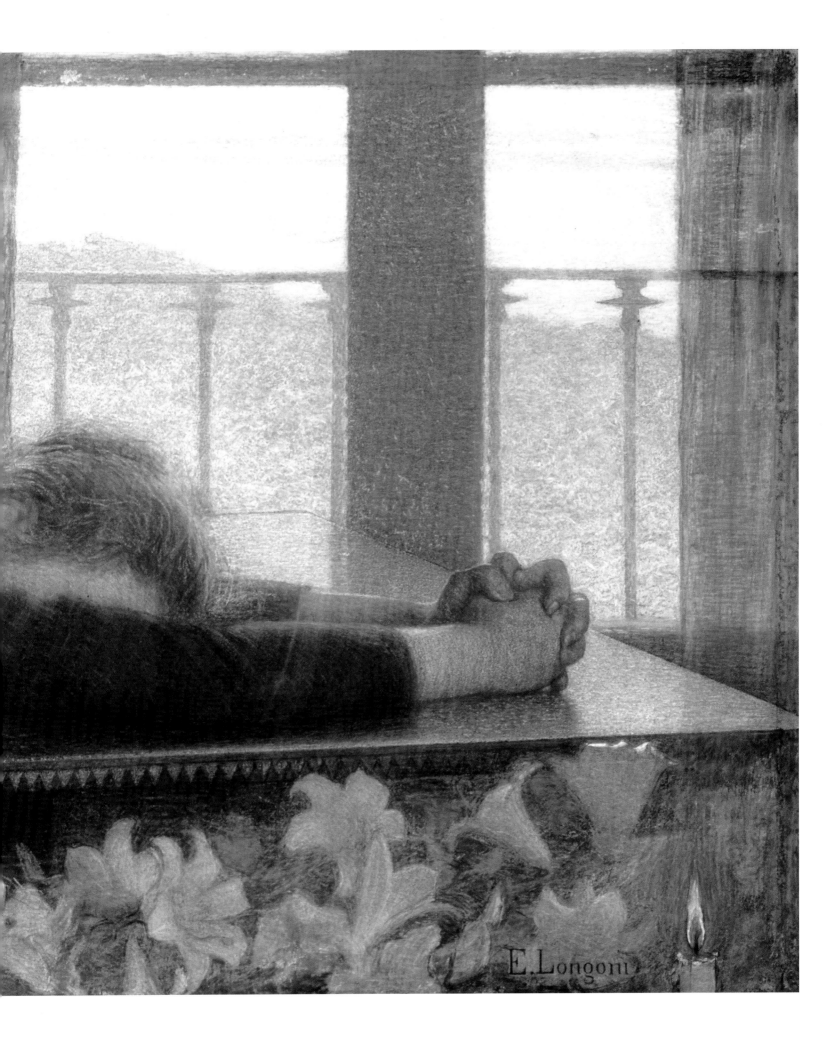

E.Longoni

Emile Verhaeren, *The Rock*
(extract)

On this decayed rock corroded and beaten by the sea,
What steps will still want to follow me, say, what steps?

It is there that I have built my soul.
Say, will I be alone inside my soul?
My soul, alas! ebony house,
Where was cracked, without noise, one evening,
The great mirror of my hope.

Say, shall I be alone with my soul,
In this nocturnal and agonising domain?
Shall I be alone with my black pride,
Seated in an armchair of hatred?
Shall I be alone, with my pale hyperdulia
For Our Lady of Madness?

Shall I be alone with the sea
In this nocturnal and agonising domain?

There, black, hairy toads of foam
Devour the clear sun on the lawn.
A large pillar no longer supporting anything,
Like a man, in an alley erects
Immensely paved marble epitaphs.

On this decayed rock that the sea makes groan,
Say, will I be alone inside my heart?

Edvard Munch,
Melancholy, 1893.
Oil on canvas, 65 x 96 cm.
Nasjonalgalleriet, Oslo.

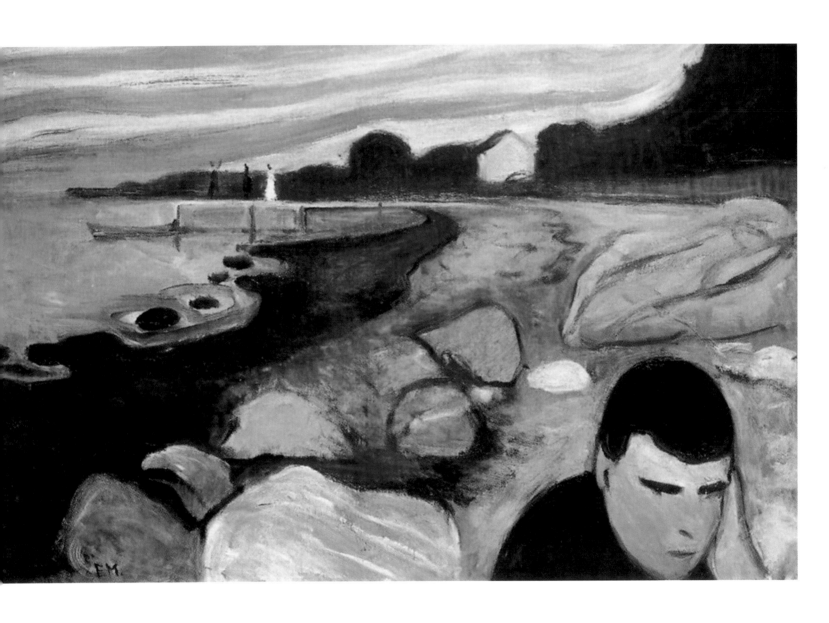

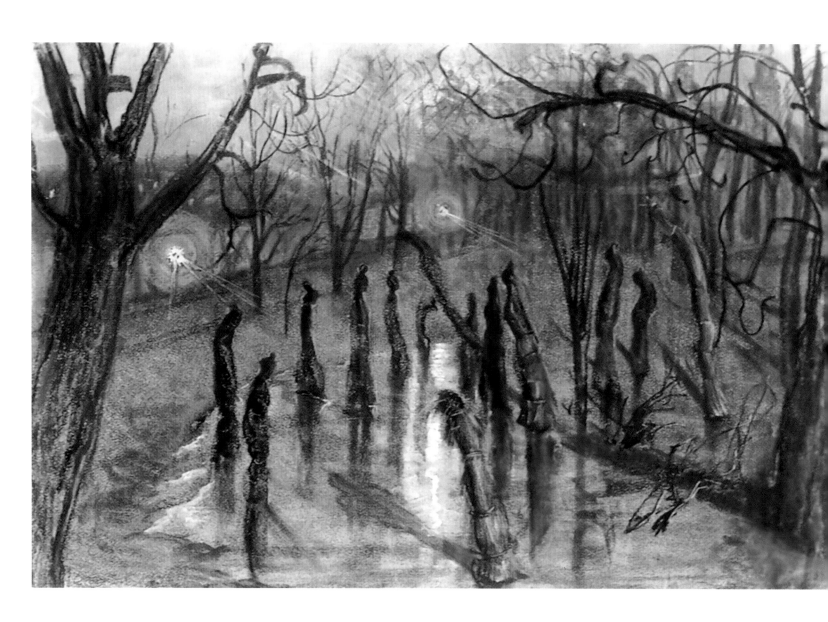

Will I finally have the atrocious joy
Of seeing, nerve by nerve, like prey,
Insanity attack my brain,
And, a stubborn patient, escaped from prison
And the forced labours of his reason,
Sailing away towards a new hope?

Say! No longer to feel one's life clambered up
By the iron heels of each idea;
No longer to infinitely hear in oneself
This cry, always identical, or fear, or rage,
Towards the great unknown which travels in the skies.

On this decayed rock, devastated by the sea,
Ageing, sad dreamer of the precipitous field;
No longer intending to keep silent in his ebony house,
That a total silence of which the dead would be afraid;
To trail long heavy steps in deaf corridors;
To always see himself follow the same hours,
Without hoping for better times;
Forever closing such a window;
Such a sign a far! - a prediction having just appeared;
Around the old salons, enjoying the empty seats
And the rooms whose double beds have seen dying,
And, each evening, to feel, the livid fingers,
The insanity under its temples, to mature.

On this decayed rock, ruined by the sea,
Say, shall I finally be with the sea,
Say, shall I finally be inside my soul?

And then, one day, die; to again become nothing.
To be somebody who no longer remembers
And who goes away without a knell sounding,
Without candle in hand, without anyone,
Without knowing what is happening,
Merry and clear in *bonnasse*,
That the alarming domain
Which was my soul and was my pain,
Is no more on these rocks, up there,
Than a somber and groaning tomb.

Stanislas Wyspianski,
Planty Park at Night or *Straw Covers on Rosebushes,* 1898-1899.
Pastel, 69 x 107 cm.
Muzeum Narodowe, Kraków.

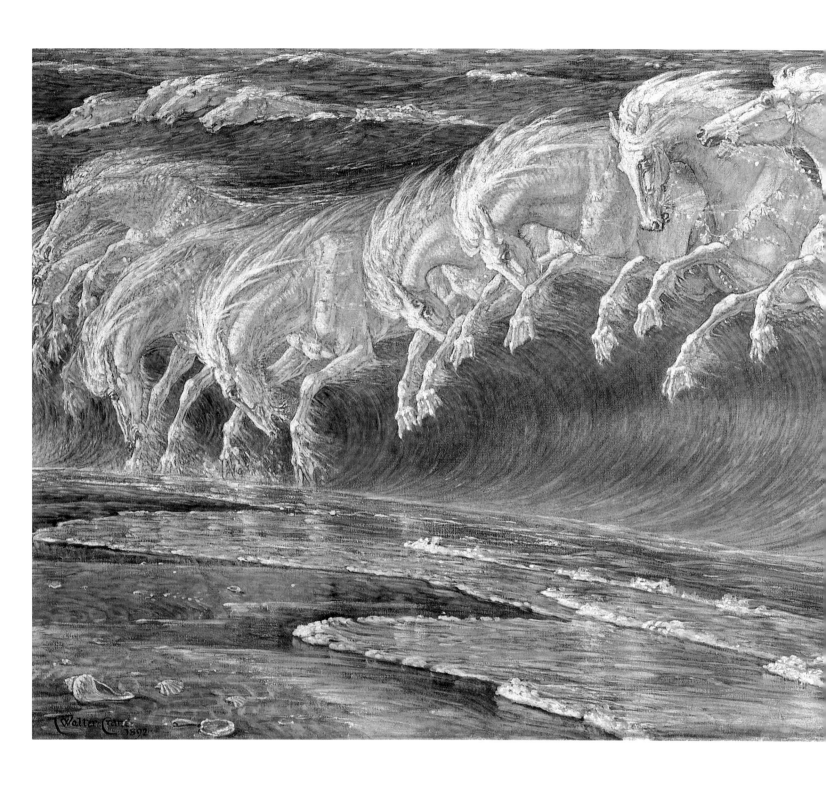

Walter Crane,
Neptune's Horses, 1892.
Oil on canvas, 85.6 x 215 cm.
Neue Pinakothek, Munich.

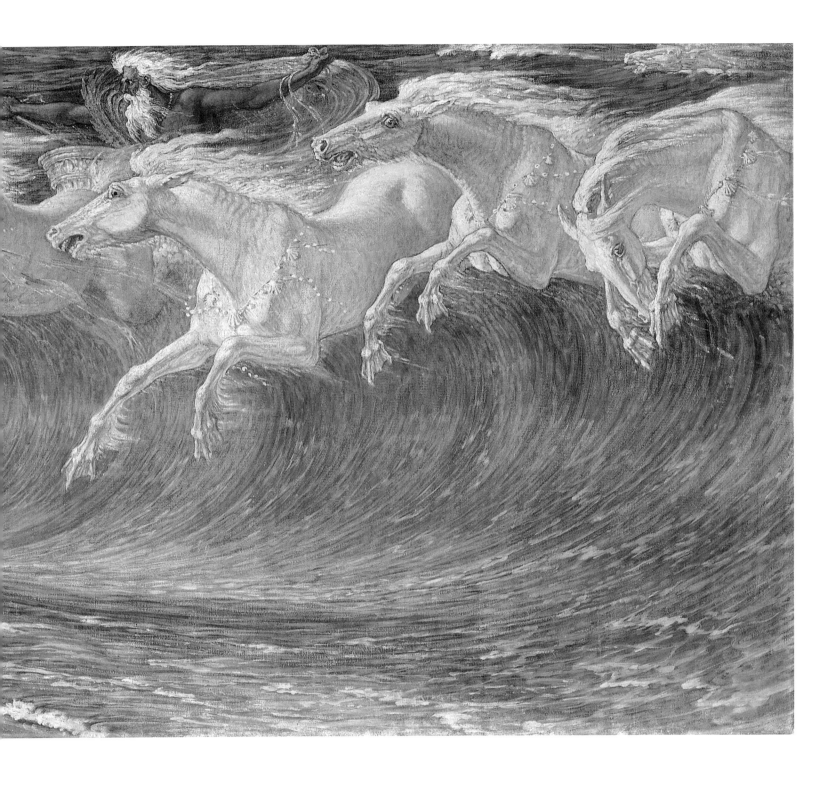

Paul Verlaine, *Poetic Art*

Music before all things,
And for that, uneven lines prefer,
More vague and more solvent than air,
With nothing in it which weighs or holds it down

Also, you must not aim to choose
Your words without some mistake:
Nothing more dear than the grey song
Where Precision meets the Hesitant

It is lovely eyes behind veils,
It is the broad trembling light of noon,
It is, by the cool autumn sky,
The blue tumble of bright stars!

For it is Nuance we want,
Not colour, only nuance!
Oh! Nuance alone can betrothe
Dream to dream and flute to horn!

Flee far from the murderous Point,
The cruel Wit and the impure Laugh,
Which makes the eyes of the sky weep,
And from all this low-cuisine garlic!

Fernand Khnopff,
A Deserted Town, 1904.
Charcoal drawing with black pencil
and pastel on paper mounted on
canvas, 76 x 69 cm.
Musées royaux des Beaux-Arts de
Belgique, Brussels.

Take eloquence and wring its neck!
You will do well, while you're at it,
To tame Rhyme a little.
Where will it stop if one doesn't take care?

O who will tell the faults of Rhyme?
What deaf child or mad counterfeiter
Forged for us this cheap jewel
Which sounds hollow and false under the file?

Music again and always!
Let your verse be a thing flown away
Which one feels flee from the soul
Towards other skies and other loves.

Let your verse be a good adventure
Scattered to the innerving morning wind
Which blossoms with mint and thyme
And all else is literature.

Paul Verlaine, *Languor*

I am the Empire at the end of its decadence,
Which sees pass the great white Barbarians,
While composing indolent acrostics
In a golden style where the sun's languor dances.

The solitary soul is heart-sick with dense ennui.
Down there, it is said there is combat, long and bloody
Oh, to be no longer capable, being so weak from wishes so idle,
Oh, to no longer wish this existence might bloom a little!

Oh to wish no more, oh to no longer be able to die a little!
Ah, all is drunk! Bathyllus, have you finished laughing?
Ah, all is drunk! All is eaten! Nothing more to say!

Alone, a foolish poem that one throws onto the fire,
Alone, a somewhat racing slave who neglects you,
Alone, an ennui of some thing which afflicts you!

Georges Frederick Watts,
Hope, 1886.
Oil on canvas, 142.2 x 111.8 cm.
Tate Britain, London.

Edward Burne-Jones,
Portrait of Katie Lewis, 1886.
Oil on canvas, 61 x 127 cm.
Private collection.

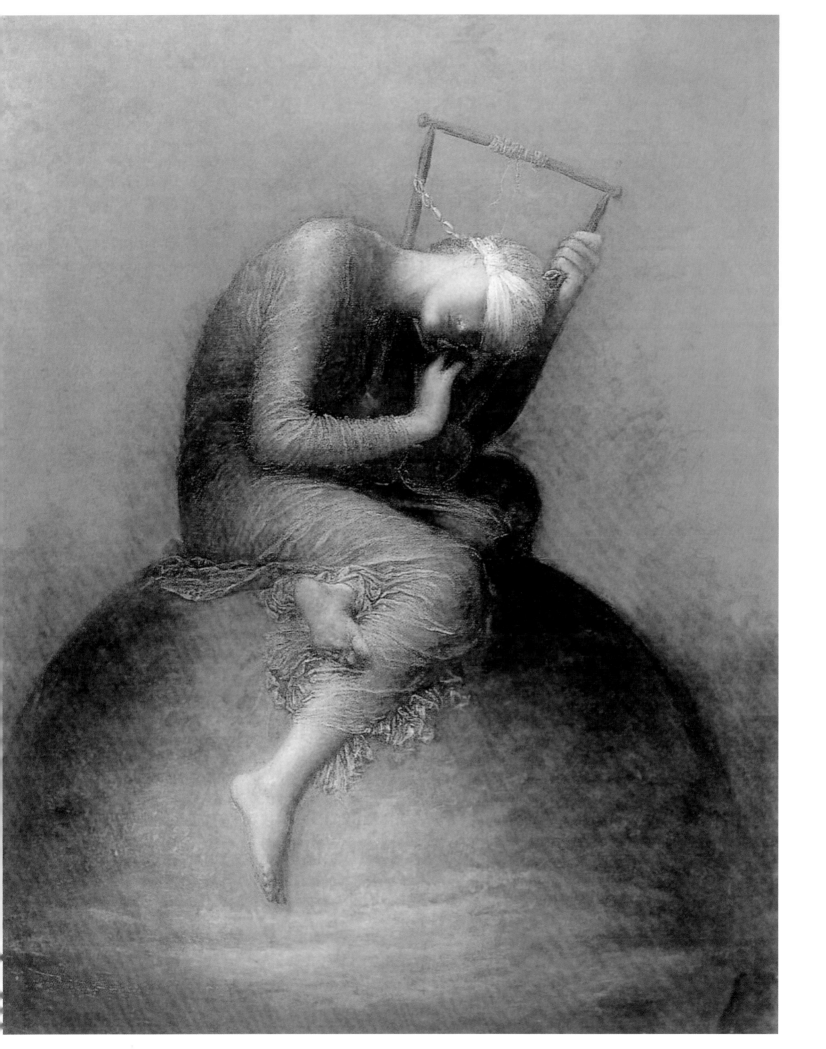

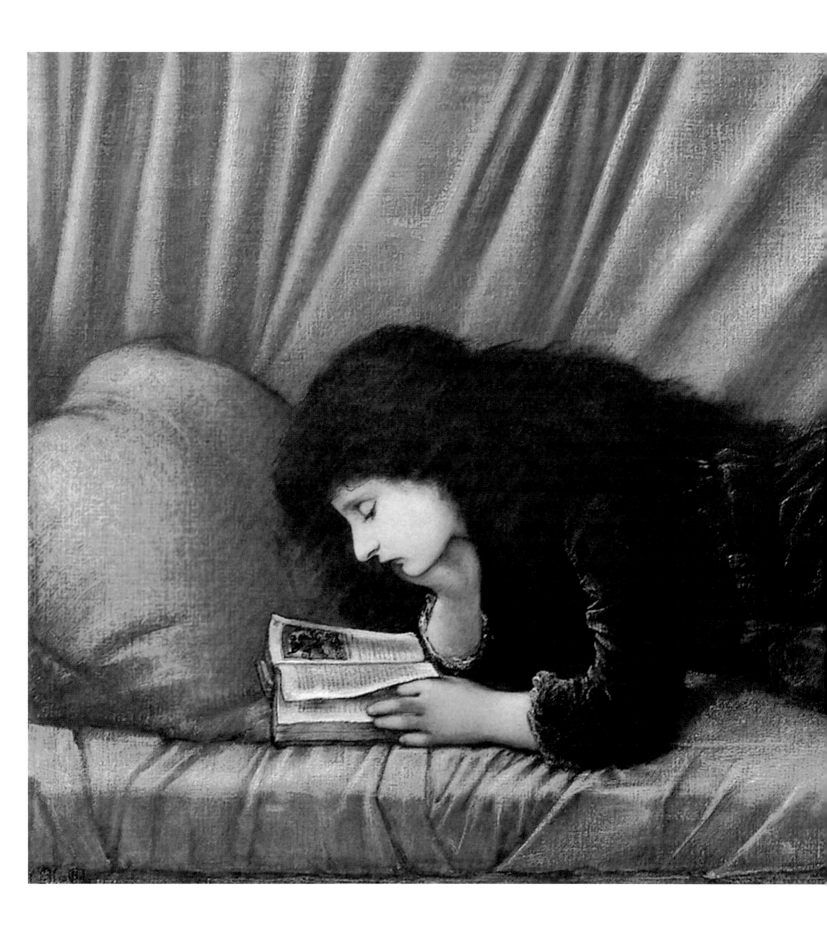

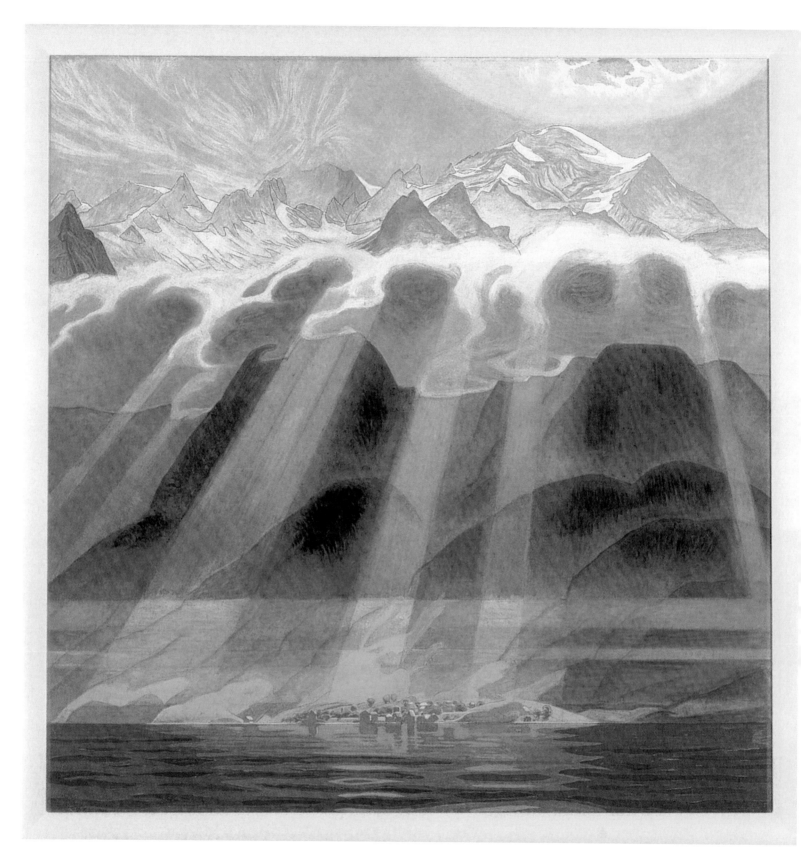

III. Symbolism in Art

A work of art connected to the ideas of Symbolism cannot be an object of calm, objective reading or contemplation. Alfred de Musset wrote that Romanticism was everything that agitates and disturbs the soul – and the same can be said of Symbolism. Only in Symbolism there is also the presence of strangeness, and mystery, and the sensation of the other-worldly, and fear, and the feeling of doom….

Remy de Gourmont, with literature in mind, said that Symbolism was anti-Naturalism. In this case, for painting, sculpture, and drawing, it is anti-Realism and anti-Impressionism. However, if Realism and Impressionism were the trends that possessed not only their ideas, but also their system of expressive means, Symbolism in the plastic arts was rather the reflection of literary-intellectual movement. The ideas of Symbolism ruled over minds in the post-Impressionism epoch and came into the art of the most diverse, in their creative aspirations, artists. The great visionaries, those whose hallucinations became the generalised expression of human emotions – the Spaniard Goya, the Englishman Blake, the Swiss Fuseli – can be considered the Symbolists' teachers of the fine arts of the past. The Symbolists' direct predecessors were the German Romanticists – Friedrich, Runge, Nazareans – and the English Pre-Raphaelites. At the close of the nineteenth century in Europe there were scores of artists who connected their work with the ideas, symbols, figurative patterns, and topics of literary Symbolism. In Germany, they were called "late Romantics" – Arnold Böcklin, Hans von Marees, Hans Thoma, Franz von Stuck. In Belgium, among the whole group of artist-Symbolists, Fernand Khnopff stood out; in Norway, Edvard Munch; in Russia, Mikhail Vrubel; in Switzerland, Ferdinand Hodler. Among Symbolists there were those who created and expressed the brightest of all the new decorative styles of the end of the nineteenth century, which was called differently in different countries: in France *art nouveau*, in Germany *Jugendstil*, in Russia *modern*. The decorative manner of work by the Englishman Aubrey Beardsley, the Austrian Gustav Klimt, the Czech Alfonse Mucha and the Swiss Eugène Grasset expressed the brightest of all this new style in drawing, posters and stained glass. Sometimes, the influences of Symbolism touched just casually some of the great masters whilst not becoming their main line of work – an example is Auguste Rodin.

In France, the motherland of Impressionism, Symbolism was first reflected in the plastic arts in the form of literary subject-matter. The idea of a painting based on a story was still very strong, despite the Impressionists' efforts to free painting from literature. The school, as in former times, graduated the ideally-prepared artist-artisans who created the masterpieces in the traditional classical manner and technique of painting. In the Salon, virtually the same as always, paintings whose subjects and characters had been taken from ancient mythology or Holy Scripture were exhibited every year. But now a tinge of mysticism, mystery, inexorable fate or melancholy appeared in them. As before they received Roman Prizes. Teachers like Cabanel, Baudry, Bouguereau, Bonnat could still be proud of their disciples, now made fashionable with a touch of Symbolism. Albert Besnard received the most prestigious orders for wall-paintings – in Paris's *Hôtel de Ville*, in the Sorbonne, in

Jens Ferdinand Willumsen,
Sun on the Southern Mountains, 1902.
Oil on canvas, 209 x 208 cm.
Thielska Galleriet, Stockholm.

Albert Pinkham Ryder,
Siegfried and the Rhine Maidens,
1888-1891.
Oil on canvas, 50 x 52 cm.
National Gallery of Art, Washington, D.C.

Gustave Moreau,
The Travelling Poet, 1890-1891.
Oil on canvas, 180 x 146 cm.
Musée national Gustave-Moreau, Paris.

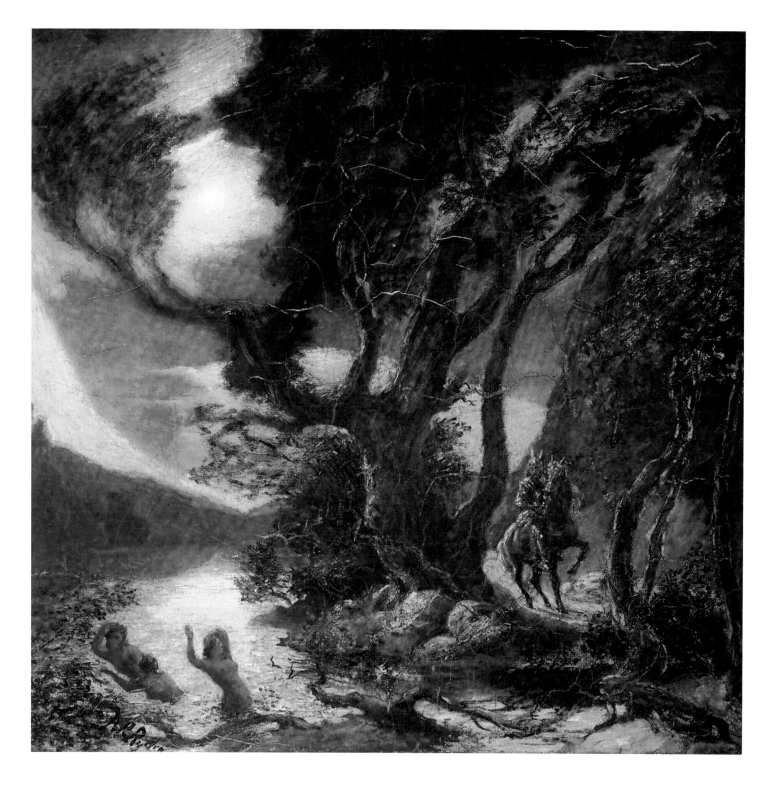

the *Petit Palais* built for the World Exhibition of 1900. Georges Clairin painted secular portraits. Henri Le Sidaner and Henri Fantin-Latour created easel paintings charming the spectator with tender sadness, the recollections of Wagner's images, mysterious visions. From 1892 to 1897 the new Salon that gathered young artists devoted to the ideas of Symbolism opened its doors six times. It was supported by Joseph Péladan, who went by the name of Sar Péladan, a member of the cabalistic Rosicrucian order. This order was based on the secret *Rosenkreutzer* societies of the eighteenth century, from which it preserved the interest in medieval Symbolism, alchemy, and esotericism. However, those artists for whom

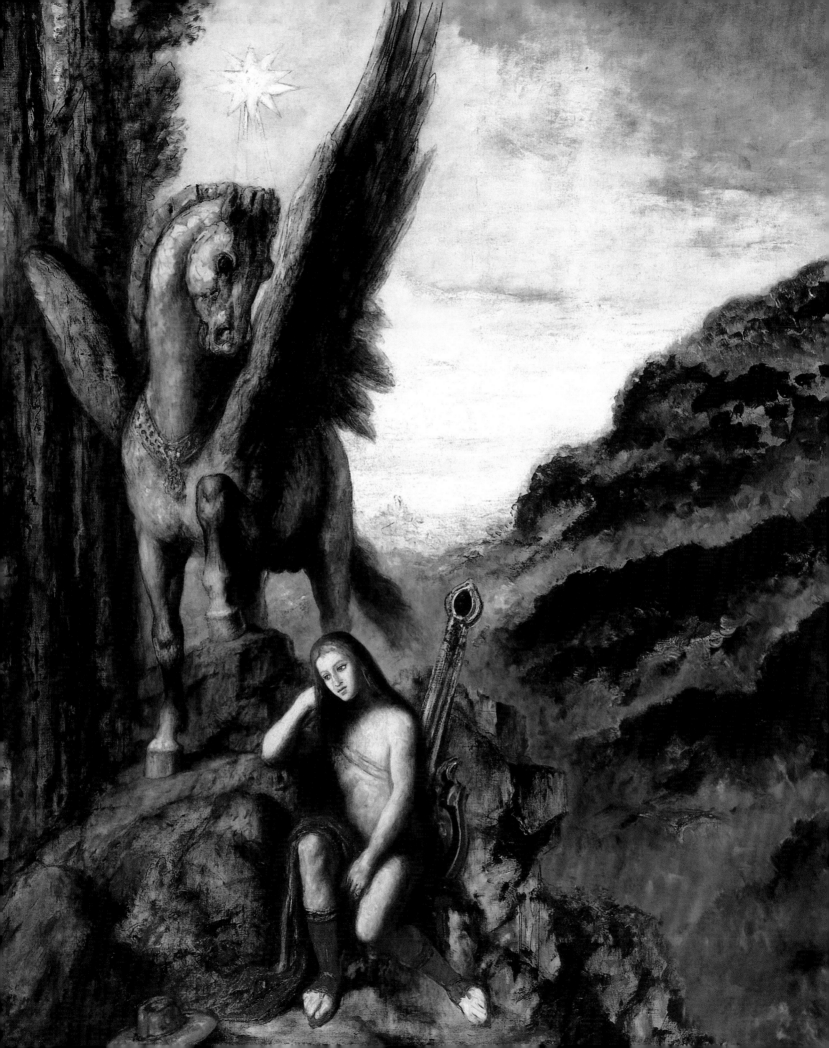

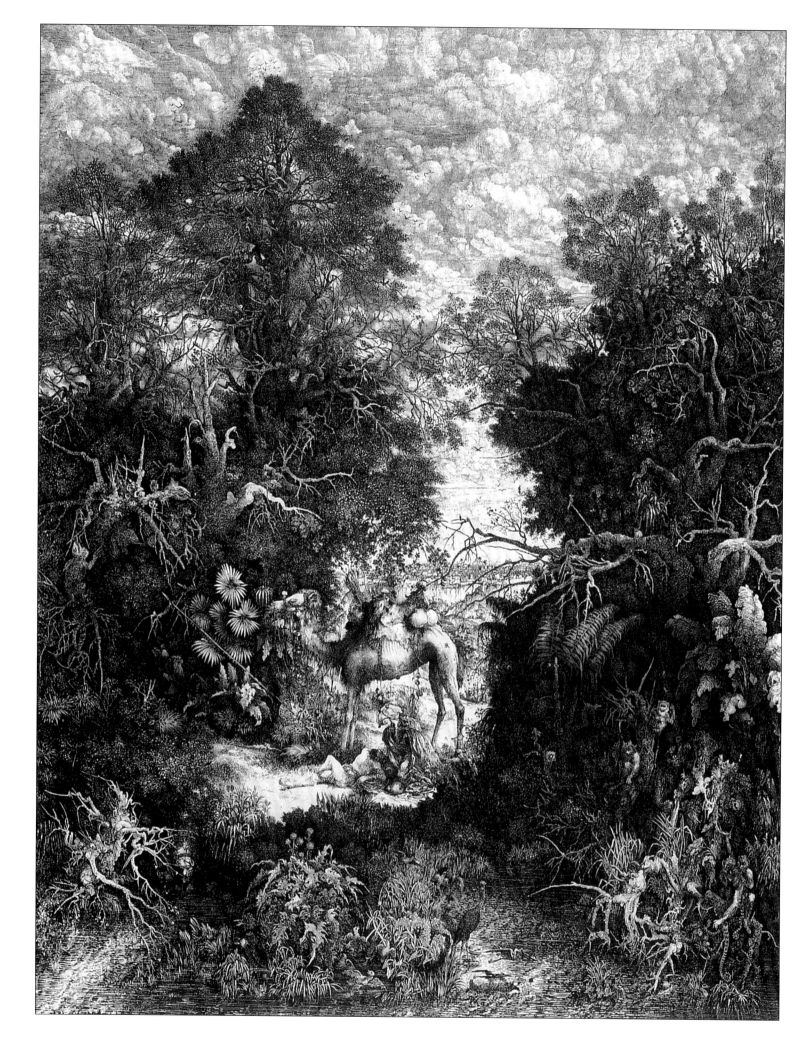

Symbolism represented something deeper than a literary topic, who came close to the expression of its ideas with the help of their painting, were never exhibited at Sar Péladan's.

The creator of monumental paintings, Pierre Puvis de Chavannes, was capable of creating the sensation of mystery and dreaminess by means of the generalisation of forms, light colouring and strangely immovable women's figures. A woman-myth, ideally beautiful and unreal – one of the most characteristic images in the painting of Symbolism – appears also in the paintings by Gustave Moreau, for whom the power of painting consisted of

Rodolphe Bresdin,
The Good Samaritan, 1861.
Lithograph, 56.4 x 44.4 cm.
Musée Jenisch, Vevey.

Aubrey Beardsley,
Illustration for the Act II of Siegfried *by Wagner*, 1892-1893.
Pen and ink with ink washes and scraping on paper, 40 x 88 cm.
Victoria & Albert Museum, London.

Pierre Puvis de Chavannes,
Mural in the Grand Amphitheatre of La Sorbonne (detail), 1886-1887.
Oil on canvas remounted on the wall, 570 x 2600 cm.
La Sorbonne, Paris.

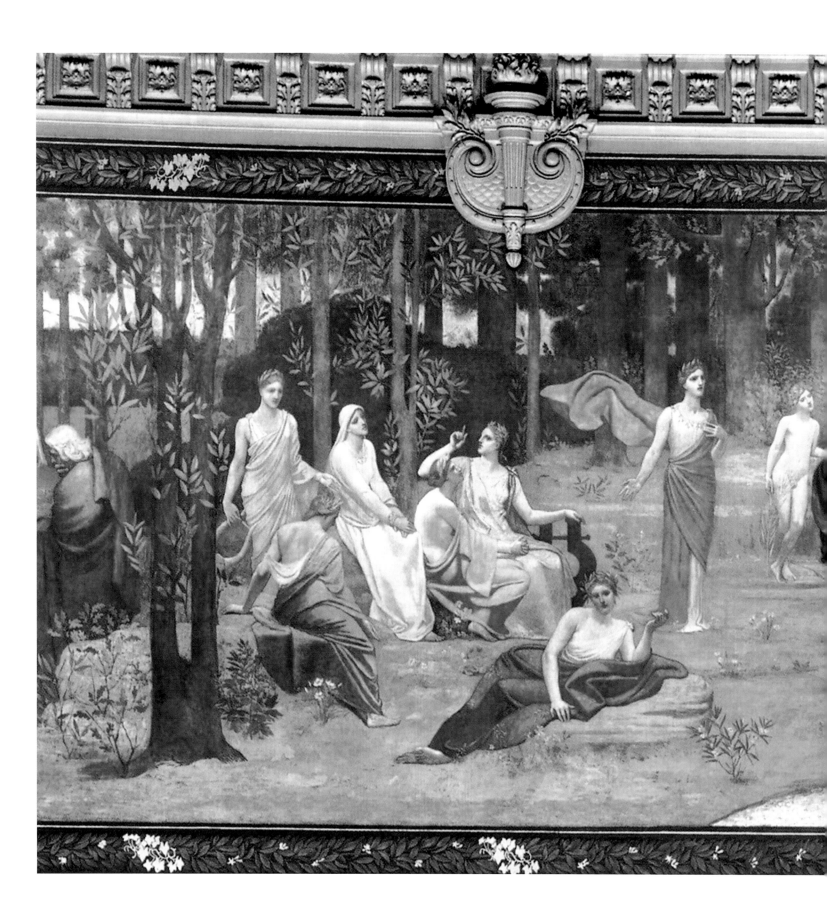

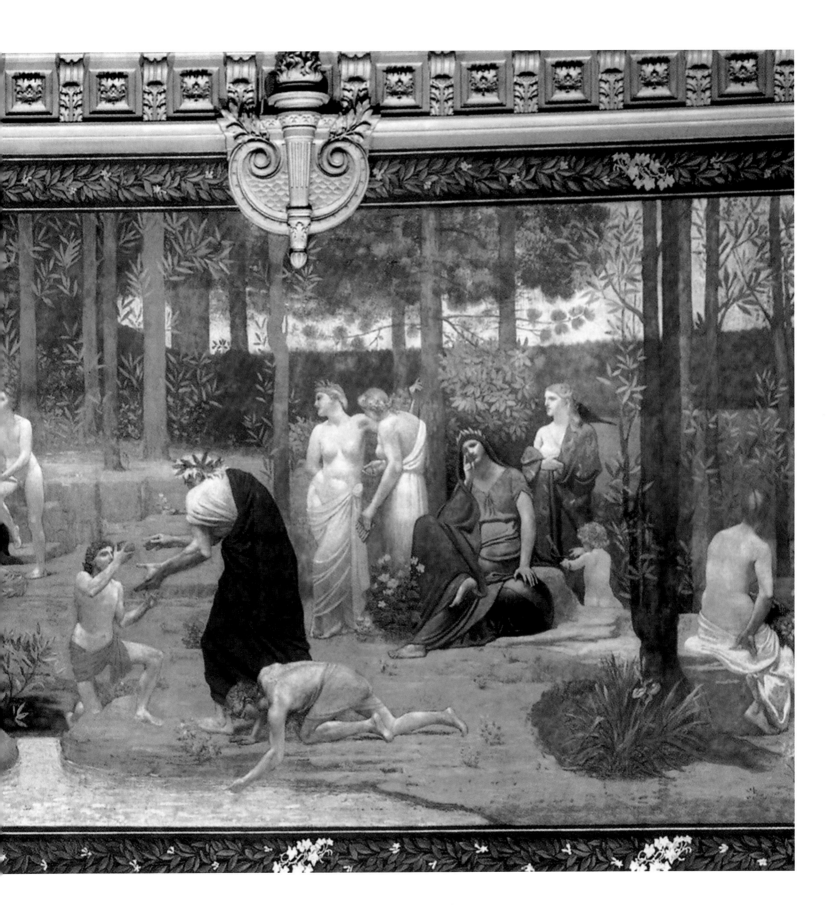

Aristide Maillol,
Two Nudes in a Landscape,
c. 1890-1895.
Oil on canvas, 97 x 122 cm.
Musée du Petit Palais, Paris.

colour. His fairies, unicorns and mythical characters are born in the maelstrom of colours and in the contrasts of bright colour, which makes them intriguing and enigmatic. Cabanel's disciple Eugène Carrière, on the contrary, leads one away into the realm of obscure visions by means of the toned manner of his painting. A simple colour does not exist for him, he works by delicate transitions of tone that immerse his characters in the unreal, misty world of dreams. And finally Odilon Redon, the only artist of the end of the nineteenth century who did not simply work in accordance with the spirit of the time, but was a true visionary. Although he studied under one of the most secular painters, Gérôme, lessons from the botanist Clavaud and the artist Bresdin, who created his own world of hallucinations in engraving, influenced Redon much more. The strange, sometimes monstrous, images of Redon's engravings, connected with animals and plants, are comparable only to Bosch's visions. The colour in his paintings sometimes melts into soft, misty transitions from one area of the spectrum to another, sometimes almost scares by strange contrasts in the bouquets of simple wild flowers. Redon's Symbolism was spontaneous and direct and his

work impressed his young contemporaries the most. Paul Gauguin remembered Redon in his letters from Pacific islands, and Maurice Denis portrayed him as the Teacher in the group of his friends the Nabis in the 1900 painting *Dedication to Cézanne*.

In the article *Paul: Symbolism in Painting* published in March 1891 in *Mercury de France*, the poet-Symbolist and critic Albert Aurier tried to formulate the basic laws of the art of Symbolism. He counted five elements characteristic of literature as well as of painting. Three of them – moral intelligence, symbolicalness, and subjectivity – are the principles of the very attitude of Symbolism. The other two – a synthetic quality and decorativeness – concern directly the manner of expression in relation to painting and figurative language. Aurier said that a Symbolist should simplify the tracing of signs. Each of his contemporaries, due to the subjectivity of art declared by Symbolists, understood these laws in his own way; however, each, more or less, realised them in his creative work. Symbolism became that background on which the heterogeneous, contradictory art of the post-Impressionism epoch existed.

Pierre Puvis de Chavannes,
Hope, c. 1879.
Oil on canvas, 70.5 x 82 cm.
Musée d'Orsay, Paris.

Fernand Khnopff,
I Lock My Door Upon Myself, 1891.
Oil on canvas, 72.7 x 141 cm.
Neue Pinakothek, Munich.

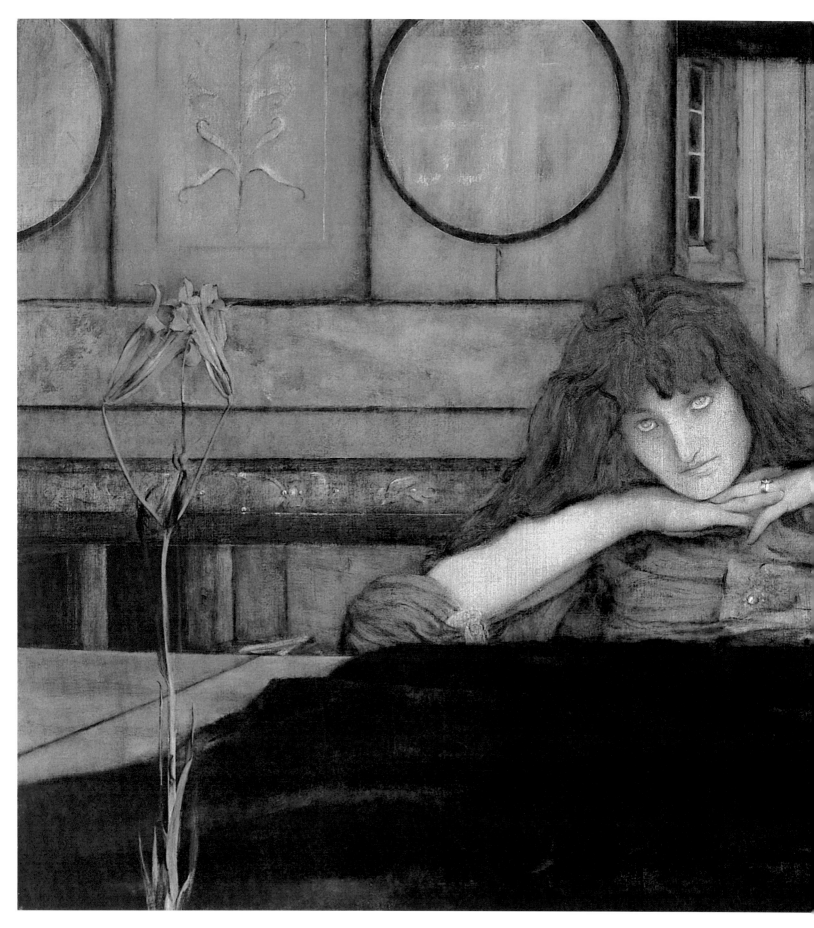

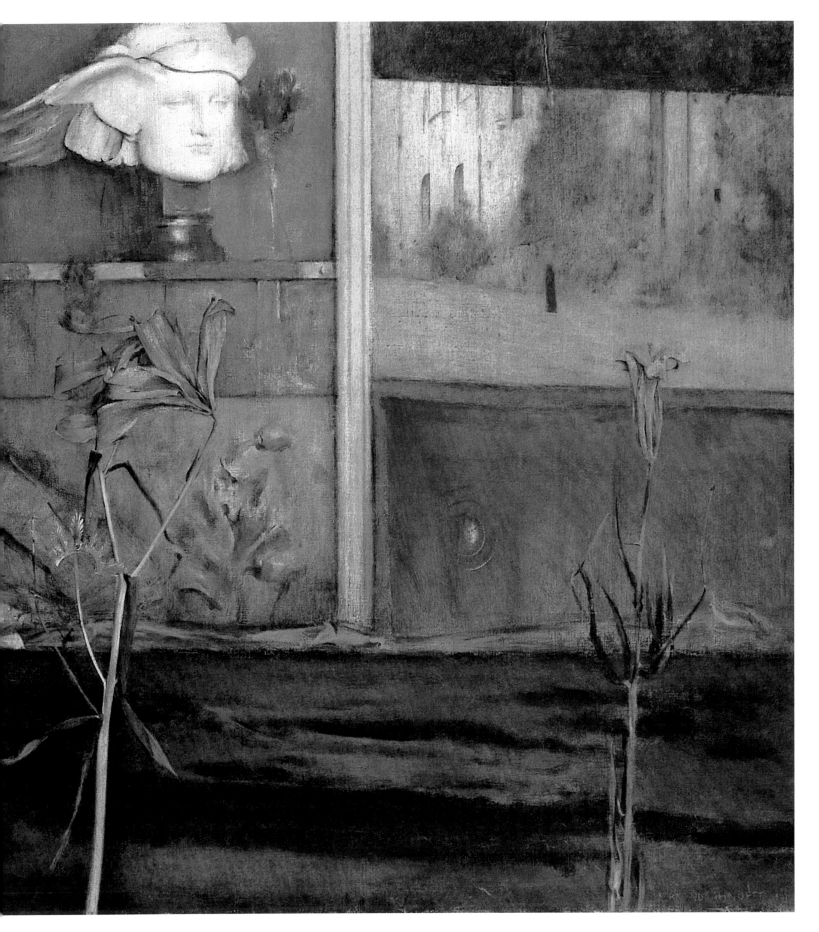

Major Artists

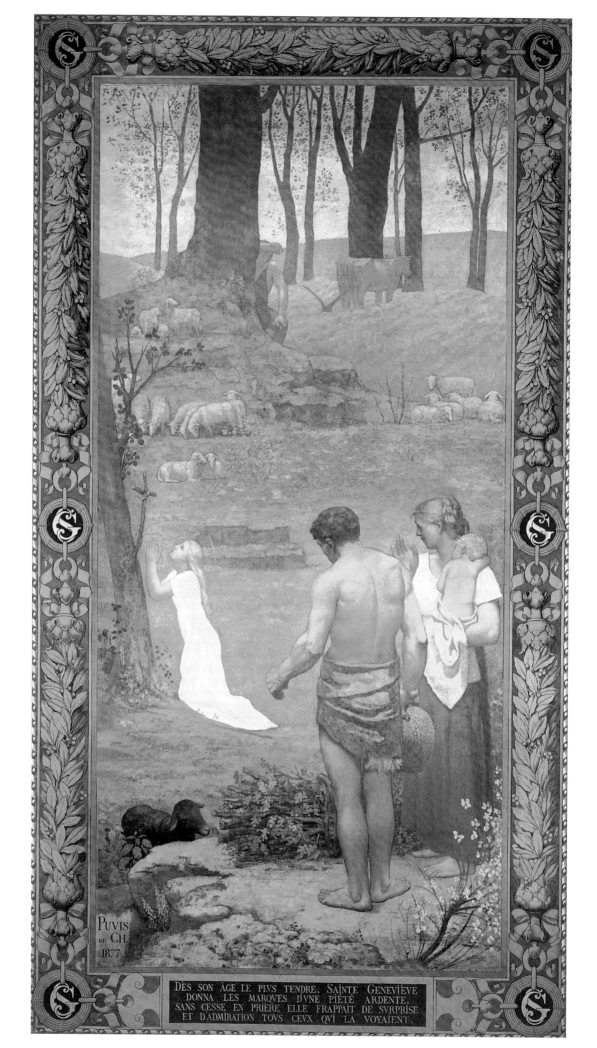

DÈS SON ÂGE LE PLVS TENDRE, SAINTE GENEVIÈVE
DONNA LES MARQVES D'VNE PIÉTÉ ARDENTE,
SANS CESSE EN PRIÈRE ELLE FRAPPAIT DE SVRPRISE
ET D'ADMIRATION TOVS CEVX QVI LA VOYAIENT.

PVVIS
DE CH.
1877

Pierre Puvis de Chavannes
(Lyon, 1824 – Paris, 1898)

Born in Lyon, Pierre Cécile Puvis de Chavannes took up painting rather late in life, at the age of thirty-five. As a member of a distinguished family (his father was a member of the French corps of engineers called *Ponts et Chaussées*), he studied literature and mathematics before entering the *Ecole Polytechnique* in Paris with the intention of pursuing a career in his father's footsteps.

Puvis was apparently standing before the still-blank walls of his father's house when he experienced an artistic awakening and discovered he had a remarkable talent for wall decoration.

Henceforth determined to devote himself to painting, he studied with Eugène Delacroix and Thomas Couture. An enlargement of one of his drawings appeared in the Salon of 1850, but several subsequent Salons rejected him.

In 1881 Puvis completed *The Poor Fisherman (Pauvre Pêcheur)*, one of his most remarkable canvases, remarkable as much for its composition as for its mood, so intensely melancholy as to be almost disturbing.

But Puvis achieved public recognition mainly through his fresco commissions, in particular for the Musée de Picardie in Amiens and the Pantheon and the Sorbonne in Paris.

On these gigantic supports the artist expressed the full range of his talent. When his work was unveiled to the public, uniquely-coloured frescos of extreme softness and delicacy were revealed. More symbolic in form than in subject matter, the work had an aura of mystical timelessness that transported the viewer to a realm of ethereal tranquillity. Although sometimes criticised for his pale tonalities, the artist's gift for colour is fully evident to anyone who wishes to see it. For the skies of his landscapes he employed an intensely luminous blue to produce a contrast with the greens of the earth. By subtly varying the quality of light in this way, Puvis enlivened his work on a whole new level: his frescos appear to proliferate quite naturally over the wall, thereby avoiding the look of man-made artifacts. The painting was vigorous, transforming the banality of the wall into an abstract, subjective statement, the symbolic essence of the artist's work. In their conveyance of a sense of air and space surrounding the figures and animating the scenes, the landscapes of Puvis are on a par with those of the greatest landscape painters.

With its pure and timeless aesthetic, the painting of Puvis was admired by the Nabis group, including Maurice Denis, and also attracted the sympathy and respect of Symbolist poets Stéphane Mallarmé and Alfred de Jarry.

Puvis co-founded the Société Nationale des Beaux-arts in 1890 after a rift occurred within the Société des Artistes Français, and served as its chairman from 1891.

At the time of his death in Paris on 24 October 1898, Pierre Puvis de Chavannes was considered one of the greatest artists of the century and was crowned in glory.

Odilon Redon,
Paul Gauguin, 1903-1905.
Oil on canvas, 66 x 54.5 cm.
Musée d'Orsay, Paris.

Pierre Puvis de Chavannes,
St Genevieve Child in Prayer, 1877.
Oil on canvas remounted on the wall,
462 x 221 cm.
Panthéon, Paris.

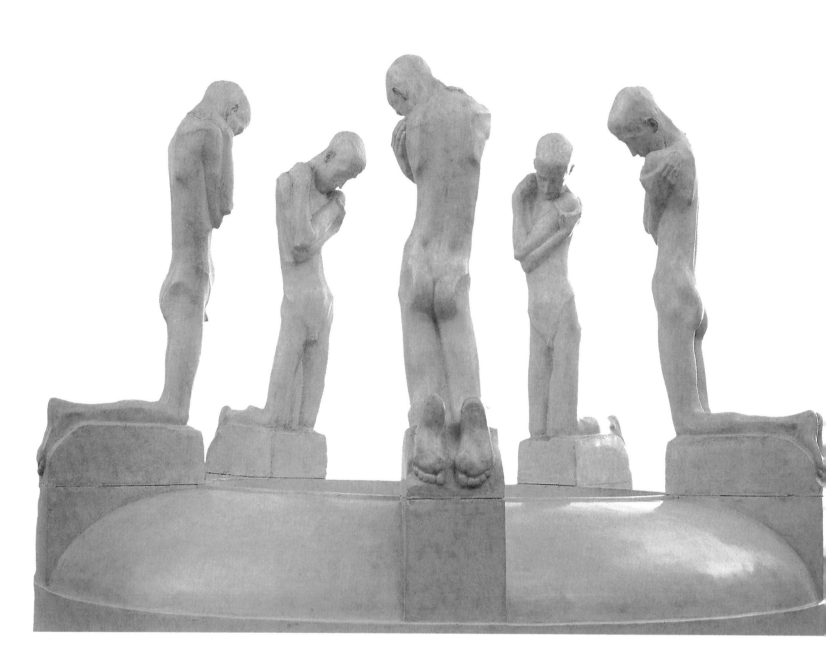

Georges Minne,
Fountain of the Kneeling Youths, 1905.
Plaster, 168 x 240 cm.
Museum voor Schone Kunsten, Ghent.

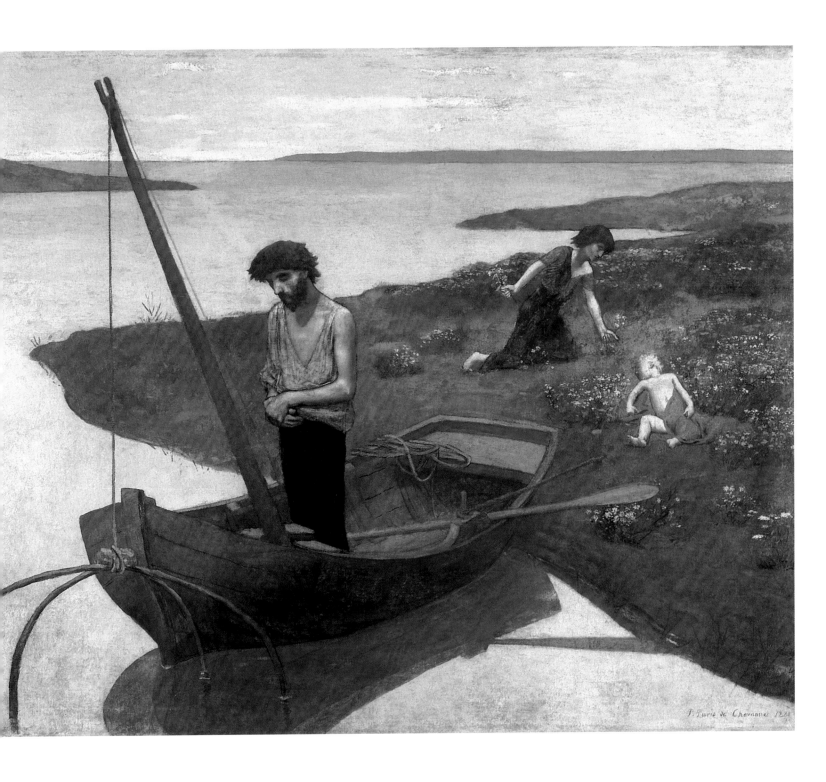

Pierre Puvis de Chavannes,
The Poor Fisherman, 1881.
Oil on canvas, 155.5 x 192.5 cm.
Musée d'Orsay, Paris.

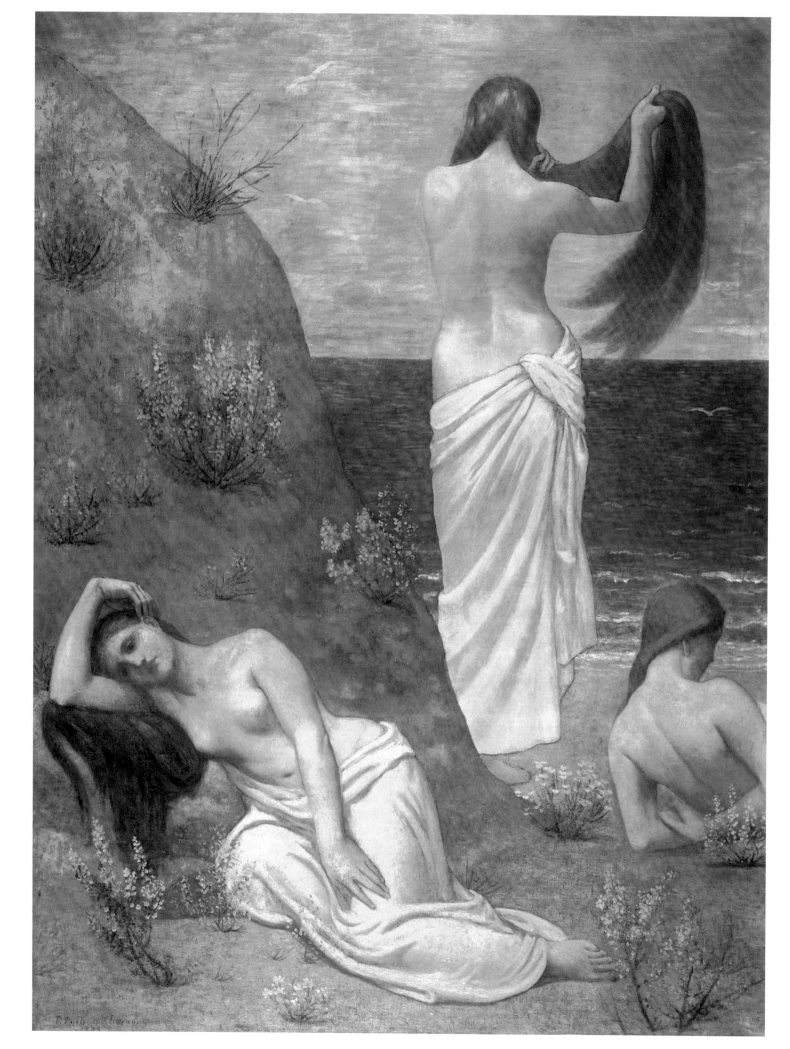

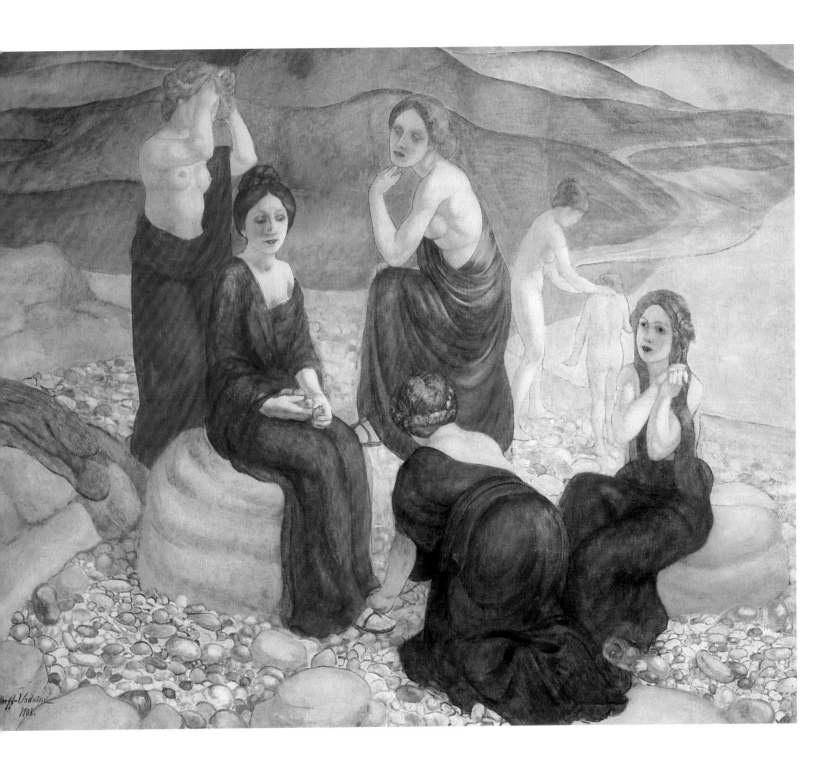

Arnold Böcklin
(Basle, 1827 – Zurich, 1901)

Arnold Böcklin is a major nineteenth-century artist who has been too-long forgotten.

Born in 1827 in Basle, Switzerland, Böcklin commenced his training while residing in Germany, entering the school in Düsseldorf at the age of nineteen. His master promptly advised him to continue his education in Brussels and Paris and then proceed to Rome. As German art preferred subject matter to artistic expression, these travels exposed Böcklin to a new concept of painting in which the artist was allowed to fully identify himself. In Italy he copied the old masters and developed his own highly-individual art, taking the Roman countryside as the inspiration for his many landscapes. Simultaneously majestic and sad, these works invariably provoke deep melancholy.

Although traditional in his devotion to nature and his sense of expression, Böcklin also conveys a modern sensibility and spirit in his canvases. Setting his work in an intensely personal world where mythological creatures encounter the folklore of German mythology, Böcklin achieves a marvellous fusion of the sometimes conflicting trends of Naturalism and Expressionism. An inspired colourist, he went on to become a leading representative of the Symbolist movement. But like so many of his fellow artists, Böcklin was unappreciated during his lifetime. The proponents of modern art were shifting emphasis away from content towards form, even to the point of abstraction, and they deemed Böcklin's work overly narrative, despite its poignant Symbolism.

In 1880 Böcklin completed the first version of *The Island of the Dead*. Within six years he would complete five variations of this painting, now considered his most important work. A true masterpiece, the canvas has a moody ambiance that draws the viewer deep inside a dramatic setting that somehow manages to be both fantastical and real. The painting gives the viewer direct access to the painter's private world, a world that is simultaneously dreamy and melancholy.

A gifted colourist at a time when Richard Wagner was extracting sound colours out of music with unprecedented brilliance, Böcklin's colours flowed over his canvases like the symphonic waves of an orchestra. With vivid colour that left viewers spellbound, the paintings became objects of bewitching splendour, and subsequent generations would honour Böcklin for being one of the most poetic colourists of the century.

In the 1920s Böcklin's work was rediscovered by the Surrealists, such as Giorgio de Chirico, Salvador Dalí, and Max Ernst. Regarding Böcklin as their predecessor, they hailed him as an "artistic genius", and found inspiration in the mythological visions, fantastic and iconoclastic, depicted on canvases populated by centaurs, naiads and other nymphs.

Pierre Puvis de Chavannes,
Young Girls at the Seaside, 1879.
Oil on canvas, 205 x 154 cm.
Musée d'Orsay, Paris.

Kosma Petrov-Vodkine,
Shore, 1908.
Oil on canvas, 128 x 178 cm.
The State Russian Museum,
St Petersburg.

Arnold Böcklin,
The Sacred Wood, 1882.
Varnished tempera on canvas,
105 x 150.5 cm.
Kunstmuseum, Basel.

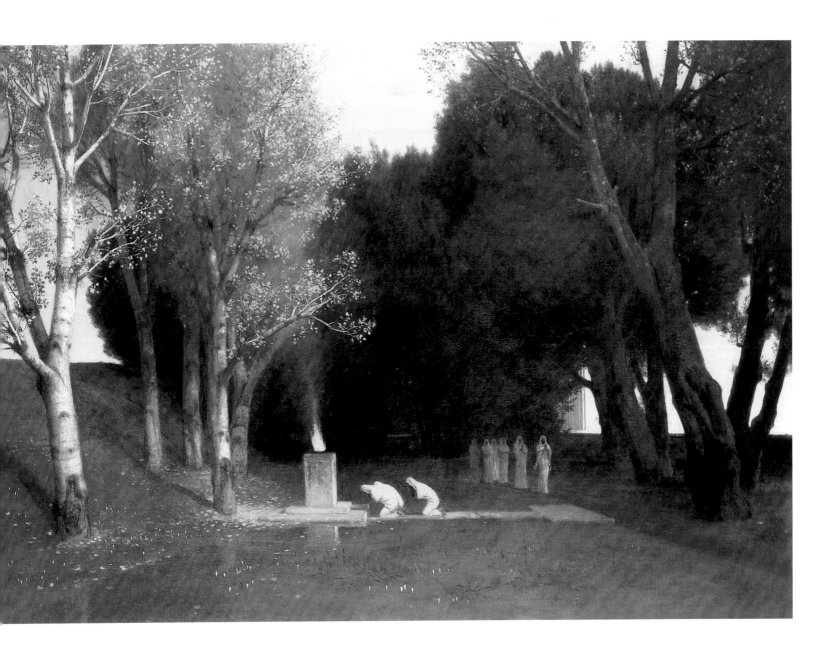

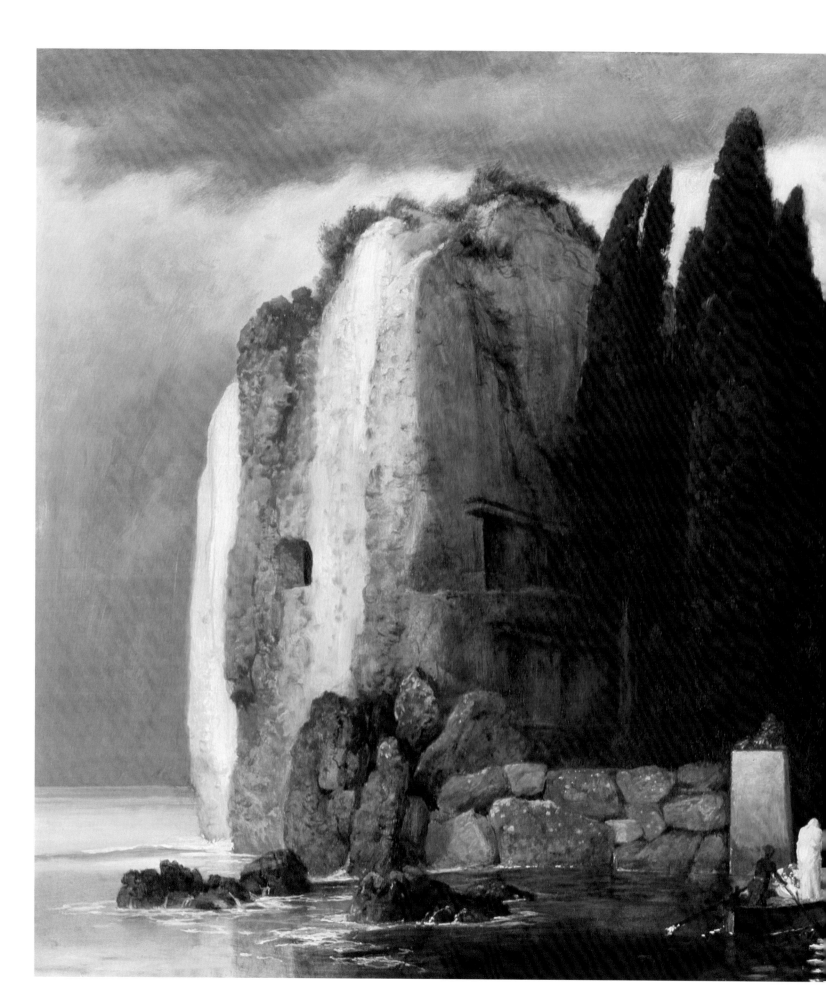

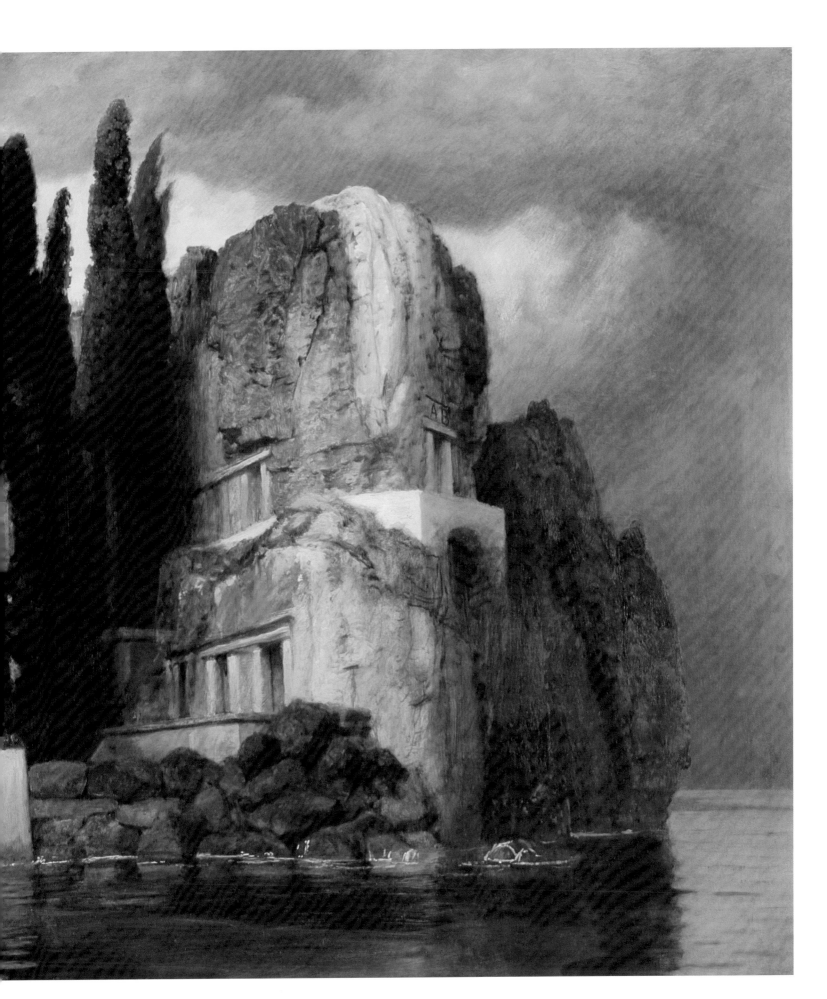

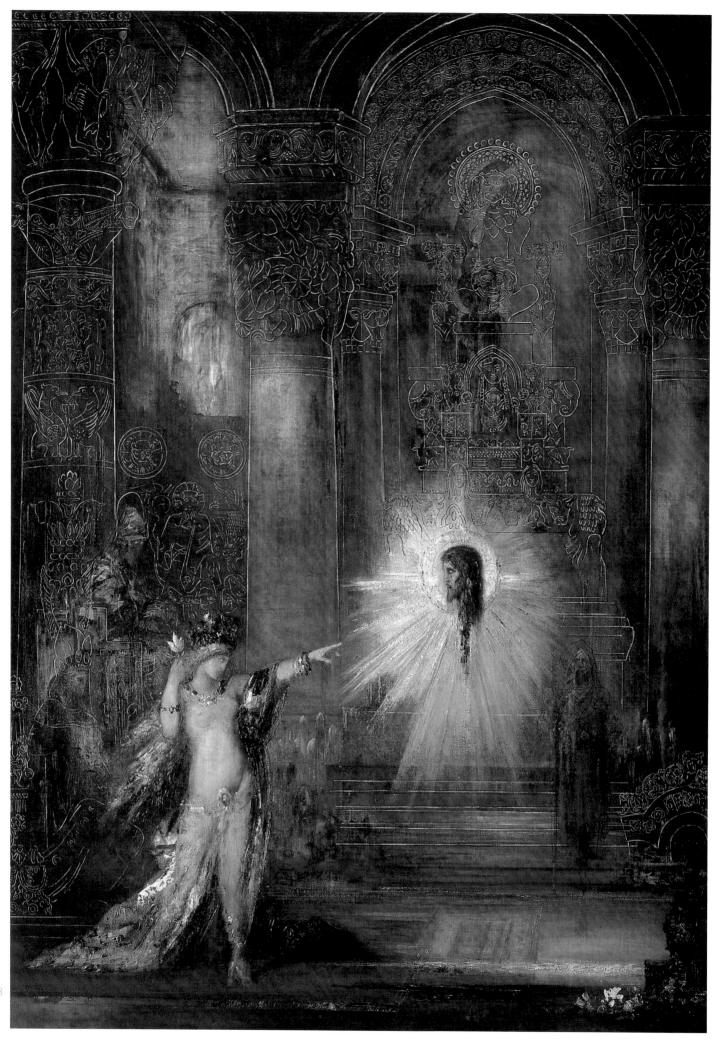

In 2002 the Musée d'Orsay devoted an exhibition to the Swiss painter in the framework of its monograph series dedicated to rediscovering overlooked artists. Particularly well-timed to coincide with the artist's centenary, the exhibition gave the public (especially in France) an opportunity to rediscover Böcklin and allowed a re-evaluation of his work so that he could be restored to his rightful place within the history of modern art, namely as an artist whose *œuvre* is both singular and fundamentally Symbolist.

Gustave Moreau
(Paris, 1828 – Paris, 1898)

Acknowledged today as one of the greatest French Symbolist painters, Gustave Moreau was born in Paris in 1828. Exhibiting at the Salon, and later decorated with the French *Légion d'Honneur*, Moreau's career unfolded primarily within the milieu of his native Paris.

As the son of an architect, Moreau was inculcated with a classical education at a very young age. He was only an eight-year-old boy when he started to develop the gifts that would make him a great draughtsman. Throughout his life he would collect drawings, copies, and photographs of works that he admired and which provided frequent inspiration.

After attending classes at Rollin College in Paris, Moreau made his first trip to Italy in 1841, filling a sketchbook with drawings in the process, and afterwards frequenting the private studio of the painter François-Edouard Picot, a decorator of public monuments and Parisian churches. These experiences made him a suitable applicant for admission to the école des Beaux-Arts in Paris, to which he applied in 1846. He was admitted, but after a second failed attempt to win the Prix de Rome, Moreau left the institution in 1849.

Retracing his travels in Italy, Moreau honed his knowledge of the Renaissance masters, including Veronese, Carpaccio, Raphael, and even Michelangelo, whose Sistine Chapel frescos Moreau spent hours copying. In Paris, Moreau likewise continued to apply himself by copying the Old Masters at the Louvre, and his work soon reflected the diversity of his many influences and indirect inspirations.

But it was his encounter with Théodore Chassériau in 1851 that would ultimately empower Moreau's work. Impressed by the work of this famous student of Ingres, Moreau borrowed the intensity of Chassériau's tones, in particular the depth of his browns and reds. Through the vibrancy of their now incomparable colours, Moreau's canvases, always brilliantly handled, were saturated with a highly personal Symbolism that immersed the viewer in a fantasy world where dreams and mythology were always intersecting.

When he exhibited *Oedipus and the Sphinx (Œdipe et le Sphinx)* at the Salon of 1864, Moreau was harshly criticised by critics and the public alike, who were unable to see the winged creature, simultaneously wild and wise, as a powerful example of a purely symbolic art.

Arnold Böcklin,
Island of the Dead, 1880.
Oil on wood, 73.7 x 121.9 cm.
The Metropolitan Museum of Art,
New York.

Gustave Moreau,
The Apparition, 1876-1898.
Oil on canvas, 142 x 103 cm.
Musée national Gustave-Moreau, Paris.

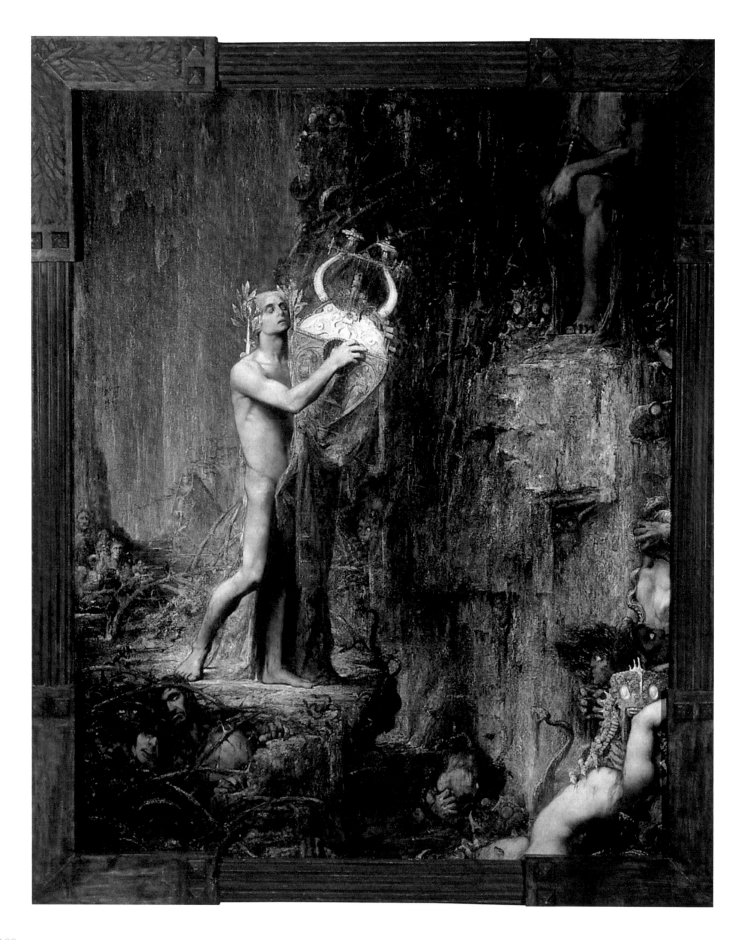

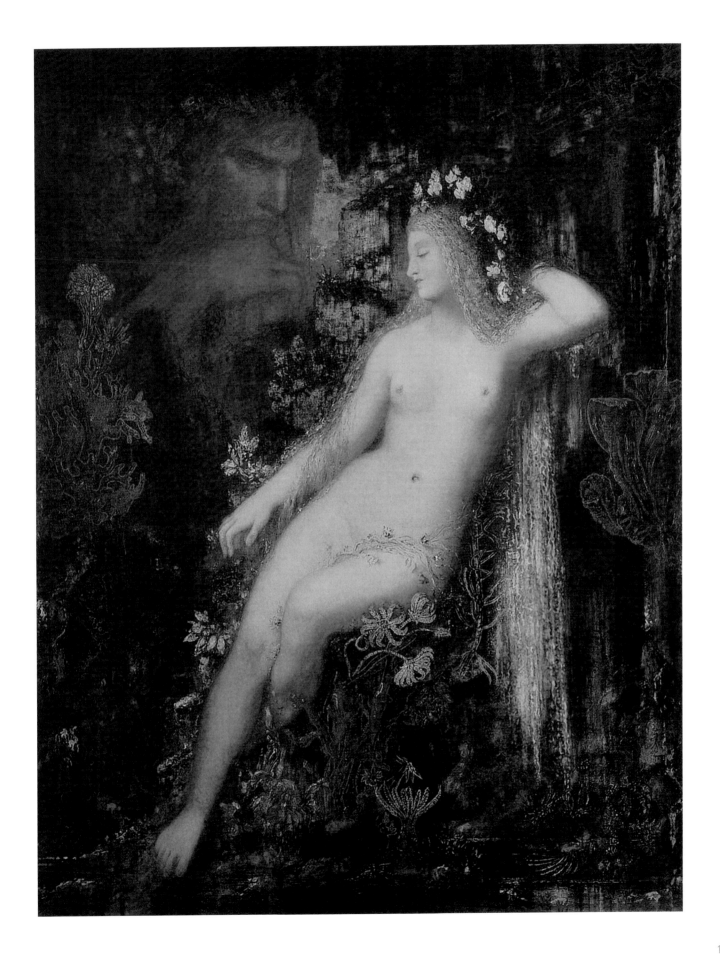

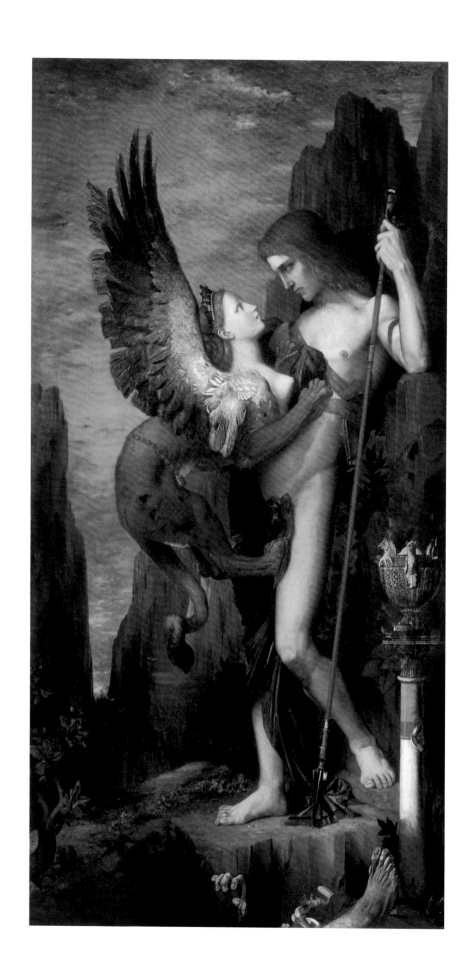

Pierre Amédée Marcel-Beronneau,
Orpheus, 1897.
Oil on canvas, 194 x 156 cm.
Musée des Beaux-Arts, Marseille.

Gustave Moreau,
Galatea, 1880.
Oil on wood panel, 85 x 67 cm.
Musée d'Orsay, Paris.

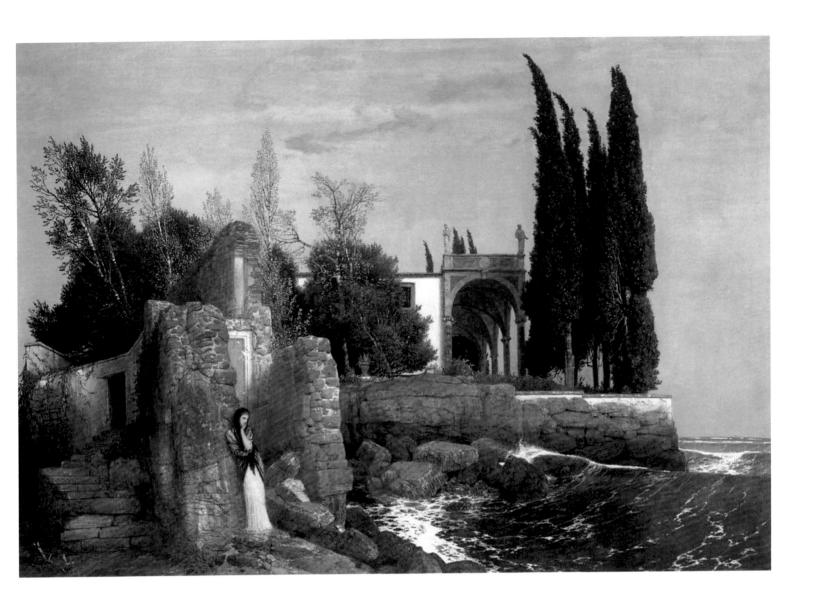

A visionary artist, Moreau had to wait twelve years for his work to be universally recognised. It was in 1876, when he offered Salon goers *The Apparition (L'Apparition)* that the public and critics finally opened their eyes to the beauty of his work. The head of Moreau's St John the Baptist that he depicted in levitation, rather than on a platter, caused a sensation.

Moreau exhibited the painting that brought him to the public's attention once again at the 1878 Universal Exposition, but he was already widely considered an essential representative of French Symbolism.

In 1888 he was elected to the Académie des beaux-arts, then appointed professor at the école des Beaux-Arts in 1892.

Gustave Moreau died in Paris in 1898. A renowned painter, he died having achieved a late masterpiece when several years earlier he had applied the last stroke to *Jupiter and Semele (Jupiter et Semélé)*. If one canvas could possibly encapsulate the great Symbolist's entire *oeuvre*, it would be this one, for its intensity, its influences, and its heightened sense of detail.

Gustave Moreau,
Œdipus and the Sphinx, 1864.
Oil on canvas, 206.4 x 104.8 cm.
The Metropolitan Museum of Art,
New York.

Arnold Böcklin,
Seaside Villa, 1878.
Oil on canvas, 110 x 160 cm.
Kunstmuseum, Winterthur.

Dante Gabriel Rossetti
(London, 1828 – Birchington-on-Sea, 1882)

Both painter and a poet, Dante Gabriel Rossetti founded the Pre-Raphaelite brotherhood in 1848, along with the critic Leigh Hunt and the painters Holman Hunt and Sir John Everett Millais. The Pre-Raphaelites crossed the plastic arts with literature and religion, but there was no limit to their aesthetic goals beyond this union. Whereas Millais and Hunt preferred to adapt the drama of real events unfolding among men and women in a naturalistic world, Rossetti was more traditional, focusing on the depiction of scenes from the Bible and literary themes, in particular from Dante, Shakespeare, Goethe, and Edgar Allan Poe.

At the same time, Rossetti worked alongside Edward Burne-Jones and William Morris, and his works were greatly admired by John Ruskin. Passionate about drawing and writing, Rossetti combined his two interests in his canvases, where words often found a place.

In what would soon become a characteristic of the Pre-Raphaelite movement, Rossetti painted slowly, always concentrating on best representing the slightest detail naturalistically. Romantic in spirit, Rossetti translated the love affairs he experienced over the course of his life into his paintings. Elizabeth Siddal, whom he would marry in 1860, haunted his works until he met Jane Burden. Although Burden ended up marrying William Morris, she remained the true Pre-Raphaelite archetype of feminine beauty to Rossetti, who loved her for the rest of his life.

Settled in Oxford, Rossetti neglected and abandoned his wife. As neither partner had much money, Rossetti chose to rely on the favours of other women. The health of his wife, known as Lizzie, declined after a stillbirth and she ended her own life with an overdose of laudanum while still quite young, only two years after the marriage. This drama had a profound effect on Rossetti, both in his art and his person. Living in Chelsea afterwards, no doubt to escape unbearable memories, Rossetti expressed his feelings for his dead wife in his paintings, and continued to paint female models in works that combined a dangerous sensuality with deep melancholy. In 1864 he started work on *Beata Beatrix*. Full of Symbolism, this work, which he laboured over for six years, is a true homage to his departed wife, perhaps in the spirit of redemption. During the final years of his life Rossetti fell into a deep depression and shut himself off in a macabre solitude. With his poetry under fierce attack by the critics, he stopped writing and buried his texts in Lizzie's grave. Having become paranoid, especially after being publicly attacked in the pamphlet *The Fleshy School of Poetry*, he stopped seeing his friends, in particular Ruskin, and only communicated by letter with a select few, including Jane Morris.

Dante Gabriel Rossetti,
Ecce Ancilla Domini! or
The Annunciation, 1849-1850.
Oil on canvas, 72.4 x 41.9 cm.
Tate Britain, London.

Edward Burne-Jones,
The Lamentation, 1866.
Watercolour and gouache on paper mounted on canvas, 47.5 x 79.5 cm.
Birmingham Museums & Art Gallery, Birmingham.

Dante Gabriel Rossetti,
The Bower Meadow, 1850-1872.
Oil on canvas, 86.3 x 68 cm.
Manchester Art Gallery, Manchester.

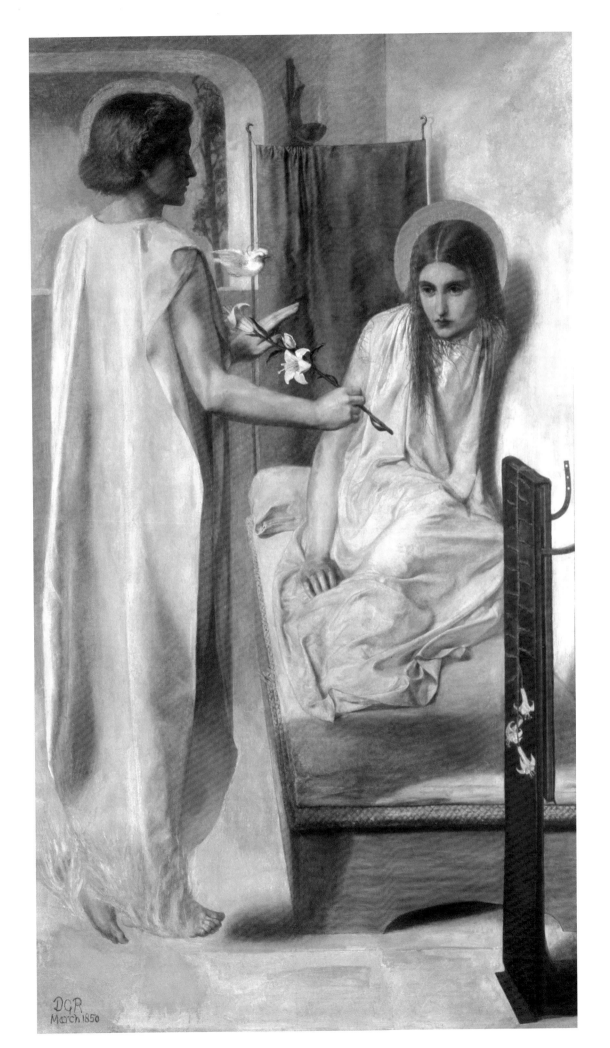

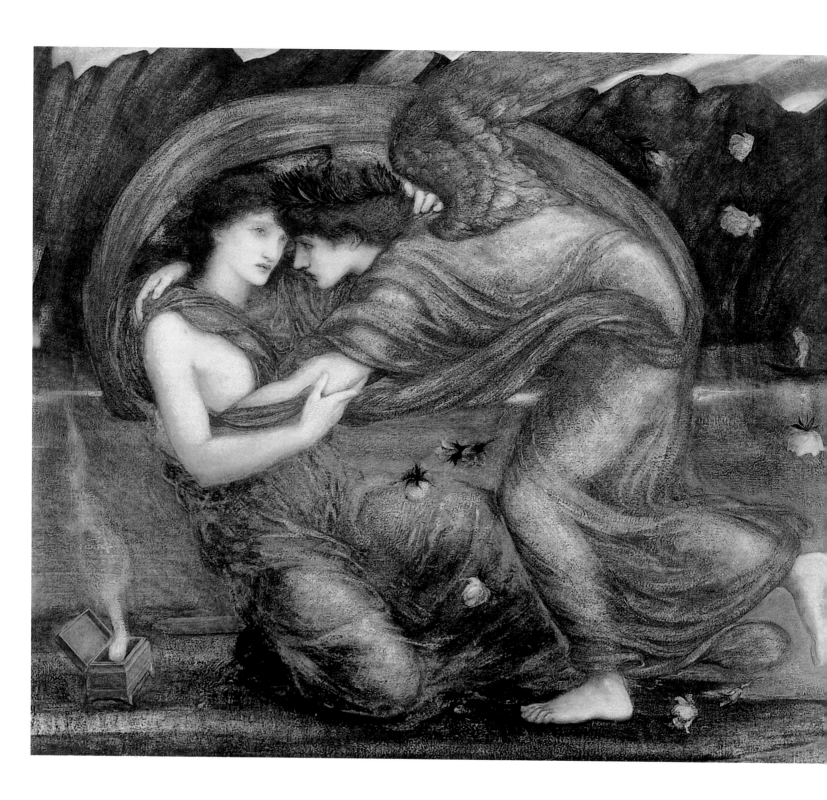

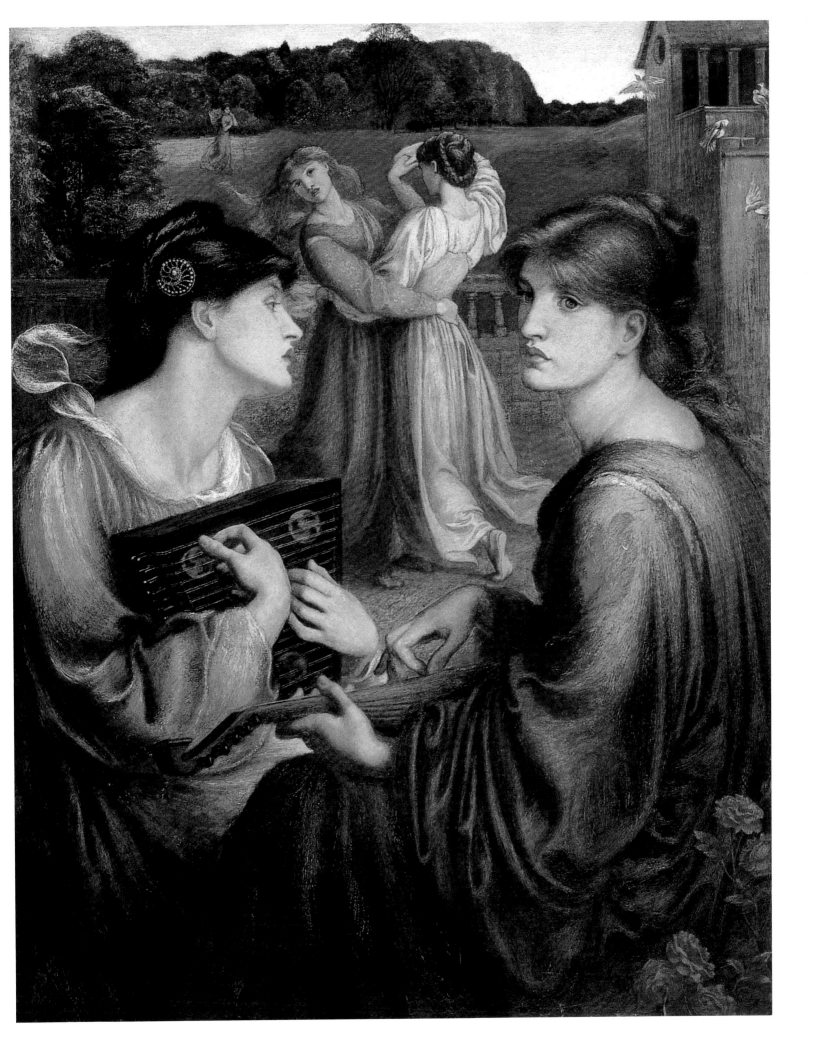

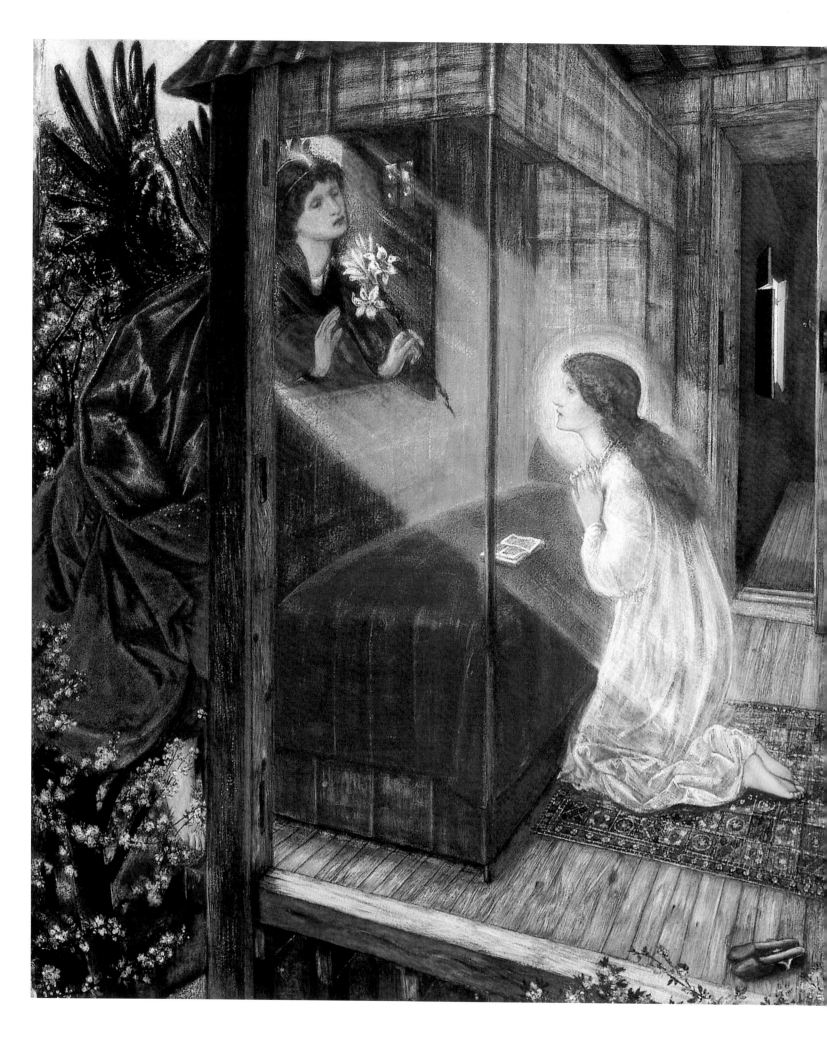

Consumed by alcohol and drugs, Rossetti died in 1882. Forever torn between his two passions of painting and writing and destroyed by his own demons, Rossetti lacked the necessary fortitude to become a true master of either specialty, but nevertheless remains a major avant-garde artist of nineteenth-century England.

Edward Burne-Jones
(Birmingham, 1833 – London, 1898)

An almost self-taught painter who received only a few drawing lessons from Dante Gabriel Rossetti, Edward Burne-Jones was born in Birmingham in 1833. As his mother died several days after his birth, he was raised by his father in his native city. A brilliant student, at the age of twenty he left home to attend Exeter College, Oxford. There he met William Morris and two years later, having discovered the work of the painter and poet John Ruskin, the two friends went to live in London; Burne-Jones had decided to become a painter, Morris an architect.

In London Burne-Jones met Rossetti, with whom he became friends. In order to support himself, Burne-Jones worked at producing stained-glass window designs, in particular for the company founded by Morris called the Morris, Marshall, Faulkner & Co., later simply Morris & Co.

Taking his inspiration from Romantic literature, Burne-Jones started working on pencil and ink drawings and watercolours.

He then made a new voyage to Italy, which he had previously discovered a few years earlier. Afterwards, inspired by these new perspectives, Burne-Jones, who had joined the brotherhood of the Pre-Raphaelites, produced a distinctive style. Combining Pre-Raphaelitism, Classicism, and Italian Primitivism, his work ultimately transcended all these influences in a subtle mixture of Romanticism and Symbolism. Always looking for inspiration in literature, myths, and legends of primarily medieval origin, Burne-Jones applied himself particularly to the depiction of figures, which he often made from nature, and quickly became one of the most important painters of the Pre-Raphaelite movement. Accentuating the power of his images by making his canvases larger than convention dictated, Burne-Jones took great care to render the sensuality of the body and drapery in the Italian tradition. Spending a great deal of time painting his canvases, he often stopped work on one to begin work on another, or to take up where he had left off on an older work in order to finish it. Line and form took precedence over colour, and the tones of his canvases are often softened, sometimes resulting in a faded appearance that nevertheless always accentuates the melancholy, dreamlike quality of his work.

Acknowledged as a painter by his contemporaries, his reputation suffered a setback when he depicted Ovidian heroes in the nude in *Phyllis and Demophoon*. As a result of the harsh criticism this work received, Burne-Jones had to resign from the Old Watercolour Society he belonged to. His collectors, however, still held his work in high regard, and were able to maintain his reputation.

Edward Burne-Jones,
The Annunciation or *The Flower of God*, 1863.
Aquarell and gouache, 61 x 53.3 cm.
Lord Andrew Lloyd-Webber collection.

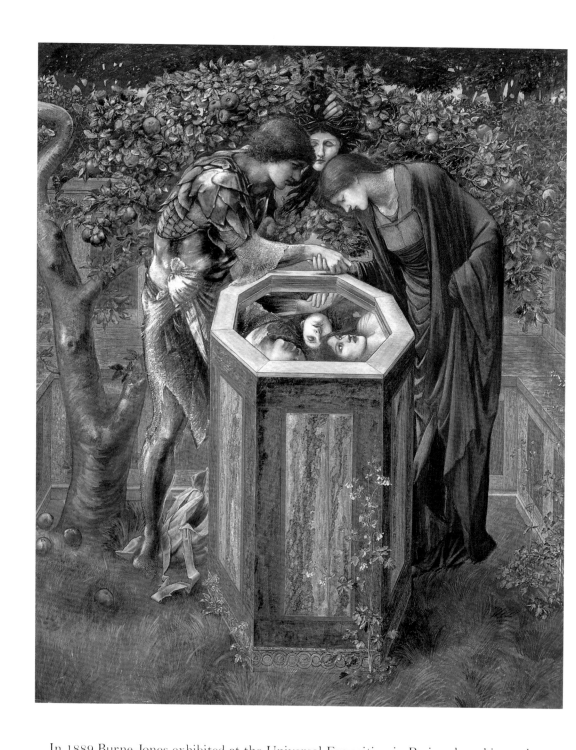

Edward Burne-Jones,
The Baleful Head, 1885-1887.
Oil on canvas, 150 x 130 cm.
Staatsgalerie, Stuttgart.

In 1889 Burne-Jones exhibited at the Universal Exposition in Paris, where his work was mostly well received by the public and where he won a first-prize medal. Acknowledged throughout Europe then as a major artist, he became a member of the *Académie royale de Peinture* in 1885, but resigned in 1893. Two years later he was knighted by Queen Victoria. Having become a major artist of his era, known throughout Europe, he died in London in 1898 as the greatest representative of the Pre-Raphaelite movement. The ultimate honour, which no other artist had previously received, was a memorial service held at Westminster Abbey at the request of the Prince of Wales, soon to become King Edward VIII.

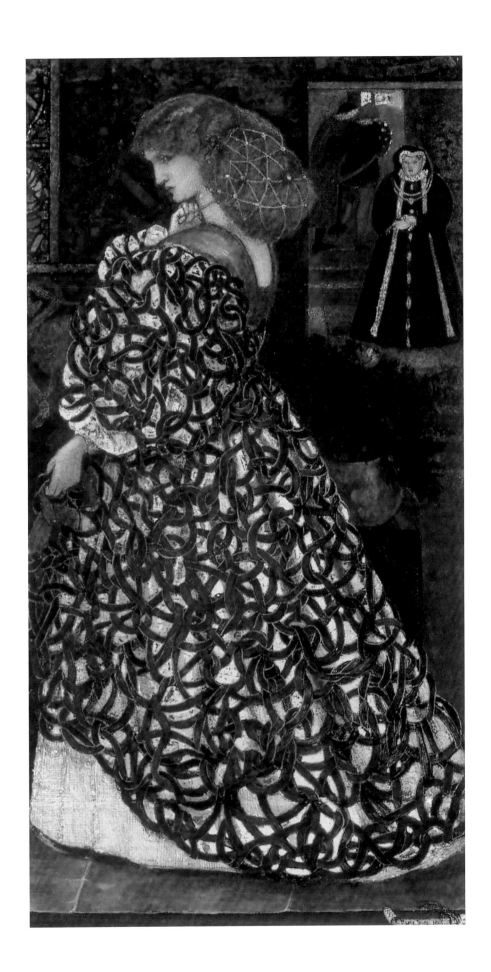

Edward Burne-Jones,
Sidonia von Bork, 1860.
Watercolour and gouache on paper,
33.3 x 17.1 cm.
Tate Gallery, London.

Edward Burne-Jones,
The Wedding of Psyche, 1895.
Oil on canvas, 119.5 x 215.5 cm.
Musées royaux des Beaux-Arts de
Belgique, Brussels.

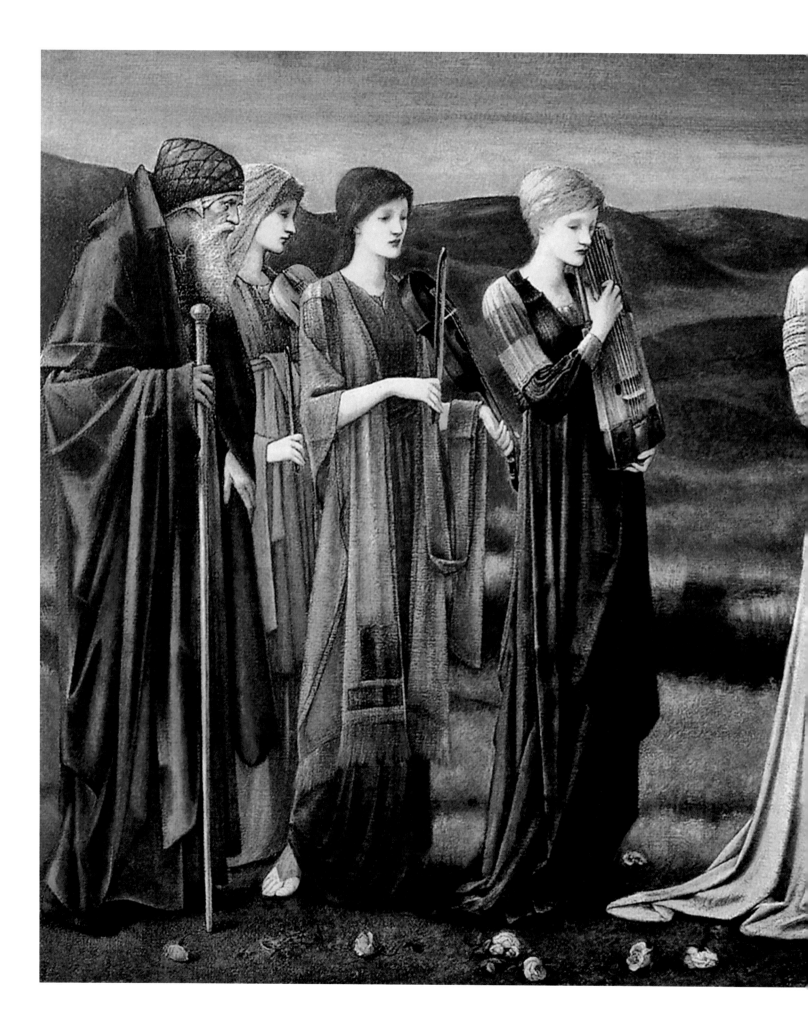

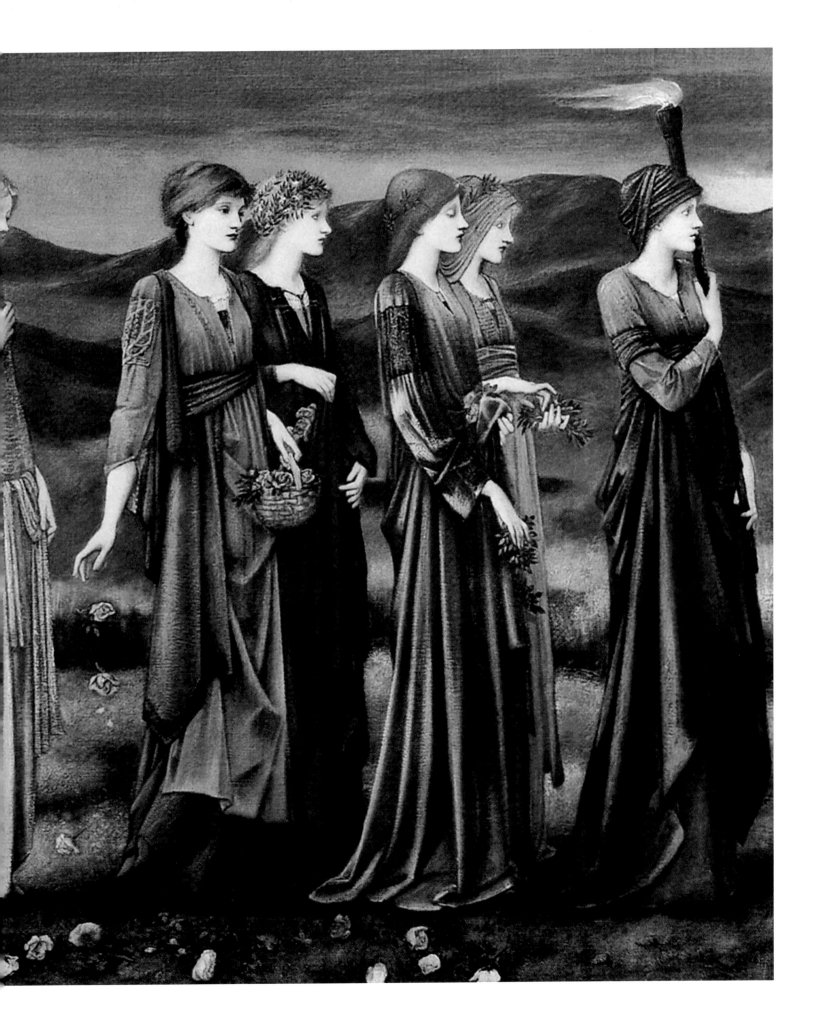

Odilon Redon
(Bordeaux, 1840 – Paris, 1916)

The son of a Creole mother and of a Frenchman who had set out to Louisiana to make his fortune, Bertrand-Jean Redon, called Odilon, was born on 20 April 1840, after his parents had returned to France and settled in Bordeaux. There, Redon would grow up and began to develop his feeling for art. At the time of his first communion, Redon was moved by the powerful gothic architecture, but the brightly coloured rays of light walled inside the place of worship by the old multi-coloured stained glass windows affected him more than anything else.

Time spent in a milieu of simple country pleasures also stimulated Redon's identity as an artist. Lost among vast country spaces pervaded by the subtleties of nature, its contrasts of light and weather, Redon created his first drawings and charcoals at a very young age. But it was no doubt his journey to Paris and his visits to Parisian museums when he was but seven years old that persuaded Redon to chose a career as an artist. Returning to Bordeaux, the boy's destiny already seemed completely mapped out.

Attending day school and pursuing architectural studies hardly changed Redon's plans in the least, but contributed to the development of his skill at drawing and his lifelong attention to detail.

From 1855 Redon took drawing classes under the tutelage of Stanislas Gorin, himself a student of Eugène Isabey d'Héroult, an independent art teacher and watercolour specialist. Gorin had a considerable effect on Redon's work, encouraging him to copy the canvases of Delacroix, and leading him to discover the art of Millet, Corot, and even Gustave Moreau.

In 1863 Redon met Rodolphe Bresdin, who introduced him to the art of printmaking and, in particular, the technique of etching. Redon proceeded to complete various albums and a large number of illustrations, primarily of Symbolist texts, including Baudelaire's *Fleurs du Mal*.

After the war of 1870 Redon lived in Paris, but continued to visit the family estate, as well as Brittany.

In 1880 Redon married a young Creole woman named Camille Falte, and started making pastels. In 1884 he began to be well-known, due to his active participation in the *Salon des indépendants*, coinciding with the publication of Joris-Karl Huysmans's novel *A Rebours (Against the Grain, also known as Against Nature)*, whose protagonist is a collector of Redon prints.

Over the years, and after conquering health problems, Redon saw his work evolving towards new colours simultaneously clear and bright, while his sombre subjects that had long focused on the theme of the prisoner and the depiction of oddities (such as creatures composed of insects with human heads) were discarded. His blacks were transformed into a flood of radiant colours that gave form to more personal ideas and emotions in which mythology meets the flowery landscapes of his dreams with unrivalled charm.

Odilon Redon died in Paris in 1916 at the age of seventy-six, leaving behind a considerable body of work as his legacy. The Nabis would claim ownership of this legacy and the Symbolists would draw on it as a source.

Odilon Redon,
The Cyclops, c. 1898-1900.
Oil on wood, 64 x 51 cm.
Kröller-Müller Museum, Otterlo.

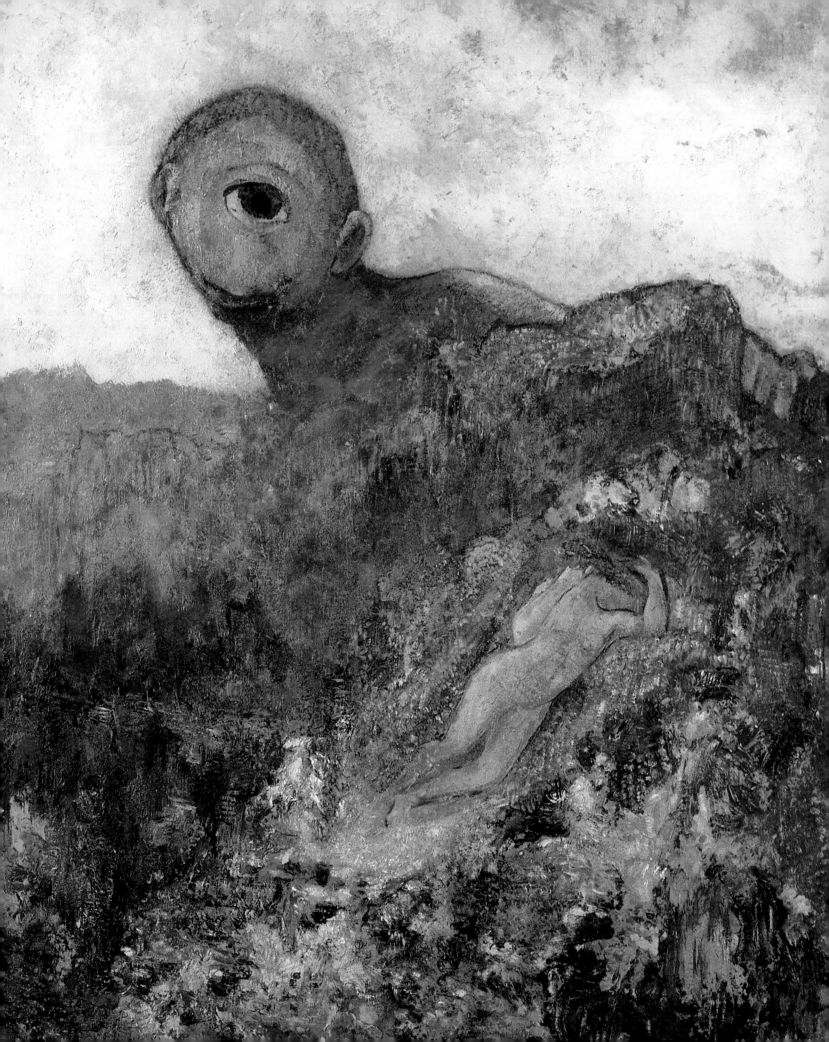

Odilon Redon,
Day, decor for the library of the
Fontfroide Abbey, 1910-1912.
Tempera on canvas, 200 x 650 cm.
Fontfroide Abbey, Narbonne.

Odilon Redon,
Night, decor for the library of
the Fontfroide Abbey, 1910-1912.
Tempera on canvas, 200 x 650 cm.
Fontfroide Abbey, Narbonne.

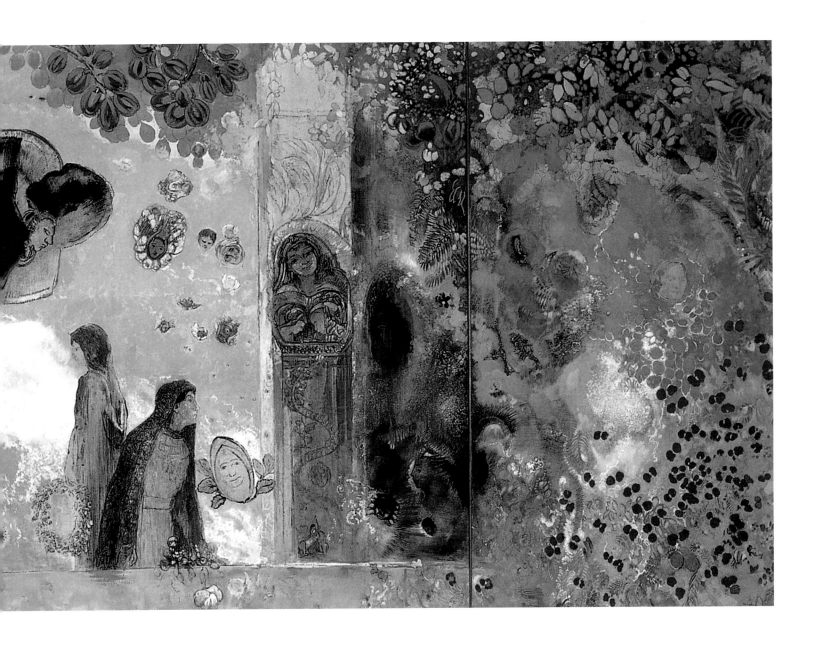

Eugène Carrière
(Gournay-sur-Marne, 1849 – Paris, 1906)

Of Flemish and Alsatian parentage, Eugène Carrière was born in Gournay-sur-Marne on 16 January 1849. Carrière left the Paris region and grew up in Strasbourg, but would return to Paris to enrol in the école des Beaux-Arts (against the advice of his father) in 1869. Although his childhood was more marked by nature walks and memories of the outdoors than by works of art, Carrière began at a very young age to commit to paper all the visible forms he was inexplicably interested in. He attended the design school in Strasbourg from the age of thirteen, entering a lithography studio in 1864.

In Paris Carrière frequented the studio of the academic painter Alexandre Cabanel, then attended the école des Beaux-Arts from 1873. Three years later he endured a failed attempt to win the Prix de Rome, but participated in his first Salon.

Inspired in particular by Dutch painting, Carrière painted a number of important family interiors, including several relating to motherhood.

Carrière's style began to evolve in the 1880s, and he started to free himself from the academic influences stemming from his previously received education.

In 1890 he participated in the Salon of the Société nationale des Beaux-Arts and took up lithography again. It was no doubt at this time that Carrière produced a truly personal style. From then on his works were characterised by monochrome, stylised detail, and sometimes distorted elements. By employing a carefully chosen tonality, he extracted portraits, intimate scenes, and other landscapes out of evanescent forms. Standing before these works, the viewer encounters true paradoxes where suffering responds to love; gentleness conquers violence; and man and devil come face to face with woman and angel.

True distillations of meaning, sources of light in deep darkness, all the forms re-interpreted in Carrière's work represent the essence of life, forcing the viewer to question what he might have previously considered paradoxical.

A passionate humanist, concerned in particular with education issues, completely anchored in the era in which he lived, Carrière participated in the debates of his time, in particular during the Dreyfus Affair (when he committed himself to Zola) and on the subject of the emancipation of women. Always more interested in what united people, as opposed to what separated them, the refinement of his work often seemed to the reflect the man that he was.

In 1898 he opened an "academy" which would train Derain and Matisse, among others.

Eugène Carrière,
Meditation II. Portrait of a Girl.
Private collection.

Eugène Carrière,
Mass Theatre, 1895.
Oil on canvas, 220 x 490 cm.
Musée Rodin, Paris.

Carrière's contemporaries paid him a sincere tribute in 1904 when Auguste Rodin organised a banquet in his honour.

Throughout his career, his painting, far from restricting itself to portraits and interior scenes, embraced most pictorial genres, always in response to Symbolist concerns. Suffering from throat cancer, Carrière underwent surgery that left him paralysed and unable to talk during the last year of his life. But he was a man who was well liked by many, and his friends continued to pay him visits, engaging in written conversations with him. Carrière died in Paris on 27 March 1906.

The Musée d'Orsay celebrated the centenary of his death with the Rodin-Eugène Carrière exhibition and also through the publication of the *catalogue raisonné* of his painted works, a final homage.

Matthijs Maris,
The King's Children, c. 1890.
Oil on canvas, 94.5 x 65 cm.
Stedelijk Museum de Lakenhal, Leiden.

Eugène Carrière,
The Motherly Kiss, 1898.
Oil on canvas, 99 x 74 cm.
Musée des Beaux-Arts, Pau.

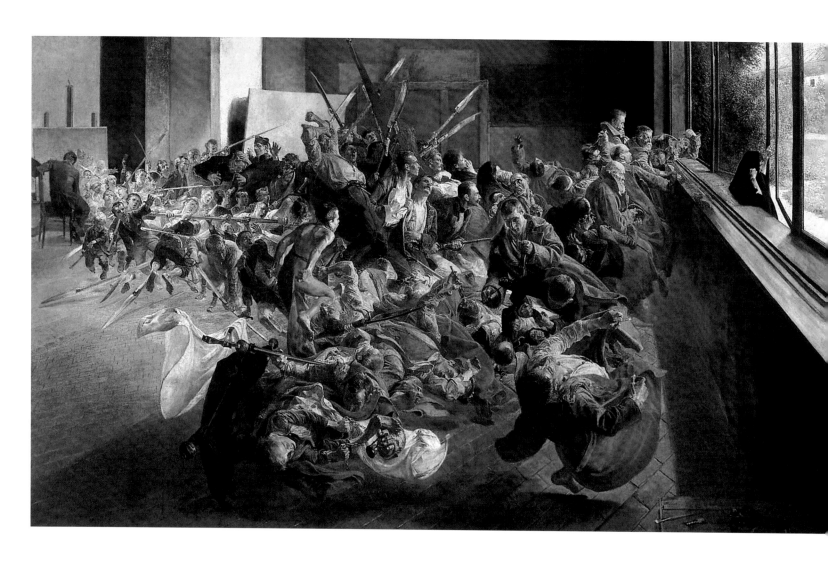

Jacek Malczewski,
Melancholia, 1890-1894.
Oil on canvas, 139 x 240 cm.
The National Museum, Warsaw.

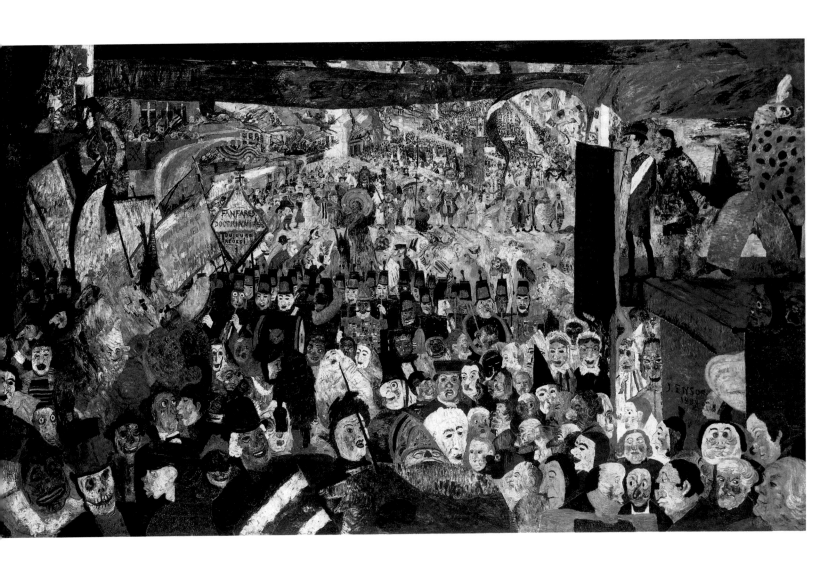

James Ensor,
Christ's Entry into Brussels in 1889, 1888.
Oil on canvas, 252.7 x 430.5 cm.
J. Paul Getty Museum, Los Angeles.

Mikhail Aleksandrovich Vrubel
(Omsk, 1856 – St Petersburg, 1910)

The son of a Russian army colonel, Mikhail Aleksandrovich Vrubel was born in the town of Omsk in Siberia. Encouraged by his father, Vrubel commenced a thorough study of history, music, theatre, and literature, as well as languages (Latin, German and French). His actual artistic training began in 1864, when he entered the Society for the Encouragement of the Arts in Saint Petersburg. Between 1874 and 1880, Vrubel studied law, and then attended classes at the Academy of Arts in Saint Petersburg. There, alongside Valentin Serov, he studied under the painter and graphic artist Pavel Tchistiakov, who would play an important role in the development of his style. In 1884 Vrubel's professors recommended that he be given the job of restoring the icons and ancient frescos of a church in Kiev. This experience led Vrubel to think about how spirituality and expressions could be depicted and how to approach issues relating to monumentality. At the same time he was doing decorations for the theatre, opera, and even private properties. He was also involved in ceramic work and developed a method of firing that enabled him to give his works a metallic sheen.

Vrubel's style continued to evolve up until the 1890s, when he moved to Moscow. In compositions always marked by considerable Symbolism, he made his forms geometric (by cutting and crossing lines) and employed colours with exceptional emotional sensitivity. As a result, his canvases often recall glasswork. It was in this period that Vrubel began a series of canvases on the theme of *The Demon*, inspired by a poem by Mikhail Lermontov.

At the same time, Vrubel joined the Abramtsevo colony, an elitist circle that was the cradle of Russian painting and culture during the late nineteenth century.

Unfortunately Vrubel suffered from mental problems during the last ten years of his life. After a stay in a clinic, his health returned, only to decline again a few years later. He was consequently forced to commit himself to an asylum on several occasions, but continued to paint in spite of his health problems. Between 1902 and 1905 he devoted himself primarily to drawing, completing in particular beautiful compositions in black and white. But with his mental health always on the decline, Vrubel was unable to finish the portrait of the poet Valeri Brioussov that he was working on in 1906. In the spring of 1910, while deeply depressed, Vrubel sat before an open window hoping that he might catch a cold bad enough to release him from his demons. The artist died of pneumonia in April 1910.

In 2006, as part of the *Europalia Russie* festival, the community museum of Ixelles in Belgium staged an exhibition devoted to Russian Symbolism within which Vrubel occupied a major position. By being the leading Russian Symbolist, as well as a practitioner of the decorative arts, he was able to re-interpret Russia's plastic arts. A unique character, Vrubel remains a profoundly original and independent artist who led Russian art to the threshold of the twentieth century, he alone making the transition between the old and new generation of Russian artists.

Mikhail Aleksandrovich Vrubel,
Quick-Tempered Demon, 1901.
Watercolour, gouache, and colours on paper, 21 x 30 cm.
Sketch for the painting of 1902.
The Pushkin Museum of Fine Arts, Moscow.

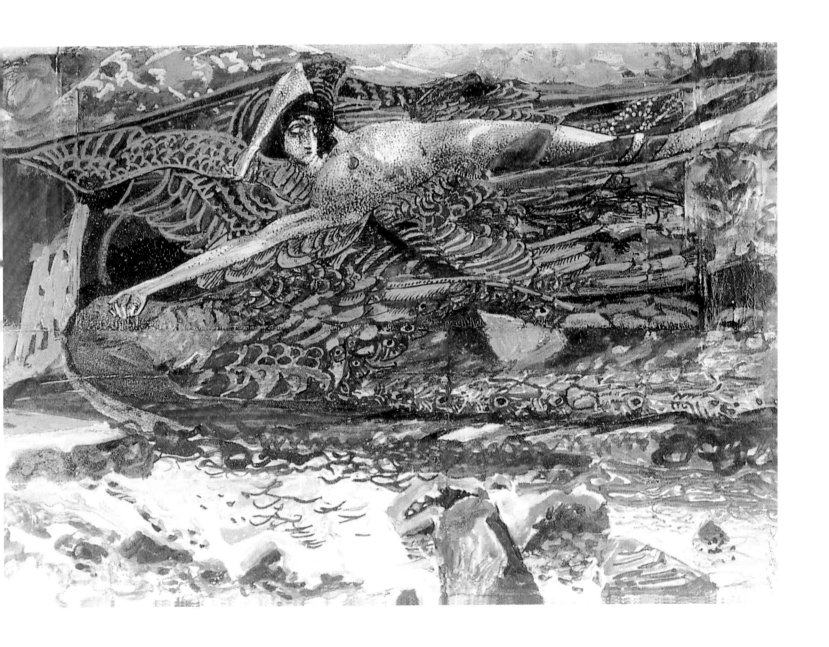

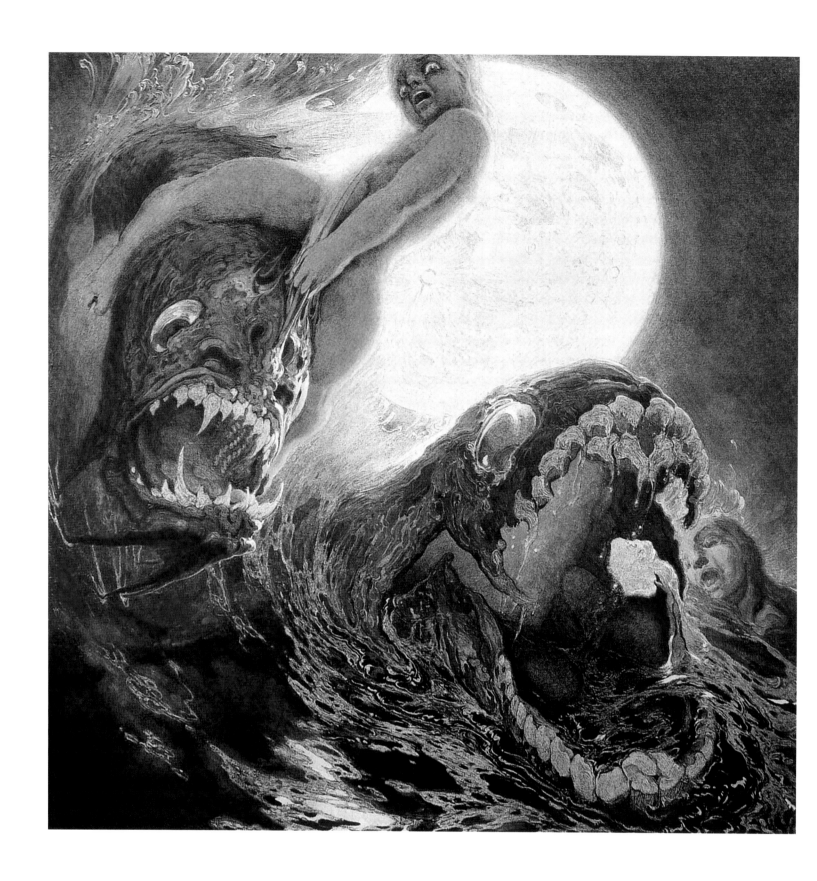

Néstor Martín Fernández de la Torre, called **Néstor,**
Night (from "Poem of the Atlantic"), 1917-1918.
Oil on canvas, 126 x 126 cm.
Museo Néstor, Las Palmas de Gran Canaria.

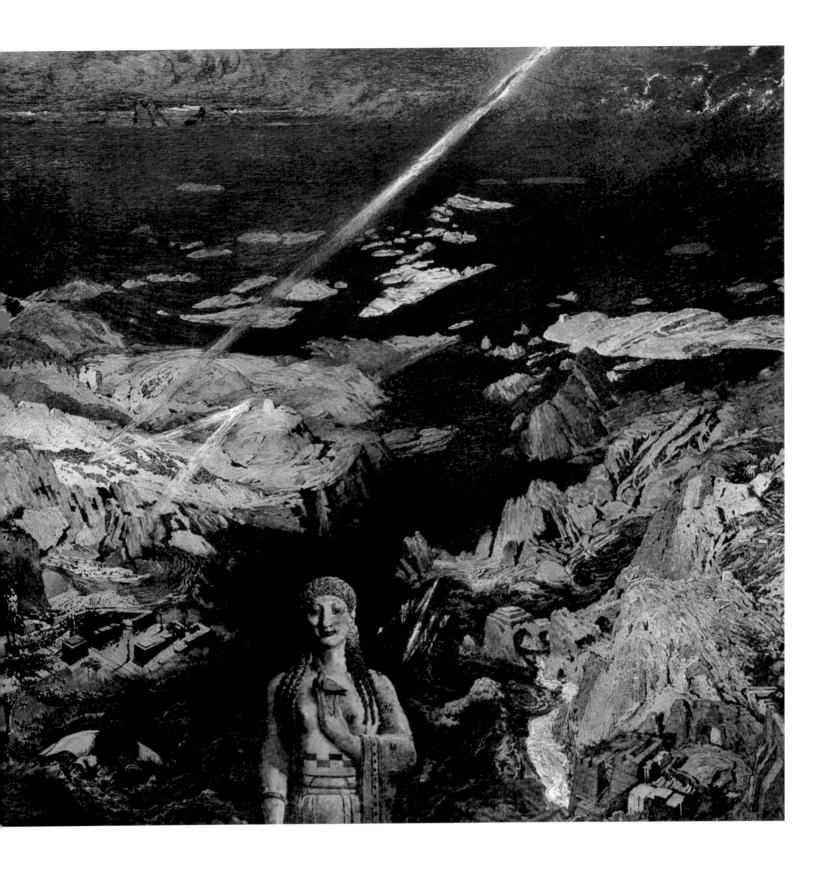

Léon Bakst,
Terror Antiquus, 1908.
Oil on canvas, 250 x 270 cm.
The State Russian Museum, St Petersburg.

Mikhail Aleksandrovich Vrubel,
Flying Demon, c. 1899.
Oil on canvas, 158.5 x 430.5 cm.
The State Russian Museum,
St Petersburg.

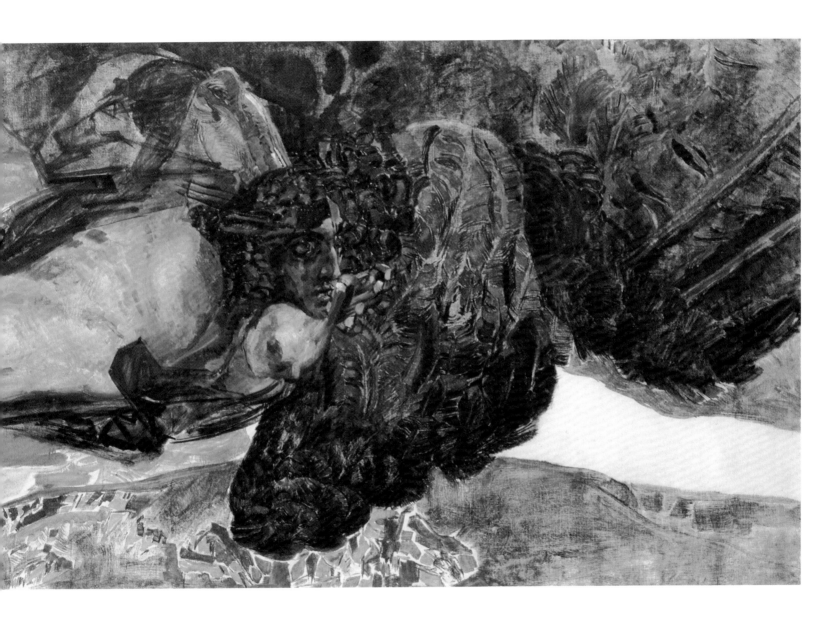

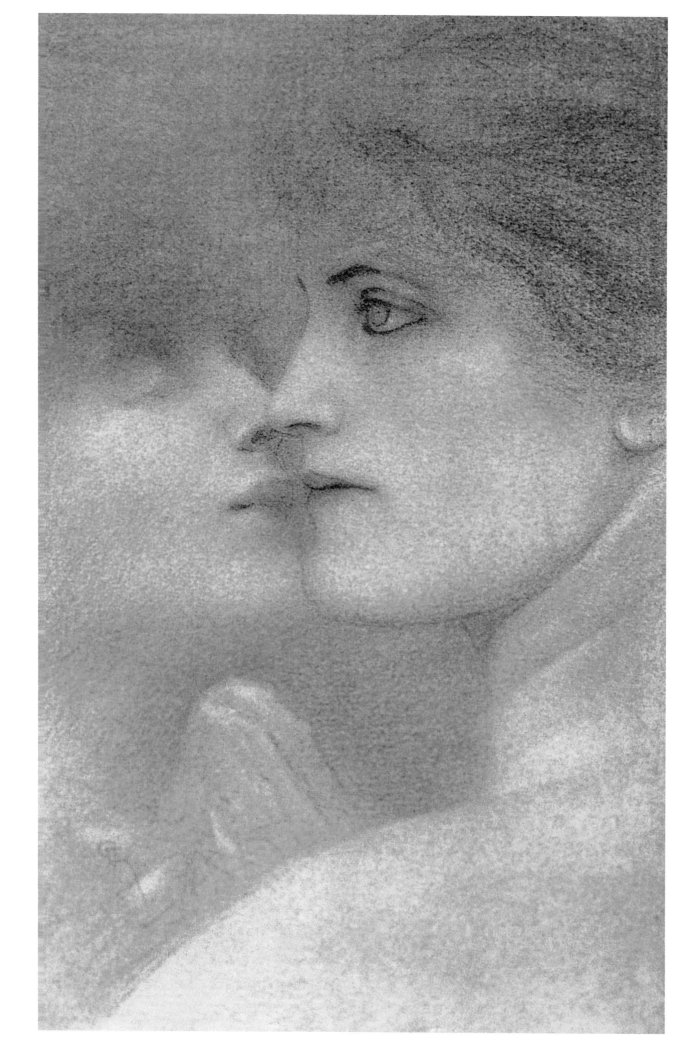

Fernand Khnopff
(Grembergen-lez-Termonde, 1858 – Brussels, 1921)

The son of a magistrate, Fernand Edmond Jean-Marie Khnopff was born in Grembergen-lez-Termonde, Belgium, in 1858. He was the eldest of three children.

In 1859 his father was appointed a public prosecutor, and the Khnopff family moved to Bruges.

His brother Georges, a future musician, poet, and art critic, was born in 1860; his sister Marguerite was born in 1864. The year after her birth the Khnopff family moved again to go and live in Brussels.

In the Belgian capital Khnopff continued his education by studying at the Faculty of Law at the Université Libre, and began frequenting Xavier Mellery's painting studio. Sometime between 1876 and 1879 he interrupted his law studies in order to enter the Brussels l'Académie des beaux-arts, where he met James Ensor.

Khnopff's first paintings were mainly landscapes, depicting in particular the town of Fosset where he normally summered.

Inspired by the writing of Gustave Flaubert, Khnopff painted his first Symbolist work in 1883 and participated in the founding of *Les Vingt*. Mentioned in the influential art magazine *L'Art Moderne*, Khnopff appeared in the annual exhibitions of *Les Vingt* until the group disbanded ten years later.

In 1885, while fascinated by the occult theories of the Rosicrucians, Khnopff met Joséphin Péladan, for whose novels he illustrated the frontispieces. Khnopff regularly exhibited in the Salon of the Rosicrucians.

In 1887 Khnopff completed the enigmatic portrait of his younger sister, Marguerite, which he thereafter always kept with him. As a woman who was both pure and sexually attractive, in the eyes of the painter she represented a type of feminine ideal, and it was she whom Khnopff depicted several times in his masterpiece *Memories*, painted in the subsequent year.

Particularly active in the bourgeois milieus of Brussels and Paris, Khnopff quickly became the portraitist of choice.

In 1889 Khnopff, who was drawn to England, began to develop relationships with Pre-Raphaelite painters, especially Burne-Jones. The following year, the Hanover Gallery in London held an exhibition devoted to Khnopff. During this period he participated in many international exhibitions in London, Munich, Venice, and Paris.

Khnopff is known for the faded tonalities of his colours that increase the viewer's experience of nostalgia and detachment when viewing his paintings.

While a correspondent for Belgium, he was also associated with the art magazine *The Studio*, for which he worked until 1914.

Fernand Khnopff,
Study of Women, c. 1887.
Red chalk on paper, 12.5 x 8.5 cm.
Private collection, New York.

Fernand Khnopff,
Memories (*Du lawn tennis*), 1889.
Pastel on paper mounted on canvas,
127 x 200 cm.
Musée royaux des Beaux-Arts de
Belgique, Brussels.

In June 1898 the Austrian Secession (an Art Nouveau offshoot), welcomed Khnopff as a guest of honour, alongside Rodin and Puvis de Chavannes. Khnopff composed his famous canvas *Les Caresses (Caresses)* the same year.

In 1903 the financier Adolphe Stoclet commissioned Khnopff to decorate the music room of his Art Nouveau mansion, the Palais Stoclet, which also included Gustav Klimt's famous mosaic murals.

At the same time, Khnopff started a series of pastels around Georges Rodenbach's Symbolist novel *Bruges la Morte (The Dead City of Bruges)* and designed costumes for various operas playing at the Théâtre de la Monnaie in Brussels.

In 1908 he married Marthe Worms, but the marriage lasted only three years.

Fernand Khnopff died in Brussels on November 12, 1921 and the work of the "painter of closed eyes" then became an essential representative of the Symbolist movement.

Jan Toorop
(Purworedjo, 1858 – The Hague, 1928)

The son of a civil servant, whose job required travel to Dutch trading posts, and an English mother, Johannes Théodor Toorop, known as Jan Toorop, was born on the island of Java in Indonesia in 1858.

In 1863 the Toorop family moved to the island of Banka in southern Sumatra.

Upon returning to the Netherlands in 1869, Jan Toorop attended secondary schools in Leiden and Winterswijk. In 1881 he continued his education at the Academy of Amsterdam in the town of Delft.

As a result of his background, Toorop developed a highly individual style in which he combined Javanese motifs with Symbolist influences.

In 1882 he moved to Brussels where he enrolled in the Academy of Decorative Arts.

Two years later he exhibited in Paris in the *Salon des Artistes indépendants* and in Brussels joined *Les Vingt*.

Toorop also made several trips to England, where he discovered the works of the Pre-Raphaelites.

In 1886 he married Annie Hall and three years later they settled in England, where Toorop prepared an exhibition showcasing the *Les Vingt* artists for display in Amsterdam. A year later he returned to the Netherlands and began painting his first pointillist canvases inspired by Seurat.

Jan Toorop,
The Three Brides, 1893.
Oil on canvas, 78 x 98 cm.
Kröller-Müller Museum, Otterlo.

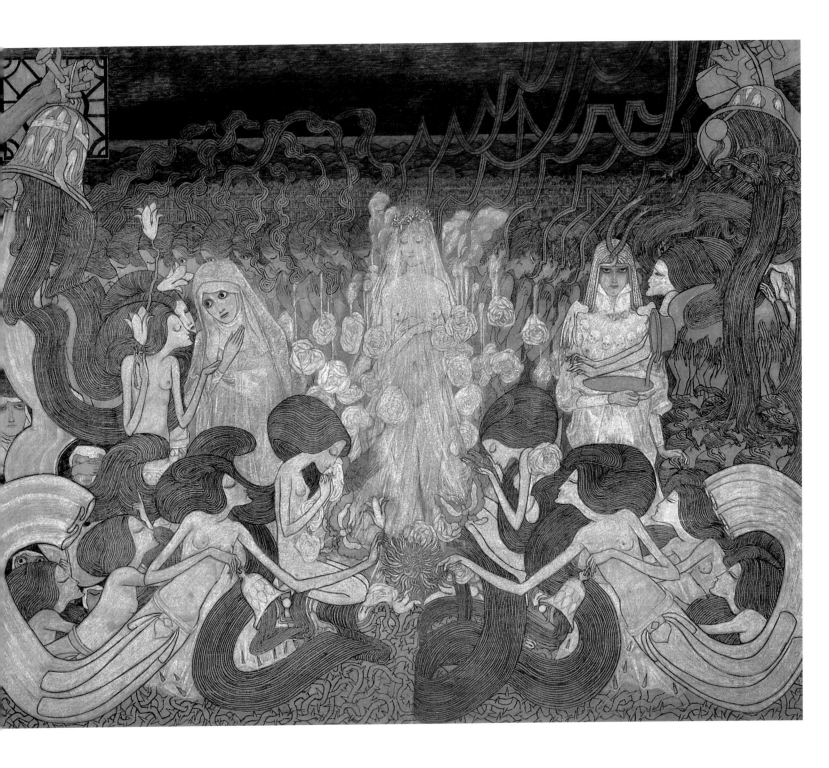

Jan Toorop,
Soul-Searching, 1893.
Ink, pencil and watercolour on paper,
16.6 x 18 cm.
Kröller-Müller Museum, Otterlo.

Around 1890 Toorop encountered Symbolism when he discovered Belgian writer Maurice Maeterlinck's poetry, which Toorop considered a revelation. His art would henceforth appear Symbolist, primarily on account of his frequent use of mythological subjects.

Additionally, the scrolls and curls of Toorop's paintings, evoking shadow puppet theatre, are like the designs of decorative Art Nouveau wallpaper. In depictions of all sorts of genuine mysteries, Toorop based his figures on a feminine silhouette with long, willowy arms interlaced with infinite waves of long hair, and placed them in a world where heaven and earth had no boundaries.

During this period the artist also designed several posters and illustrated various works.

In 1905 Toorop entered upon the path of religion and saw in it a second revelation. Baptised as a Protestant at the age of ten, he converted to Catholicism and henceforth structured his work around his faith. His art thus became more religious and mystical.

Toorop subsequently refined his lines and simplified his style. He died in The Hague in 1928.

Until the twentieth-century rupture, Toorop's art filled the gap between Symbolism and Art Nouveau in a remarkable manner. His departures make him one of the most brilliant representatives of these movements, whereas the different developments of his style make him a precursor of most of the avant-garde movements of the twentieth century.

Jan Toorop,
Desire and Satisfaction, 1893.
Pastel, 76 x 90 cm.
Musée d'Orsay, Paris.

Adria Gual-Queralt,
The Dew, 1897.
Oil on canvas, 72 x 130 cm.
Museo de Arte Moderno, Barcelona.

QVAN HA NIT FA PAS AL
JORN·
JOIAS HE VISTAS·
DE LAS PLANAS·AL·
ENTORN·
VOLEJANT·TRIS·
TAS·
SONIAS·FI·
LAS·DE LA·
NIT *

MES·TART FANM·
Y·VE·LA·MARINA·

LA R

ADA

QV·OMPLENADAS·DE·
NEGVIT·
SE·NDESPEDEIXEN·
Y·AB·L·HVMITEIG·
DE·LLVRS·PLORS·
REBIFANAR·
BRES·FLORS·
Y·S·ESFV·
MEIXEN·

PIR·D'ENAMORADA·

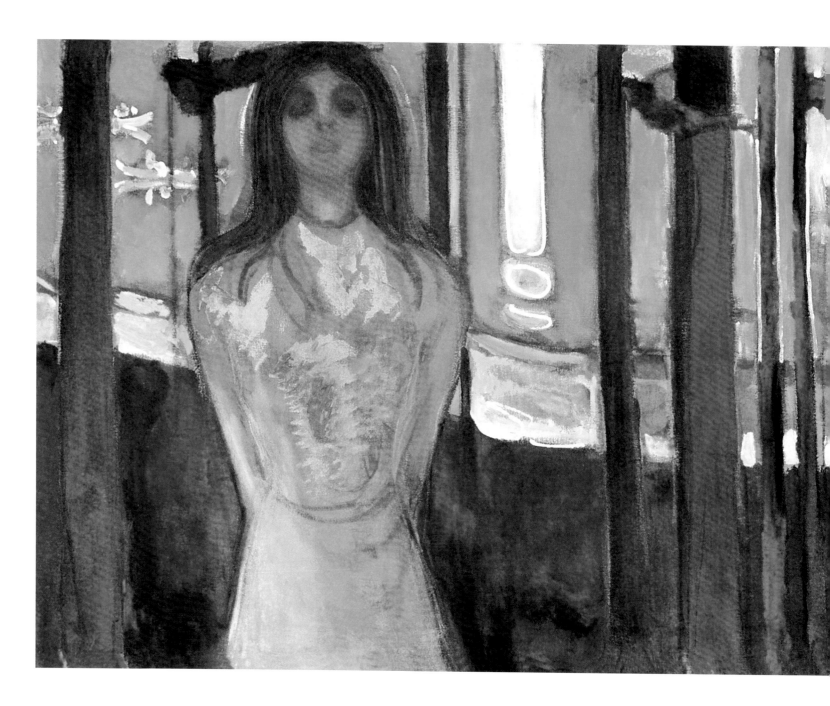

Edvard Munch
(Løten, 1863 – Ekely, 1944)

Throughout his career, the work of Edvard Munch would be affected by his childhood tragedies: the death of his mother when he was five and the death of his sister when she was just fifteen.

Born in Løten in 1863, Munch grew up in the Norwegian capital of Christiana, now known as Oslo. In 1881 he enrolled in the Royal College of Art and Design under the direction of the sculptor Julius Middelthum, where he only gradually turned to painting, the medium that would truly showcase his talent.

The following year Munch studied with the naturalistic painters Christian Krohg and Frits Thaulow. As a result of his apprenticeship with these masters, his first canvases from the 1880s, such as *Landscape, Maridalem (outside Oslo)*, and even *The Old Church of Aker*, are in a particularly naturalistic vein. Munch nevertheless quickly cast off these influences, and, as he was a particularly gifted student, became Norway's prodigy. In 1883 he began to participate in exhibitions and was then included in the Salon of Decorative Arts and a group exhibition in Christiana. Munch's canvases, however, were still naturalistic and did not attract much attention.

In 1885 Munch started composing *The Sick Child*, an outlet for the guilt he felt over his sister's death, then participated in the Universal Exposition in Anvers. The same year he travelled to France for the first time, visiting the Salon and the Louvre in Paris.

Returning to Norway, Munch participated in Christiana's Autumn Exposition, where he publicly exhibited *The Sick Child*, which caused a scandal.

During the last decade of the nineteenth century, he had his first one-man exhibition at the Christiana Students' Association, and a student prize enabled him to return to Paris.

Munch's canvases were henceforth marked by the profound torments that haunted the painter's soul and gave birth to Expressionism.

Often symbolic, Munch's works became true indications of his emotions and feelings.

In 1892 he was invited to participate in an exhibition of the Berlin Artists' Union, but his works caused a serious scandal and the exhibition space that was devoted to Munch was closed after one week.

The next year he started working on *The Frieze of Life*, a series of four canvases (*The Voice*, *The Scream*, *Anxiety*, and *The Ashes*) and made several lithographs. During the last years of the century, Munch also met numerous artists and authors, in particular Symbolists and the Nabis, with whom he associated on Mallarmé's Tuesdays.

Edvard Munch,
The Voice, 1893.
Oil on canvas, 98 x 110.5 cm.
Munch Museet, Oslo.

Boleslas Biegas,
Enchanted Palace, 1902.
Plaster, 47.5 x 27 cm.
Private collection.

Edvard Munch,
The Scream, 1893.
Tempera on board, 83.5 x 66 cm.
Munch Museet, Oslo.

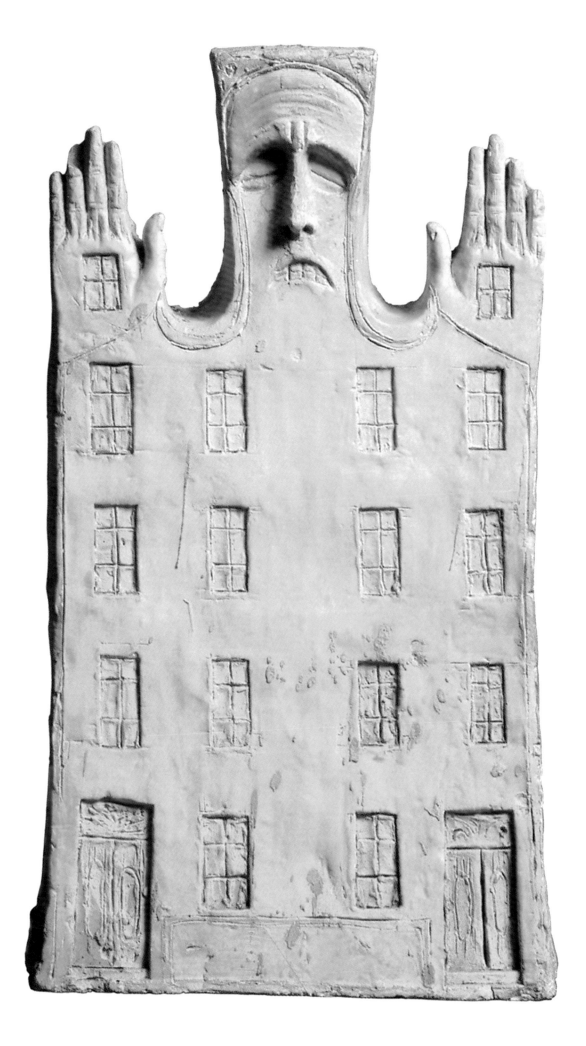

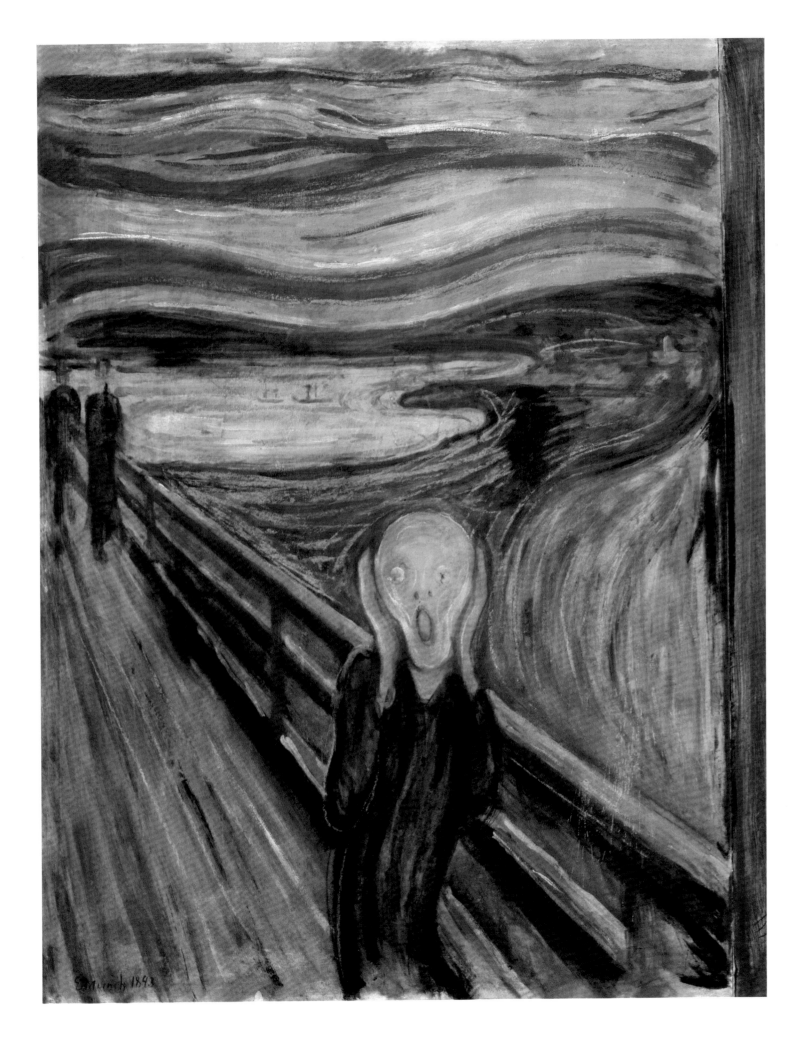

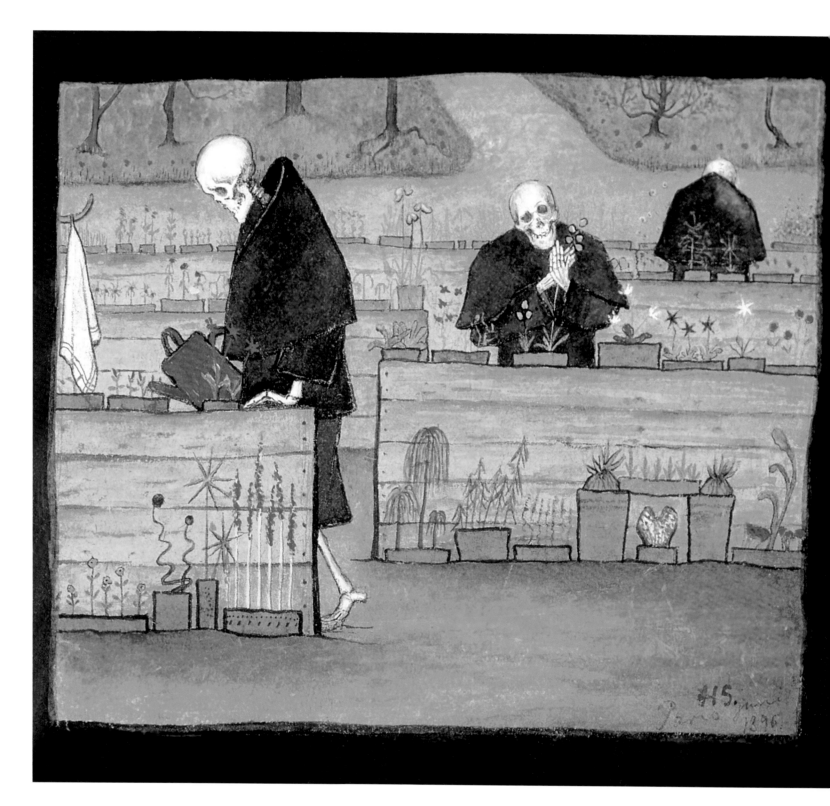

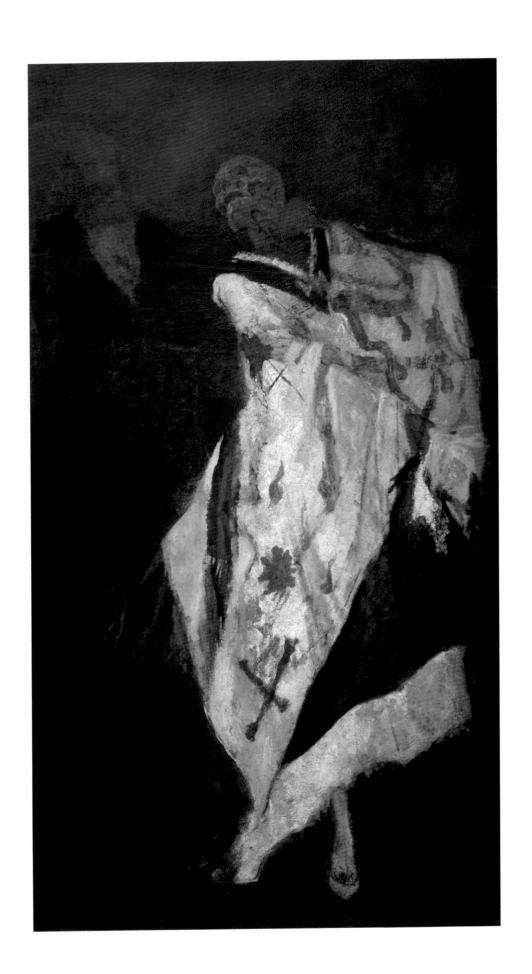

Hugo Simberg,
The Garden of Death, 1896.
Watercolour and gouache on paper,
16 x 17 cm.
Ateneumin taidemuseo, Helsinki.

Félicien Rops,
Death at the Ball, c. 1895.
Oil on canvas, 151 x 85 cm.
Kröller-Müller Museum, Otterlo.

Despite health problems and the wounds of stormy love affairs, Munch entered a productive period at the dawn of the twentieth century and experienced significant success, in particular at the Exposition of Prague in 1905. Surviving an outbreak of Spanish influenza in 1919, he had a retrospective at the national galleries of Berlin and Oslo in 1927 that featured 223 of his works. Ten years later, however, Munch's work was seized from German museums after the Nazis labelled it "degenerate art." During the German occupation of Norway, Munch led a solitary life of seclusion. He died on 23 January 1944, leaving his complete *oeuvre* to the city of Oslo.

Franz von Stuck
(Tettenweis, 1863 – Munich, 1928)

Franz von Stuck was born in the Bavarian town of Tettenweis in 1863. From 1878 to 1881 he attended the *Kunstgewerbeschule* in Munich, where he was encouraged by the painter Ferdinand Barth, then continued his artistic training at the Academy of Munich, where he met Wilhelm Lindenschmit and Ferdinand Löfftz, until 1885.

But von Stuck did not devote himself entirely to painting until 1889. A versatile artist with diverse interests, he also made decorative paintings and worked on publishing the humorist magazine *Fliegende Blätter*, as well as the series *Allegorien und Embleme* and *Karten und Vignetten*, which he illustrated. These activities were vital in establishing his reputation as a skilled draughtsman with a good sense of humour.

At the same time, von Stuck obtained a perfect union of masterful drawing and intensity of colour in his paintings. If he tackled mythological and allegorical subjects, the symbolic treatment he gave them caused all conventionality to be forgotten. In 1889 he received a Gold Medal at the annual *Künstlergenossenschaft* exhibition, where he showed *The Guardian of Paradise*. Despite this acknowledgment, von Stuck nevertheless remained widely criticised by curators who called his work 'daub'. But in 1893, at the exhibition of the Munich Secession, a group in which he played an active role, his glorification of *The Sin* was a success and caused a sensation. In this depiction of Eve wrapped in a serpent, von Stuck created not only one of his now most widely-known paintings, but also a work emblematic of the Symbolist movement.

Von Stuck died in Munich in August 1928. Considered one of the most popular and widely known artists in Europe at the turn of the century, his work was called into question by artists, critics, and the public after his death. He had to wait until the period 1960-70 and the revival of interest in late-nineteenth century aesthetic movements for his vast and varied *Œuvre* to be re-evaluated and re-established in its proper place.

Franz von Stuck,
The Sin, 1893.
Oil on canvas, 94.5 x 59.5 cm.
Neue Pinakothek, Munich.

František Kupka,
Money, 1899.
Oil on canvas, 81 x 81 cm.
Národní Galerie, Prague.

Franz von Stuck,
Water and Fire (detail from the triptych
Air, Water, Fire), 1913.
Oil on canvas, 114 x 49 cm.
Piccadilly Gallery, London.

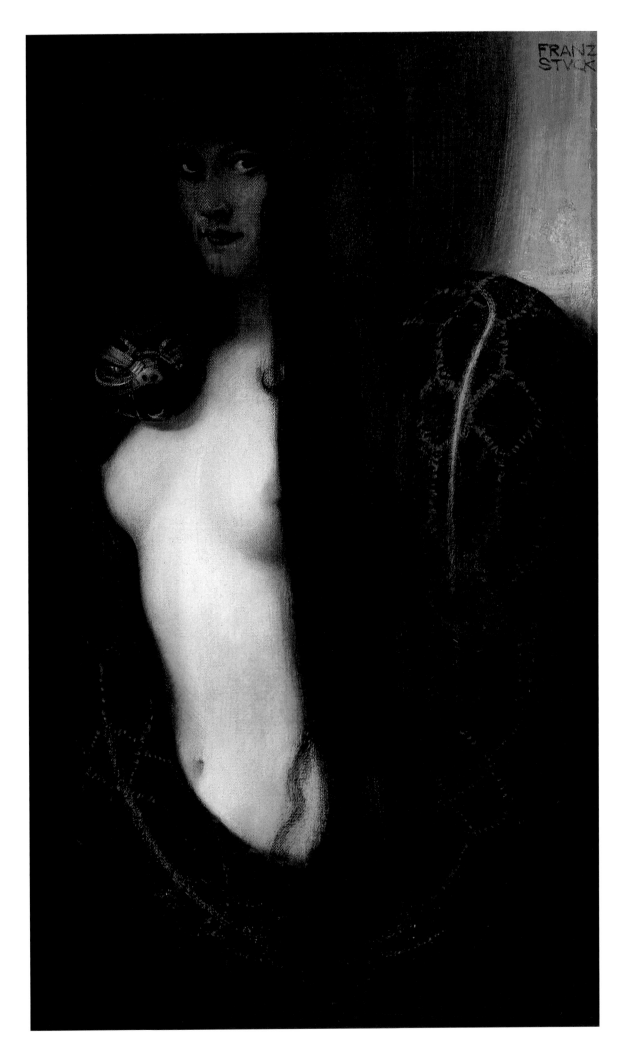

181

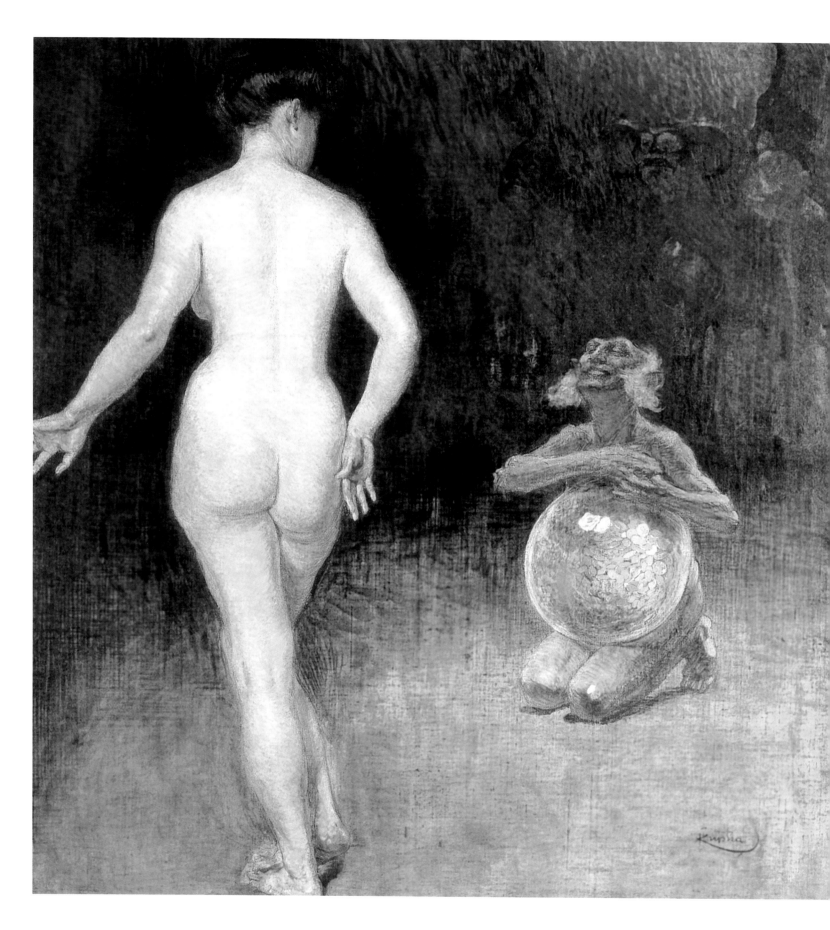

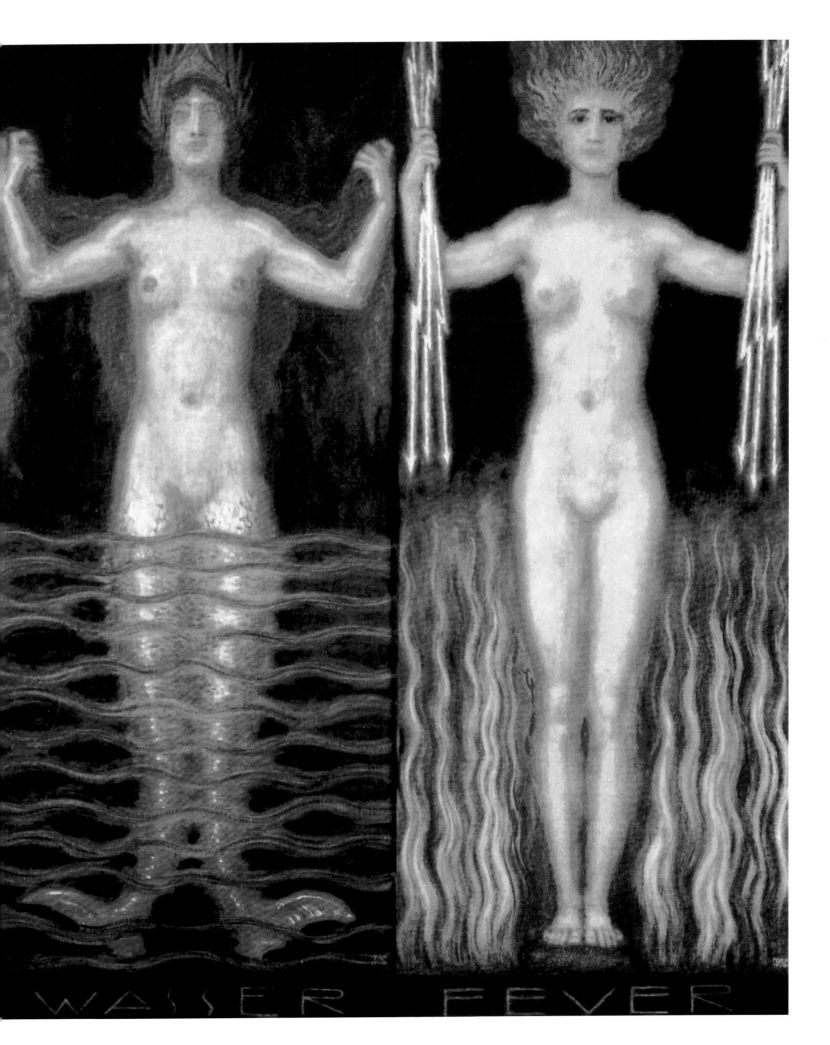

WASSER FEVER

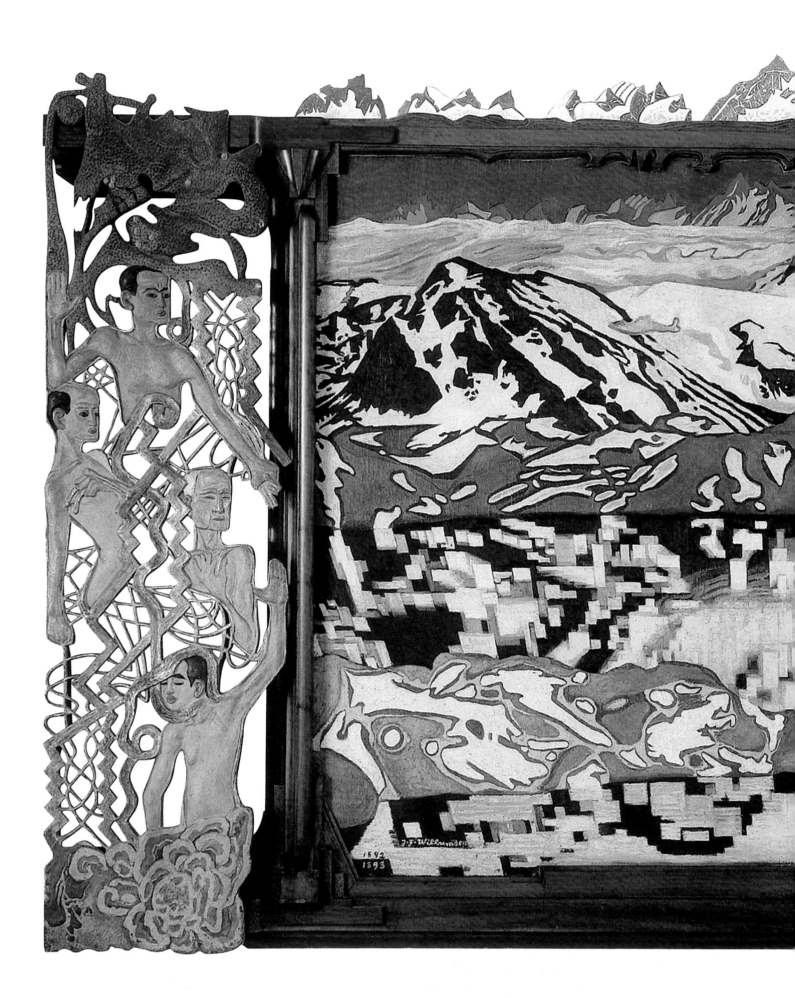

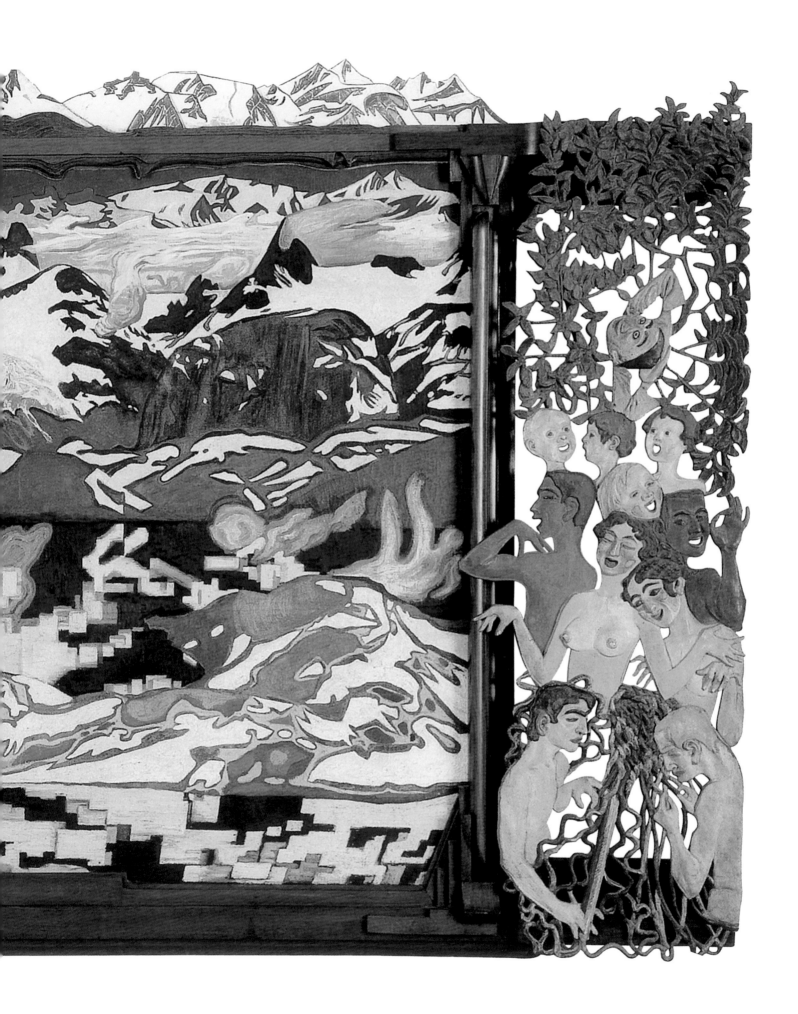

Jens Ferdinand Willumsen
(Copenhagen, 1863 – Le Canet, 1958)

Born in Copenhagen in 1863 of English parentage, Jens Ferdinand Willumsen entered the Royal Academy of Fine Arts of that city in 1881. Willumsen was taking architecture classes at the same time and later sharpened his technique under the painter Peder Severin Kroyer.

In 1888 he made his first trip to France. Upon his arrival, he thoroughly immersed himself in the culture of *fin de siècle* Paris. His initial canvases were in a naturalistic style.

In 1890 he met Paul Sérusier and Maurice Denis and discovered the work of the Symbolist Odilon Redon through Theo Van Gogh. During a summer trip to Brittany in that same year he met Gauguin and visited him at Pont-Aven and le Pouldu. Steeping himself in the works of these major artists, Willumsen also borrowed from the German Expressionist groups, the Danish school, and Nordic Symbolism.

Already recognised in France, Willumsen's fame also grew after the 1900 Universal Exposition held in Paris, where he exhibited *Jotunheim*. It is a work of masterful geometricised Symbolism, in which sculpture combines perfectly with painting, particularly in the intensity of the canvas and its frame. Painted between 1892 and 1893, after a stay in Norway, the work was very popular with the public.

After this period Willumsen, a great traveller, never stopped pushing himself beyond boundaries. He visited the United States, Italy, Spain (where he discovered and admired El Greco), and North Africa, returning to live in France in 1916. Although only rarely going back to Denmark, he exhibited there regularly.

Painting remained Willumsen's preferred means of expression, but he nevertheless explored different visual art forms throughout his career. Working in this way he developed multiple talents, practising painting at the same time as engraving, photography, and ceramics. His output therefore was related to the use of many different techniques. Additionally, his style was always changing and following the various aesthetic trends of the period. Willumsen adapted his themes, which became simultaneously naturalist, symbolic, and expressionist. But his *oeuvre* will always be characterised by the use of lively colour and theatrical effects that bear witness to his singular and original personality, always in search of freedom.

Jens Ferdinand Willumsen died at Canet in 1958 at the age of eighty-five.

Jens Ferdinand Willumsen,
Jotunheim, 1892-1893.
Wood, oil on zinc and enamel on copper,
150 x 270 cm.
J. F. Willumsens Museum,
Frederikssund.

Jens Ferdinand Willumsen,
Fear of Nature. After the Storm,
No. 2., 1916.
Oil on canvas, 194 x 169 cm.
J. F. Willumsens Museum,
Frederikssund.

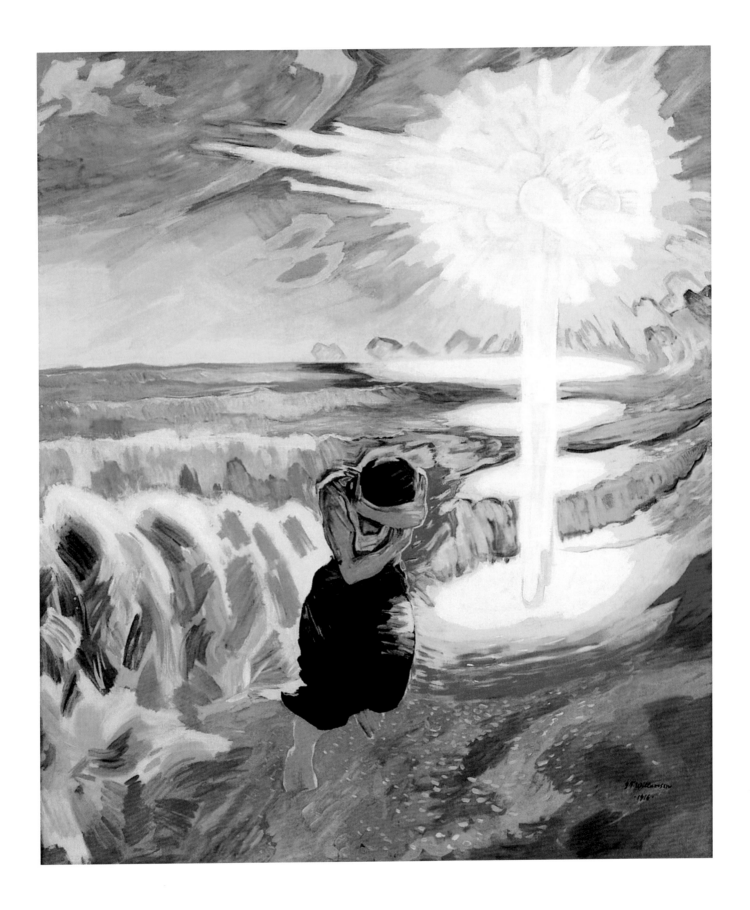

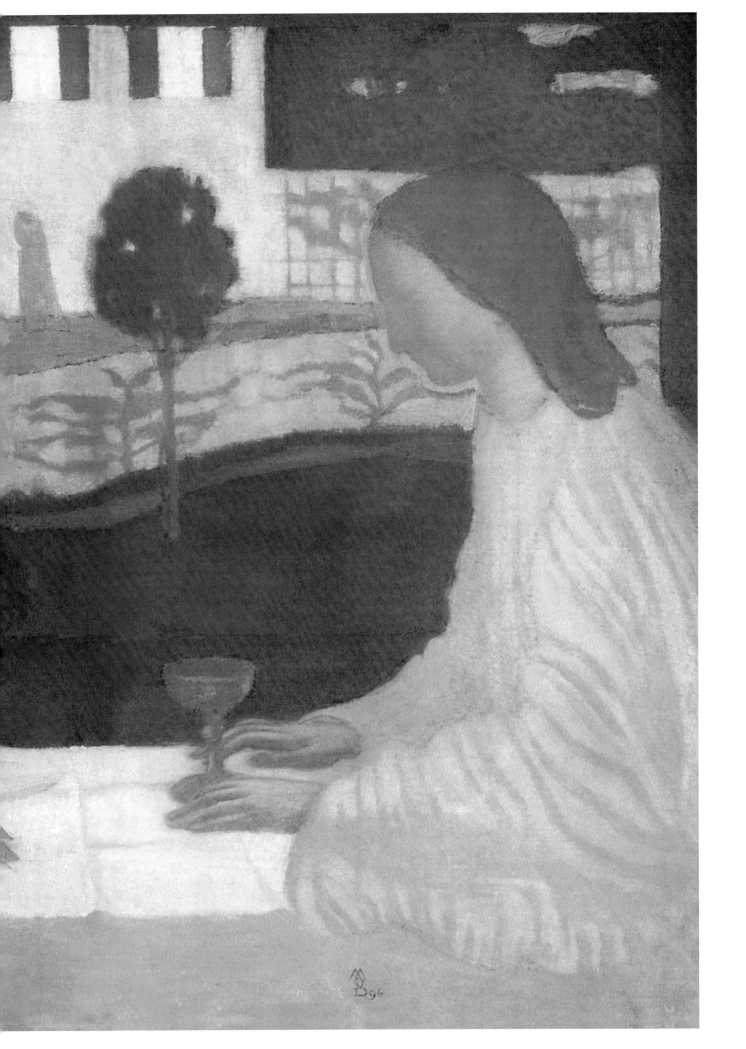

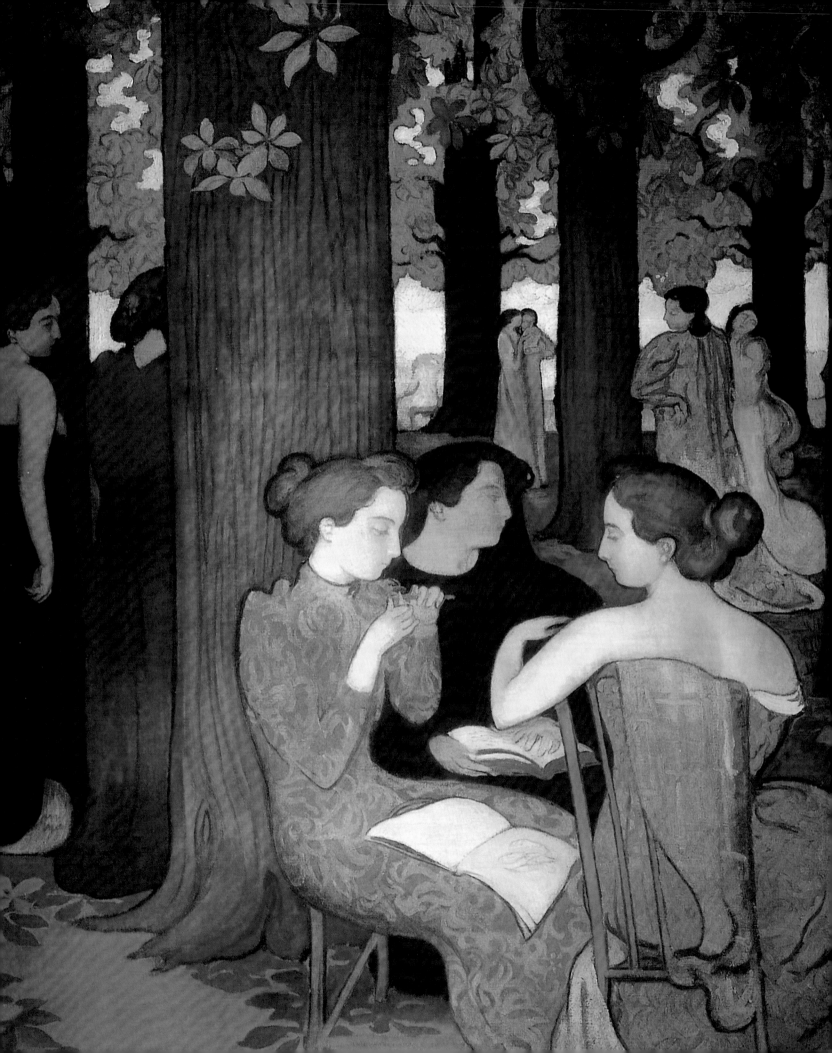

Maurice Denis
(Granville, 1870 – Paris, 1943)

Born in Granville, while his father, a French railway employee, was away on business, Maurice Denis would live his entire life in Saint-Germain-en-Laye.

At the age of twelve he got off to a brilliant start in his education at the Lycée Condorcet, a secondary school in Paris where Edouard Vuillard and Ker-Xavier Roussel were also registered. In 1888 Denis was attending the Ecole Nationale des Beaux-Arts and the Académie Julian at the same time. But his time at the first would be of limited duration: Denis found the teaching there much too academic and left shortly afterwards. Meeting Paul Sérusier at the Académie Julian, Denis established around himself the Nabis group, which included among its members Pierre Bonnard, Edouard Vuillard, and Henri-Gabriel Ibels. Taking their name from the Hebrew word *nabi*, meaning "prophet", the Nabis sought spiritual paths in relation to modern doctrines and philosophies, particularly in relation to the East, Orphism, and esotericism. The group was also greatly influenced by the painting of Paul Gauguin. Sérusier, who would meet the master of Pont-Aven on a trip to Brittany, during the course of which he painted *Talisman* under Gauguin's sensible advice, shared what he learned then with the group.

In 1890 Denis exhibited for the first time at the *Salon des Artistes Français* and the same year he published the *Manifeste du Mouvement Nabi (Manifesto of the Nabi Movement)* in an issue of the journal *Art et Critique*, setting out his now famous definition:

Remember that a painting, before it is a cavalry horse, a female nude, or any other subject, is primarily a flat surface covered with colours arranged in a certain order.

The next year he exhibited in the Salon des indépendants, followed by the Salon of *Les Vingt* in 1892.

In accordance with his ideas, his works henceforth became highly decorative. He made several panels or cartoons for stained glass windows, in particular for Siegfried Bings' Art Nouveau gallery and at the request of Louis Comfort Tiffany. In 1893 he painted his *Muses* for Arthur Fontaine.

Always coloured by a deep spiritualism, in essence symbolic, the works of Denis, with their fragile lyricism, draw us into a world that has an atmosphere of unreality. With their simplified forms, marked halos, and colour harmonies, the works can make time stand still for those who look.

In 1899 Denis started working on the decorations at Vésinet, first for the chapel of the college of Sainte-Croix, then for the church of Sainte Marguerite, while the year 1901 was marked by the *Homage to Cézanne (Hommage à Cézanne)* that he exhibited in the Salon of the Société nationale des Beaux-Arts.

After the turn of the century, Denis made several tours, mainly in France, and still continued to produce a significant number of decorations, monumental compositions for townhouses, theatres and religious structures. Beginning in the 1920s he gave himself much more over to religious art.

Maurice Denis died in 1943 at the Cochin Hospital as a result of injuries sustained by being struck by a car. He left future generations a respected *Œuvre* that was highly personal and haunted by the religious interests that inspired him throughout his life.

Maurice Denis,
Marthe and Marie, 1896.
Oil on canvas, 77 x 116 cm.
The State Hermitage Museum,
St Petersburg.

Maurice Denis,
The Muses, 1893.
Oil on canvas, 171.5 x 137.5 cm.
Musée d'Orsay, Paris.

Odilon Redon,
Ophelia, c. 1900-1905.
Pastel, 50.5 x 67.5 cm.
Private collection.